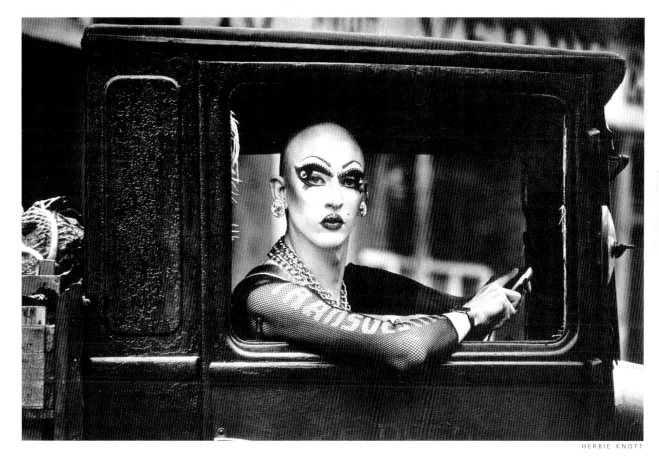

HERBIE KNOTT

AN INDEPENDENT EYE

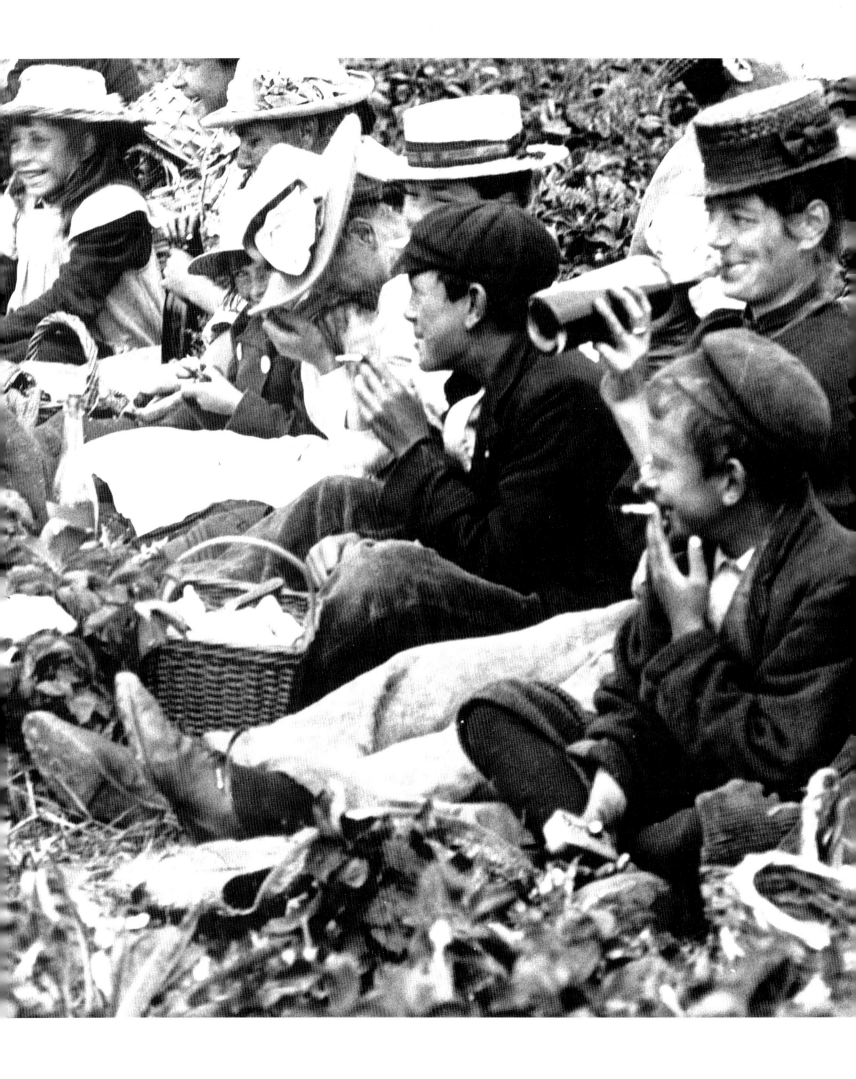

F. J. MORTIMER

THE HULTON GETTY
PICTURE COLLECTION
& THE INDEPENDENT

An Independent Eye

A Century of Photographs

Roger Hudson

SUTTON PUBLISHING

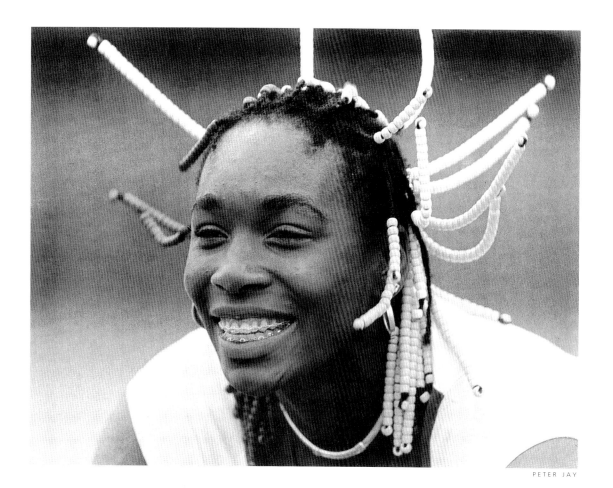

PETER JAY

(Half-title picture)
A transvestite (Petit Chou) at the wheel of a 1928 Ford AA flatbed cabbage lorry in Spitalfields Market, London, taking part in Alternative Fashion Week in March 1994.

(Title page picture)
Strawberry pickers in a Hampshire field at the turn of the century pause for a break and a youthful smoke.

Venus Williams
the American tennis player happy after a practice session at Roehampton Club in June 1998 (left), *shortly before the Wimbledon Championships.*

First published in 1998 by
Sutton Publishing · Phoenix Mill
Thrupp · Stroud · Gloucestershire · GL5 2BU

Copyright © The Hulton Getty Picture Collection 1998

British Library Cataloguing in Publication Data
A catalogue record for this book is available from the British Library

ISBN 0-7509-2107-2 (case)
ISBN 0-7509-2127-7 (paper)

Project manager: Richard Collins
Designer: Paul Welti
Picture researcher: Alex Linghorn
Scanner: Antonia Hille
Typesetter: Peter Howard

Typeset in Frutiger
Origination by Jade Reprographics Ltd
Printed in Great Britain by Butler & Tanner, Frome, Somerset

 ALAN SUTTON™ and SUTTON™ are the trade marks of Sutton Publishing Limited

An Independent Eye is the result of the work of many different parties. It was inspired by Photo 98, the UK Year of Photography and the Electronic Image. Anne McNeill of Photo 98 and David Swanborough at the *Independent*, working with David Allison at The Hulton Getty Picture Collection, sifted through thousands of images to select an individual photograph for each year of the century. This quirky selection was featured daily for three months in the *Independent* newspaper where it quickly acquired a dedicated following.

Photo 98 was created as part of an Arts Council initiative to celebrate a different art form for each year through to the millennium. Its aim has been to raise the profile of creative photography in the UK. The image on this page of a woman from Chechnya was selected for "10 x 8", one of the first major exhibitions commissioned by Photo 98.

This book is a further development of the day by day concept. The images chosen reflect the vast resources of The Hulton Getty Picture Collection which dates back to the very beginning of photography in the middle of the nineteenth century and now incorporates well over 12 million images. These include some of the world's greatest photojournalism, ranging from pictures by *Picture Post* news photographers Bert Hardy and Thurston Hopkins to Keystone Press photographers Fred Ramage and Ron Case and many more, as can be seen in the following pages.

Of all the daily newspapers published in the British Isles today, the *Independent* is the most committed to the very best of contemporary

During the Chechnya offensive
in August 1996 a woman emerges from an air raid shelter to the horror and destruction of the central market in Grozny (below).

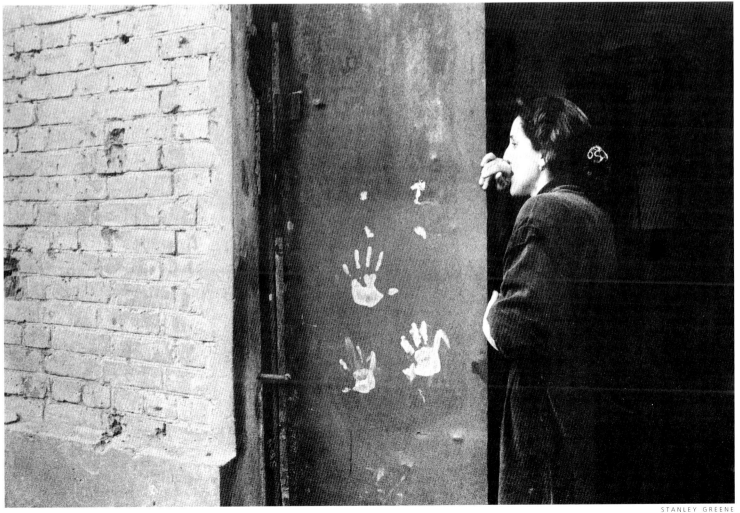

STANLEY GREENE

photography. Continuing the great tradition of photojournalism, the paper has contributed images from its own archives and these are represented in the many extraordinary and striking images for the years 1986 (when the *Independent* was launched) to 1999.

Sutton Publishing is one of the most successful publishers of history in the country, with an expansive list and an approach that is both academic and popular. *An Independent Eye* therefore represents a meeting of like minds – The Hulton Getty Picture Collection, the *Independent*, Photo 98 and Sutton Publishing – all united in a firm commitment to history, photography and photojournalism.

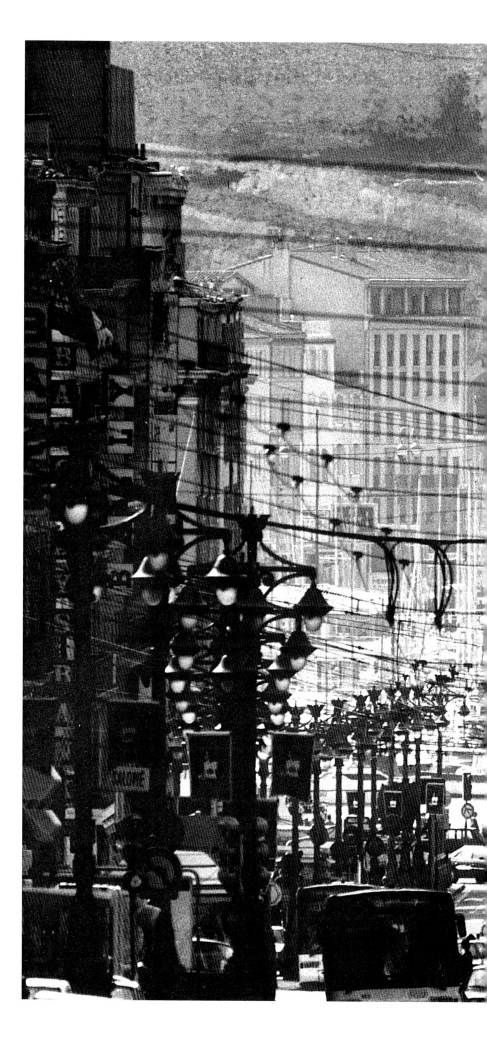

Looming over harbour traffic,
the pirate galleon Neptune *dominates the Marseille*
waterfront. Built especially for Roman Polanski's film,
Pirates, *and photographed in 1992, it remains*
in its berth to this day.

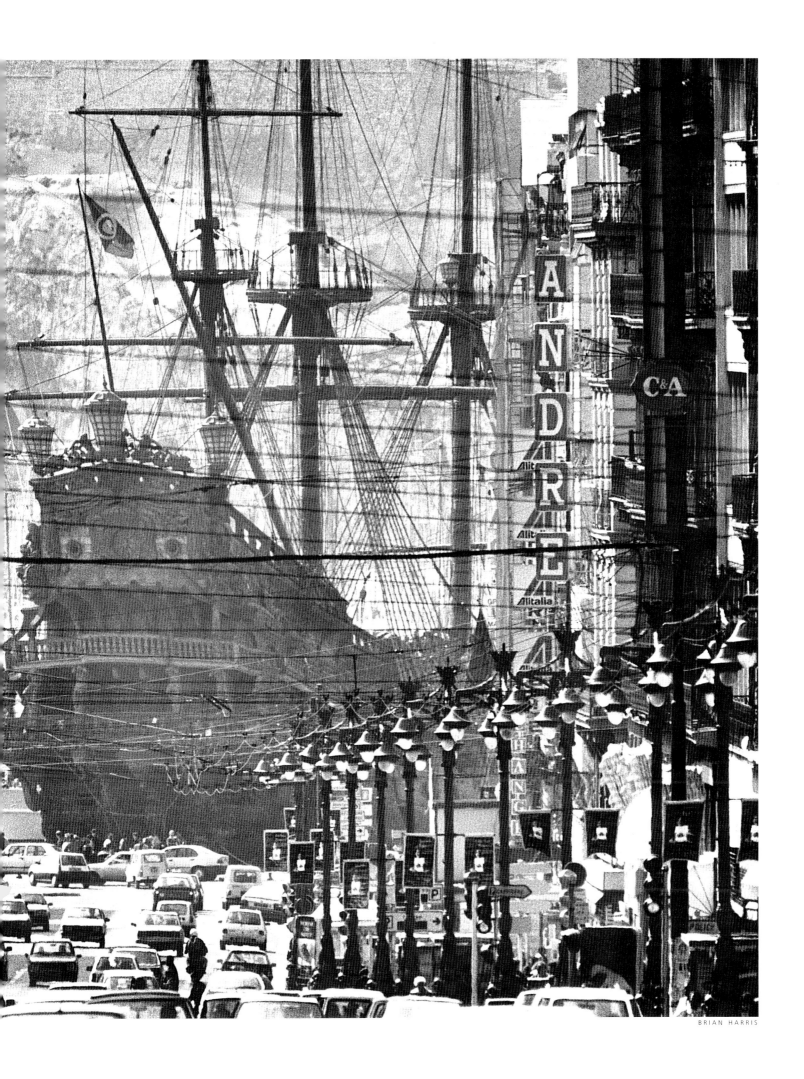

BRIAN HARRIS

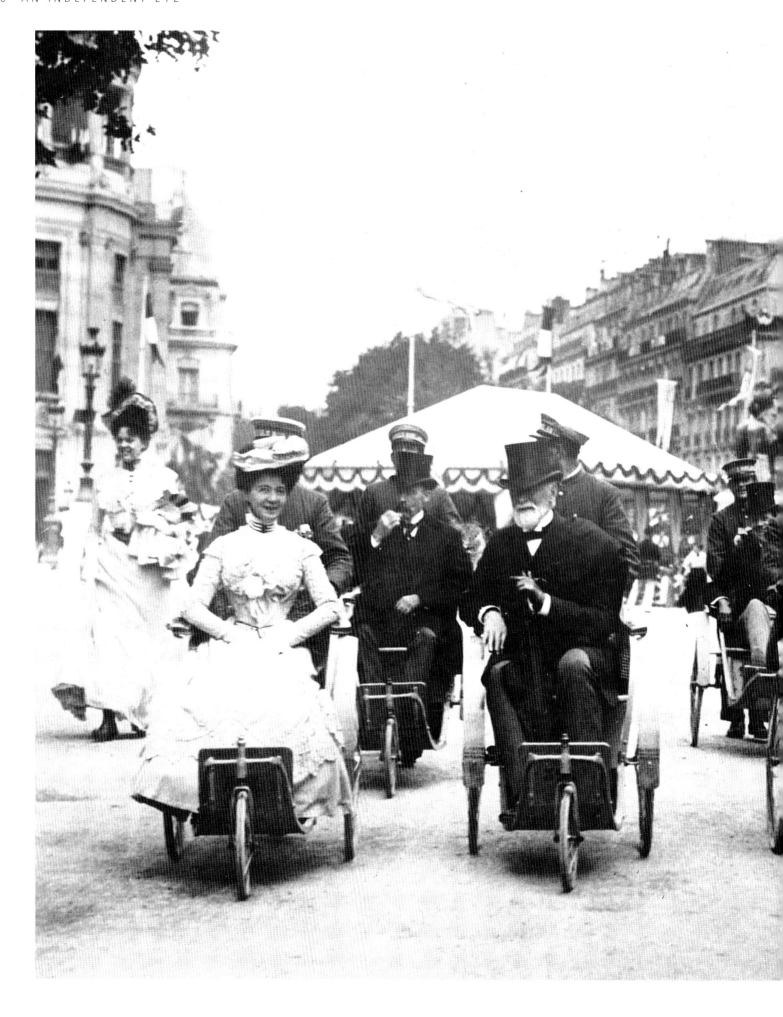

In January Lord Roberts becomes Commander-in-Chief of the British Army fighting the Boers in South Africa, with Kitchener as his chief of staff. After a string of defeats, Britain's fortunes begin to take a turn for the better under this new leadership. The besieged town of Ladysmith is relieved in February and then Colonel Baden-Powell, later to found the Boy Scouts, is relieved at Mafeking in May, which causes wild rejoicing in England. By the end of the year both the Orange Free State and the Transvaal have been annexed by Britain, but the Boers are stepping up their guerrilla warfare. The Boxer Rebellion breaks out in China in June and the European legations in Peking are besieged until an international relief force arrives in August. Arthur Evans' excavations at Knossos in Crete begin to uncover the remains of the Minoan civilisation from the second millennium BC. Speech is transmitted for the first time by the wireless. The first motor bus runs in Britain and the first international motor car race is held in France. The Paris Metro opens. The Brownie box camera is introduced by Eastman Kodak in the USA. Sigmund Freud's *The Interpretation of Dreams* and Joseph Conrad's *Lord Jim* are published. Puccini's *Tosca*, Mahler's Fourth Symphony, Elgar's *Dream of Gerontius*, G. B. Shaw's *You Never Can Tell* and Anton Chekhov's *Uncle Vanya* have their first performances.

Off to the Exhibition.

*Smart Parisians are pushed to the
Exposition Internationale of 1900 down one
of the wide new boulevards of the French capital.
The bath chairs in which they ride have been adapted,
with the steering tillers to the front wheels removed and
mudguards added to preserve the elegant dresses of the
ladies. Anyone whose feet have suffered at a modern
trade fair must envy this mode of transport. By the end
of the 19th century international exhibitions have
become a regular feature of life in Europe and North
America, expressions of national pride and rivalries,
shop windows for industry and commerce. The
Eiffel Tower had been erected for the 1889
Exhibition in Paris. The Grand and Petit Palais
have been built for this one. The gold medals
awarded at exhibitions still linger on the
labels of old-established products.*

Queen Victoria dies on 22 January and is succeeded by her son, Edward VII. During the course of the year, negotiations for an Anglo-German alliance gradually break down. President McKinley of the United States is shot by a Polish-American anarchist and on his death in September Theodore (Teddy) Roosevelt becomes President. Marconi transmits wireless messages from Cornwall to Newfoundland and Britain sees its first motor bike. *Kim* by Rudyard Kipling and *Buddenbrooks* by Thomas Mann are published. Rachmaninov's Second Piano Concerto, Chekhov's *Three Sisters* and Strindberg's *Dance of Death* have their first performances.

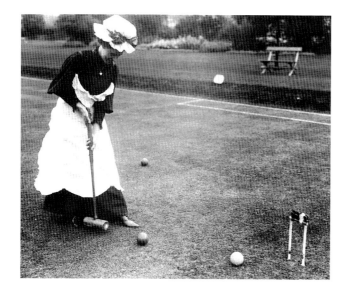

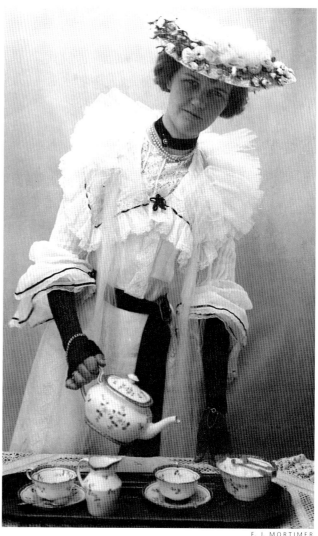

F. J. MORTIMER

A Boer markswoman,
*Mrs Otto Krantz (opposite), poses for the camera in smart riding habit
and jaunty slouch hat towards the conclusion of the Boer War (1899–1902).
There are few concessions to the practicalities of war in her dress or her equipment – that is
a side-saddle on the horse. She took part in the early Boer defeat at Elandslaagte in October 1899
and in the fighting on the Tugela River in January 1900. By 1901 such set-pieces are long over and
the Boers are fighting a guerrilla war, while their families are rounded up into concentration camps
so they cannot supply their men. Disease and malnutrition in the camps are the biggest killers of
all – 26,000 women and children die. Women's clothes in Britain are no more practical,
whether one is a lady in mittens pouring tea (above right), a maid trying her
hand at croquet (above left), or balancing extravagant headgear like
these chorus girls from the show The Matinee Hat (top left).*

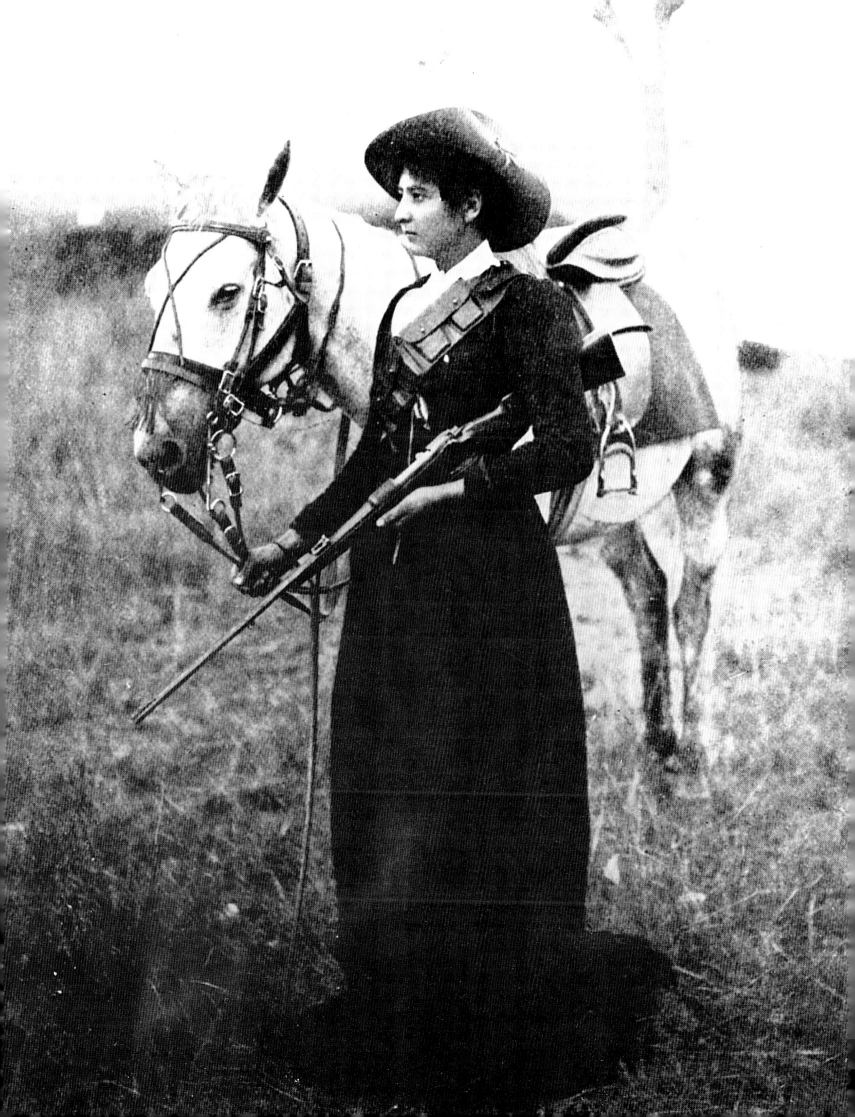

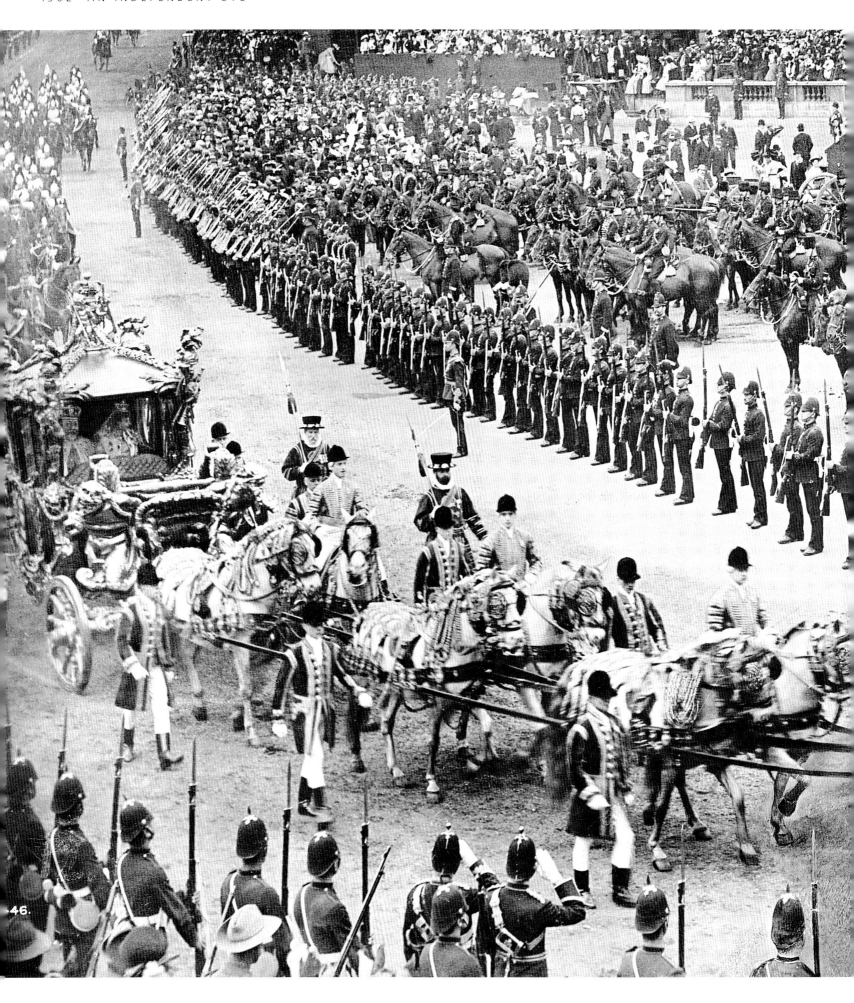

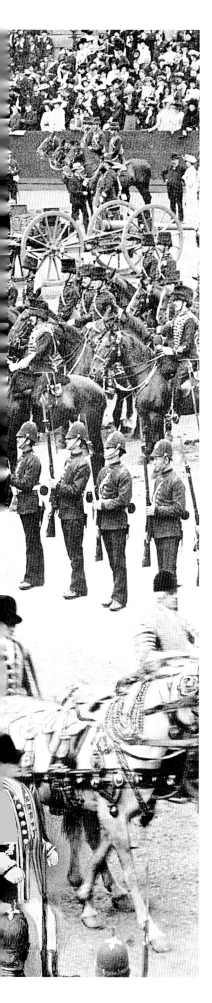

Britain ends its isolation by signing an agreement with Japan to maintain the independence of China and Korea. The Boer War ends in May. Nearly 6,000 British have been killed and 16,000 have died of disease. Arthur Balfour succeeds his uncle Lord Salisbury as Conservative Prime Minister in July. The Education Act provides for secondary schools. Cuba gains its independence from Spain. Ibn Saud seizes Riyadh, so marking the beginnings of Saudi Arabia. The artificial fibre rayon is patented in the USA. *The Hound of the Baskervilles* by Arthur Conan Doyle, *Peter Rabbit* by Beatrix Potter, and *Just So Stories* by Rudyard Kipling are published. The opera *Pélleas et Mélisande* by Debussy is performed for the first time.

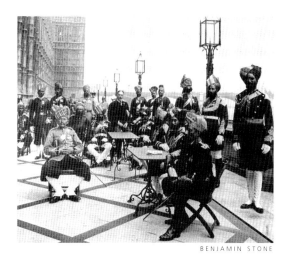

BENJAMIN STONE

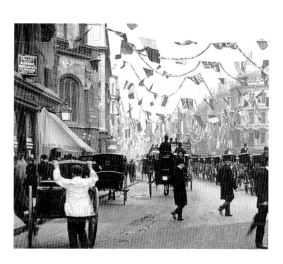

Pomp and circumstance.
The Coronation coach conveys King Edward VII and Queen Alexandra to Westminster Abbey (left). Originally planned for 26 June, the ceremony has to be postponed until 9 August when the King gets appendicitis. Edward Elgar composed the music for a Coronation Ode, not performed until November, which includes his 'Land of Hope and Glory' and in turn becomes part of his 'Pomp and Circumstance' marches. During the ceremony, the King has to help the aged and infirm Archbishop of Canterbury to his feet when he is unable to rise from the kneeling position. Participants include representatives of the Indian Army (top left) and choristers of the Chapel Royal (top right). As shown by these views of the Empire Music Hall in Leicester Square and Queen Victoria Street (above left and right), the capital is fully decorated for the occasion.

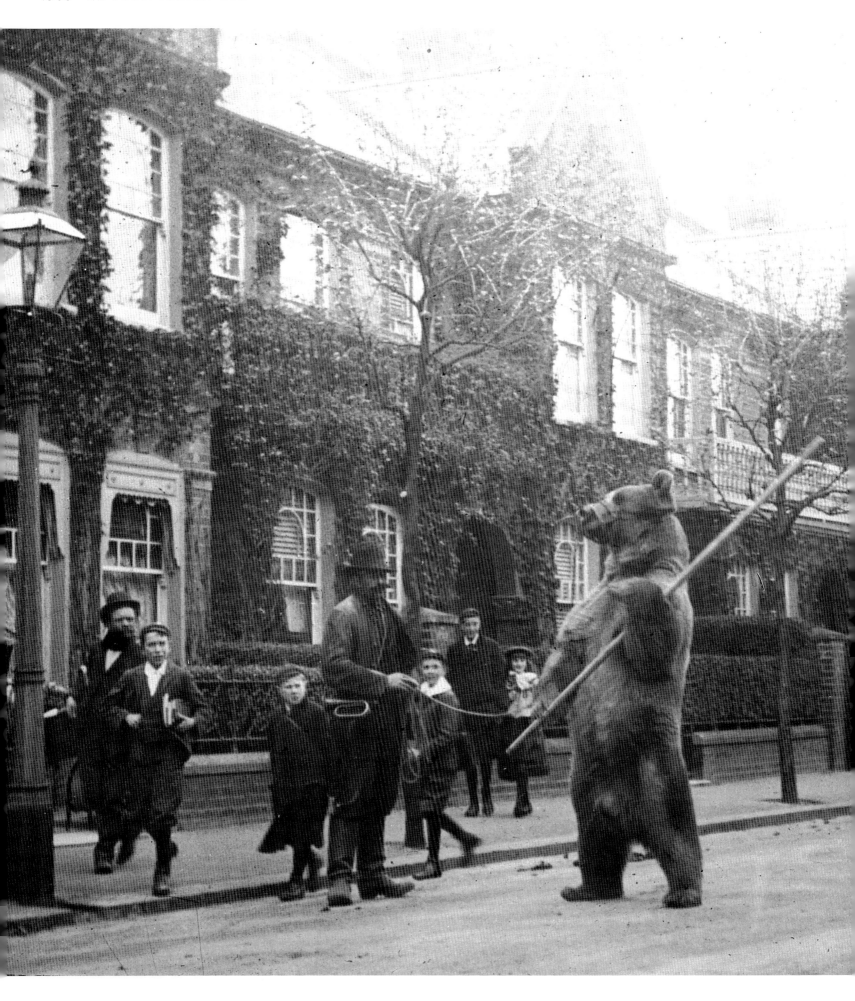

The British conquest of northern Nigeria is completed. Edward VII's visit to Paris in May and the visit of the French Premier to London in July signal the beginning of the Entente Cordiale alliance between the two countries. Joseph Chamberlain resigns from the British Government so that he can champion the cause of Imperial Preference, which seeks to penalise imports not from the British Empire. Russia looks to expand its empire into Manchuria and Korea. The Russian Social Democrats split at their London Congress and the Bolshevik Party emerges, led by Lenin and Trotsky. Mrs Pankhurst founds the Women's Social and Political Union which becomes the centrepiece of the suffragettes' movement seeking votes for women. The Wright brothers make their successful flight in a petrol-engined aeroplane in the United States. London sees its first motor taxis. Henry James publishes *The Ambassadors* and G. B. Shaw's play *Man and Superman* has its first night.

REINHOLD THIELE

A dancing bear
in an outer London street stops the children on their way to school (left). Its handler has not had to blow his bugle to attract this audience, but they are unlikely to give him much for his pains. The gramophone and the cinema may just be making their presence felt, but street entertainers – Italian organ grinders with their performing monkeys, German bands – can still scrape a living in these early decades of the electronic age. The first electric tram goes into service in 1903, but roads are still lit by gas lamps, like the one on the left. The boys' knickerbockers reflect the ideas of the dress reformers prevalent since the 1880s. To see these freaks of human nature (above) you would have to pay good money at Barnum's Menagerie. From the left: Laloo (two bodies), Young Herman (expanding chest), J. K. Coffey (skeleton body), James Morris (elasticated skin) and Jo Jo (the dog-faced man).

PAUL MARTIN

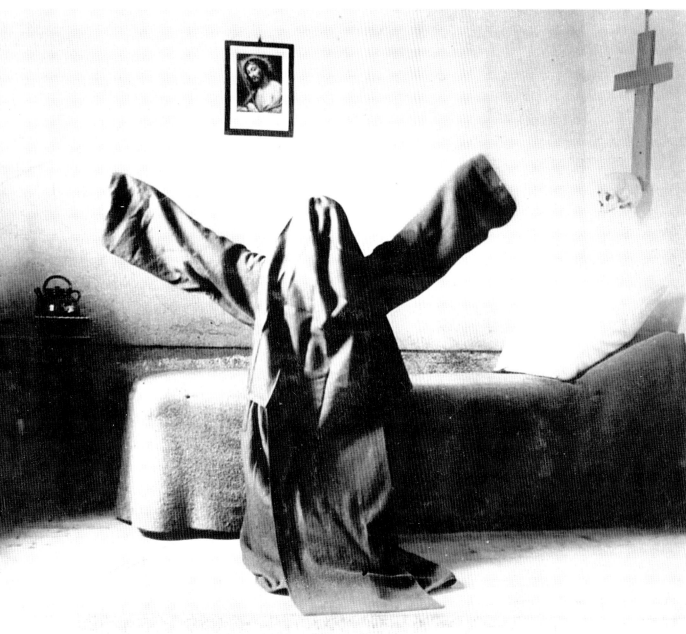

BUYER D'AGEN

Carmelite nuns

*at prayer, while one of their number prostrates herself in worship,
in the shape of the cross, before the altar* (right). *Another kneels before a
devotional picture of Jesus* (above), *with her arms outstretched, in her cell. A skull
below the crucifix at the head of her bed is there as a* memento mori. *The
kettle at the foot is, however, a reassuring touch.*

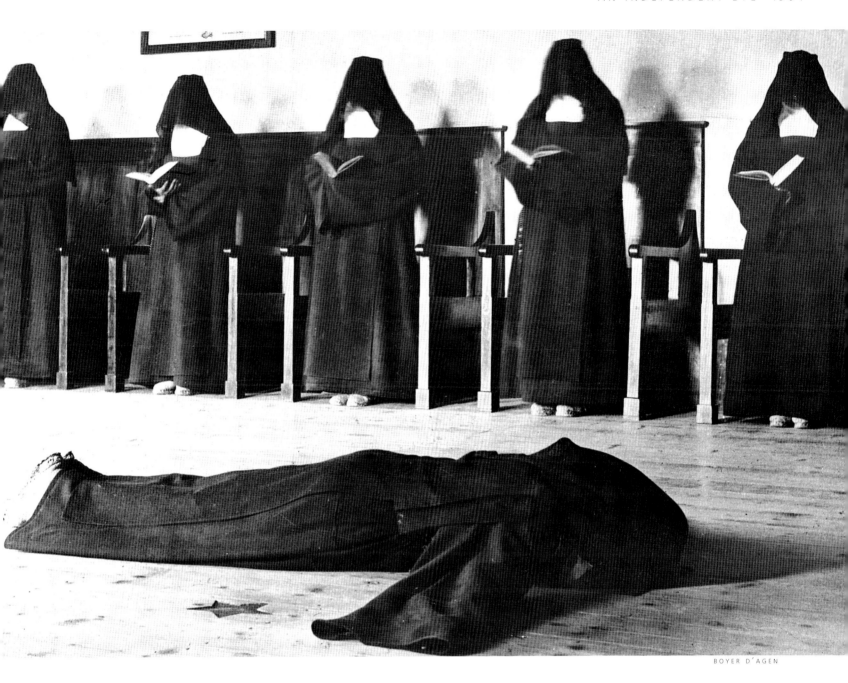

BOYER D'AGEN

In February Japanese torpedo boats launch a surprise attack on the Russian fleet anchored at Port Arthur in north China, starting the Russo-Japanese War and foreshadowing Japan's surprise attack on the US Pacific fleet at Pearl Harbor in 1941. In April the Entente Cordiale is formally enshrined in an Anglo-French treaty. In November the first submarine journey takes place, from Portsmouth to the Isle of Wight, while *Peter Pan* by J. M. Barrie has its first performance on Boxing Day. At the beginning of the year *The Cherry Orchard* by Anton Chekhov had opened in Moscow and *Madam Butterfly* by Puccini in Milan.

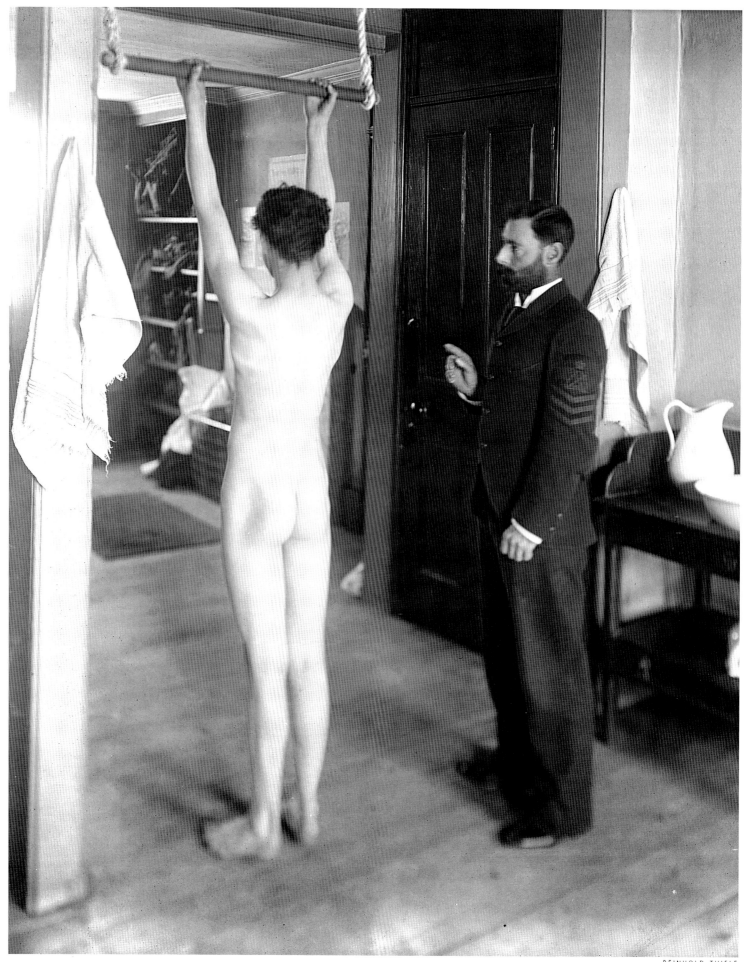

REINHOLD THIELE

1905

Although not an outright Japanese victory, the Battle of Mukden in March ends with 70,000 Russians killed. When Russia's Baltic fleet finally arrives in the Far East in May, it is shot out of the water by the Japanese. A peace is signed in September. This humiliating defeat leads to demonstrations, strikes and massacres within Russia itself, culminating in the promise of an elective assembly from the new Tsar, Nicholas II. It also demonstrates to fledgling nationalist movements all over Asia that European powers are not invincible. Another certainty to crumble is the idea of Time and Mass both being fixed, succumbing to Albert Einstein's Theory of Relativity published in September. A new absolute is erected in their stead, the speed of light, than which nothing can go faster. In response to public demand, Arthur Conan Doyle resurrects his most popular creation in *The Return of Sherlock Holmes*. Norway gains its independence from Sweden.

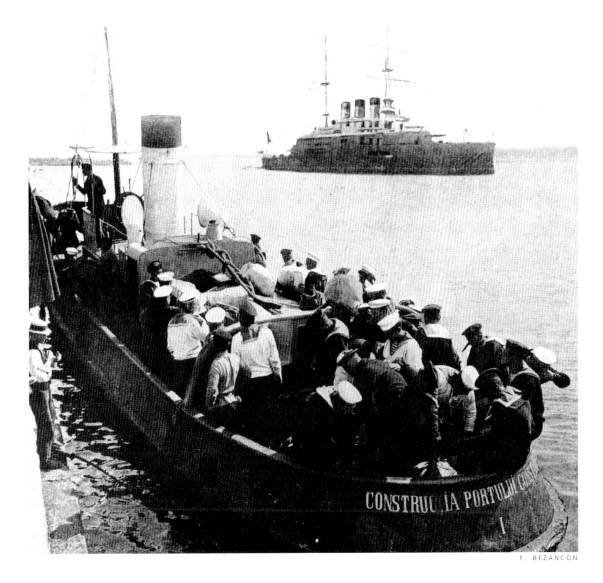

F. BEZANCON

A Royal Navy recruiting office,

where a youth is inspected by a Petty Officer (opposite) *to see whether he has the makings to become an Able Bodied Seaman, the lowest rank in the service. In the 1890s the Navy had undergone a great expansion and this continued in the 1900s, as Germany started to build its own battlefleet. The first of Britain's dreadnoughts, 'all-big-gun' battleships, is laid down in October 1905. In the Russian fleet, defeat by the Japanese brings mutiny in its wake, aboard the battleship* Potemkin *at Odessa in the Black Sea. The mutineers come ashore to give themselves up in the nearby Romanian port of Constanta* (above). *Their mutiny will be immortalised in 1925 by the great Russian film maker, Sergei Eisenstein, in* The Battleship Potemkin.

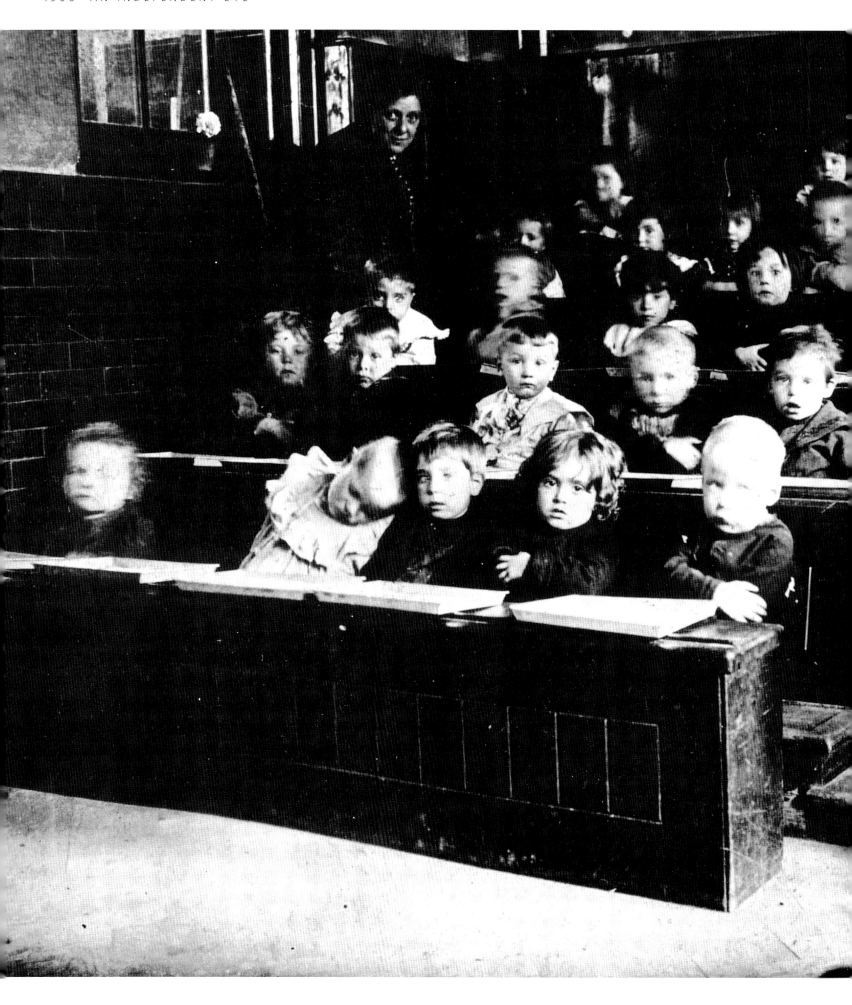

1906

The Liberal Party wins a landslide victory in the British General Election in February, though twenty-nine Labour MPs are also elected. Social reform is very much on the agenda and, if the new suffragettes have their way, so too will be votes for women. San Francisco is devastated by an earthquake and still more damage is done by subsequent fires, leaving 250,000 homeless. Permanent waves for women are introduced in London, cornflakes are invented by William Kellogg, and the electric washing-machine appears for the first time. John Galsworthy publishes the first volume of *The Forsyte Saga*. HMS *Dreadnought*, the first modern battleship, is launched in February, rendering every other battle-ship obsolete and initiating a naval armaments race in Europe, Japan and the USA.

Belfast children
playing in the street (above) *look well cared for and dressed, though some have no shoes.*

A class at an infants' school
in Chelsea (left). *The strain of holding the pose for the camera has been too much for one child in the front row. Primary education for all only became compulsory in 1870. Both before and after that date many schools were run by the different churches, like this Roman Catholic one belonging to the Chelsea Oratory. There is no trace of child-centred learning here, as the children face the blackboard, out of shot. The mistress has moved from her normal position, in front of the whole class, so as to be included in the photograph.*

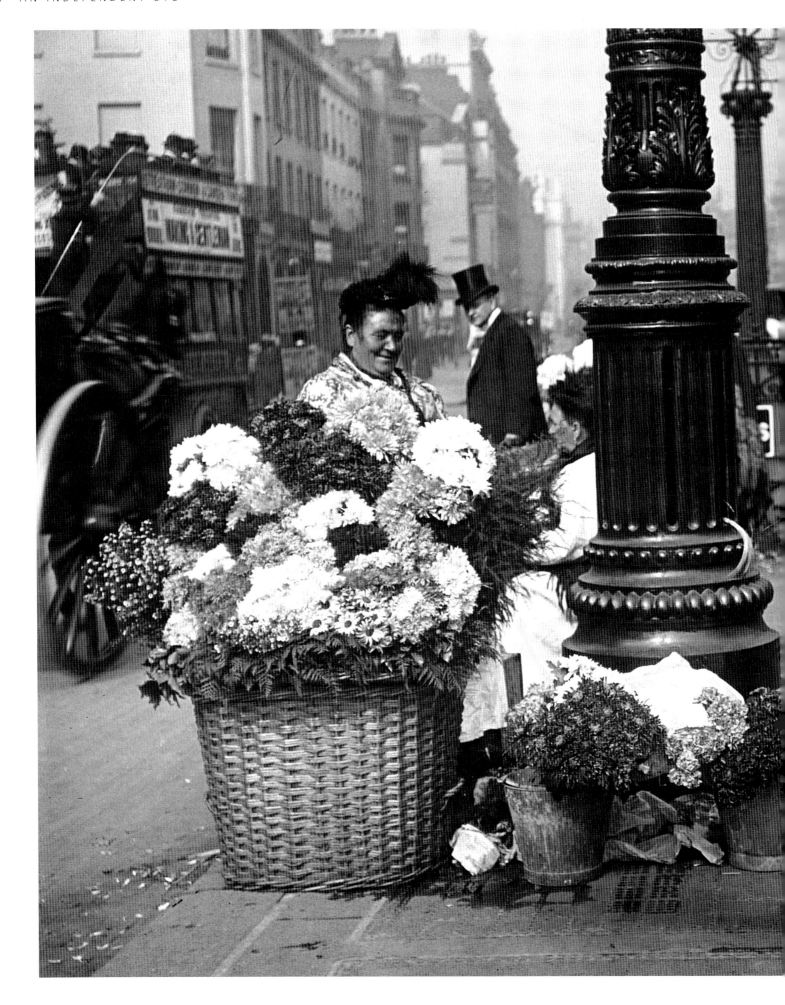

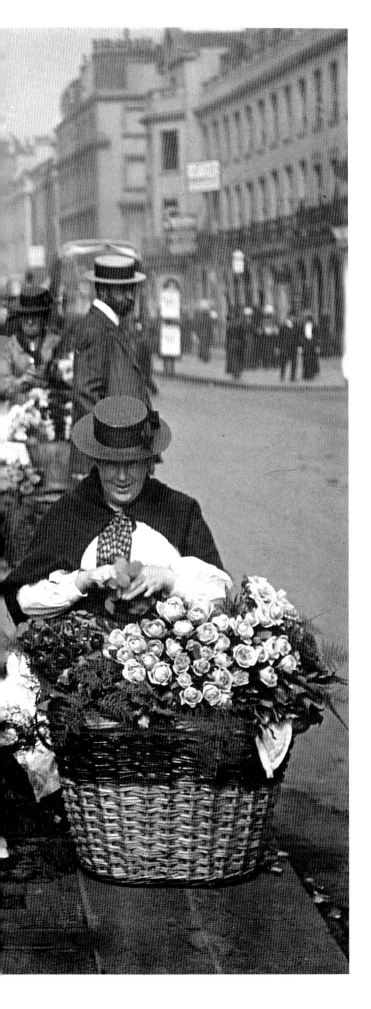

The Liberal Government at Westminster runs up against a campaign in the House of Lords to wreck its legislative programme, so determines to introduce a bill to curb the Lords' power of veto. Robert Baden-Powell, the hero of Mafeking, launches the Boy Scout Movement. Cubism, one of the great innovations of modern art, is launched with Picasso's painting of a group of Barcelona prostitutes, *Les Demoiselles d'Avignon*. Reacting against Romanticism and Impressionism, the strongest influence detectable in this particular work is primitive African sculpture. Richard Strauss's opera *Salomé* opens in New York and is soon banned, while the first night of J. M. Synge's *The Playboy of the Western World* causes a riot in Dublin when Nationalists see in it a slight offered to Irish womanhood. The artistic situation is perhaps redeemed when Kipling becomes the first British writer to win the Nobel Prize. In medicine, chemotherapy and blood transfusions are introduced.

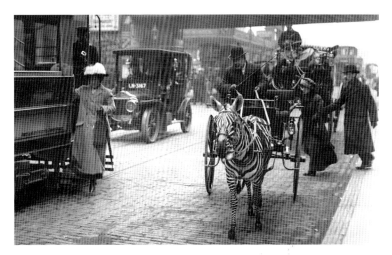

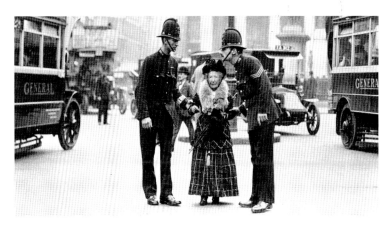

London flower 'girls'

with their baskets on a traffic island (left). Here they avoid prosecution by the police for obstructing the pavement. They will have bought their stock very early in the morning at Covent Garden wholesale market before carrying it to their regular pitch. The most famous is round the statue of Eros at Piccadilly Circus. A few years later, George Bernard Shaw will make a flower girl, Eliza Doolittle, the heroine of his play Pygmalion. They have to put up with extremes of weather and exhaust fumes from motor buses, taxis and cars. A trap drawn by a tame zebra, however, is no hazard to health (top). Why does it take two City policemen (above) to help the old lady across Threadneedle Street?

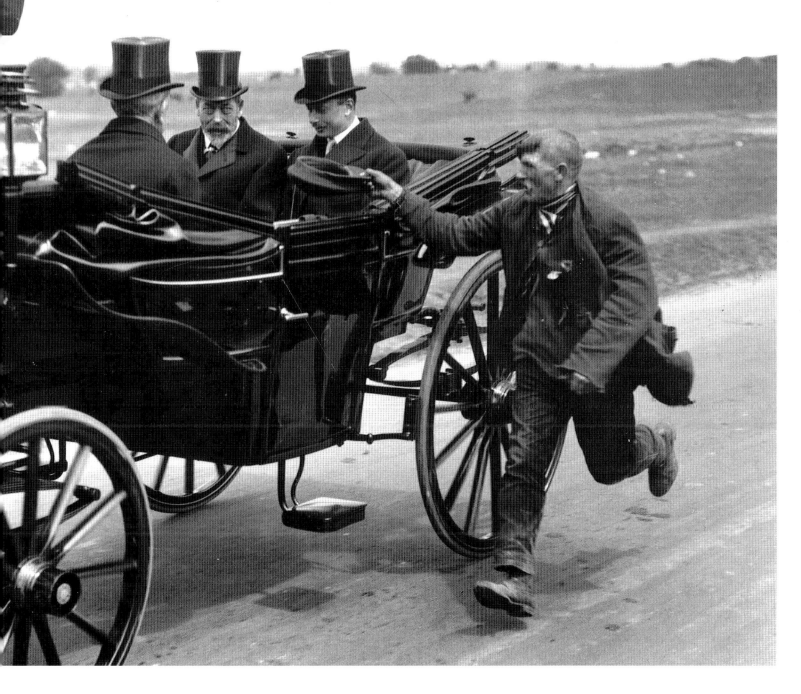

1921

Britain's post-war boom comes to an end with 2 million out of work, the miners unsuccessfully on strike and agricultural wages halved. A truce is agreed with Sinn Fein, the Irish Nationalists, in June. Mustafa Kemal, later Kemal Atatürk, becomes ruler of Turkey and starts to push back the invading Greeks. Mussolini and his Fascists win thirty-five seats in the Italian parliament. Hitler becomes leader of the National Socialist Workers' Party in Germany, where the currency begins to collapse in November. A way to manufacture insulin for the treatment of diabetes is invented, Chanel No. 5 perfume goes on sale and Marie Stopes opens her first birth control clinic.

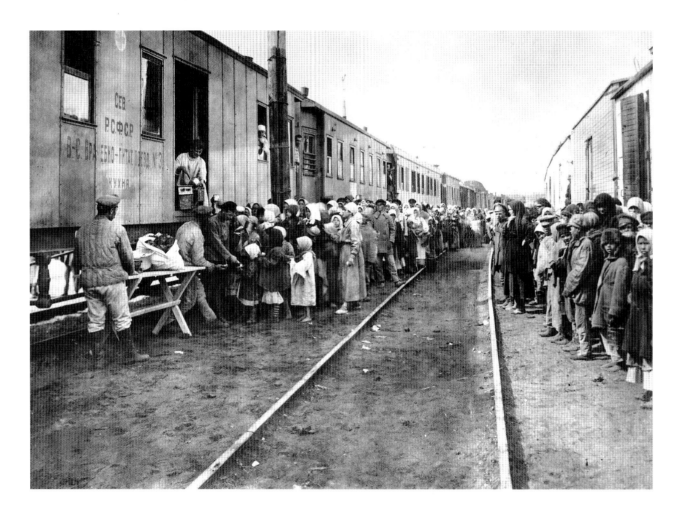

Famine comes to Russia

on the heels of the civil war between Reds and
Whites (opposite). The Communists' requisitioning of food
leads to the peasants planting less and less. This, and the drought,
mean that output in 1921 is less than half of what it had been in 1913.
Disease accompanies the famine and there are reports of cannibalism.
Only the lucky ones are brought food by the government's relief
trains (above), and in two years about 5 million will die. Peasants
who rebel in Tambov province are shot in batches and the sailors'
revolt at Kronstadt naval base is brutally crushed. Food
requisitioning is eventually dropped and free trade
permitted, but this is only a temporary tactical
retreat from the party's hard line.

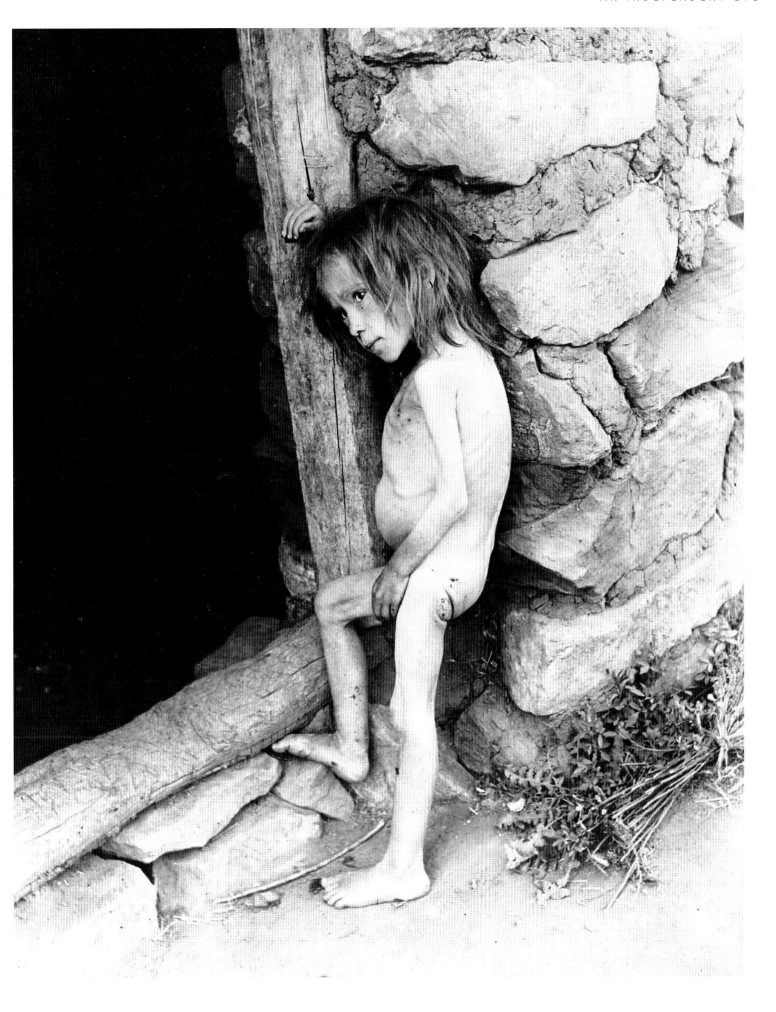

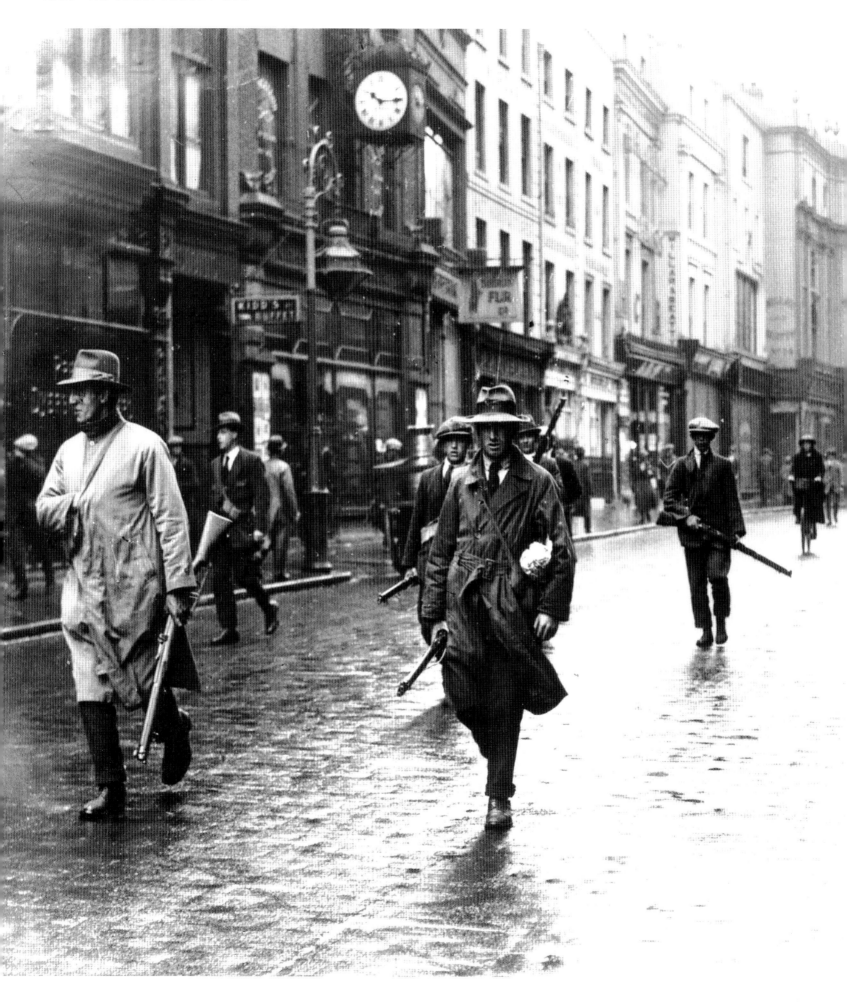

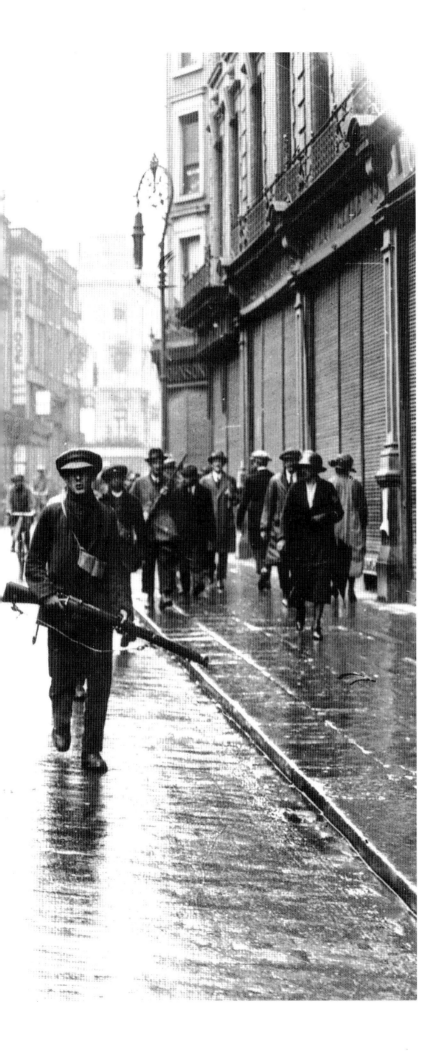

Lloyd George's post-war coalition government is replaced by Bonar Law's Conservative one. The Turks take Smyrna (Izmir) from the Greeks and Britain almost goes to war with Turkey when intervening between the two sides. Gandhi is jailed in India for civil disobedience. Mussolini forms Italy's first Fascist Government. The British Broadcasting Company (later Corporation) is formed. Tutankhamen's tomb is discovered by Howard Carter and Lord Carnarvon in Egypt. *Ulysses* by James Joyce and the poem *The Waste Land* by T. S. Eliot are published.

Irish Republican Army
*men and youths put on a show of strength
in the streets of Dublin. Michael Collins signed
a treaty in December 1921 with the British, giving
birth to the Irish Free State, an independent entity
within the British Commonwealth, but this is not
enough for diehards like these, who are prepared
to plunge their country into civil war. In April they
seize Dublin's Four Courts until they are shelled out
by Free State troops using artillery lent by the British.
The fighting then moves to the countryside
with Collins himself being killed in an ambush
in County Cork in August. Peace only comes
in 1923 after 4,000 lives have been lost,
mainly Republicans.*

1923

Stanley Baldwin becomes Britain's Conservative Prime Minister. All non-Fascist parties are banned in Italy. Germany suffers hyper-inflation, at its height running at 2,500 per cent a month. In November Hitler stages his abortive beerhall *Putsch* in Munich and is arrested. He uses his time in prison to write *Mein Kampf*. Mustafa Kemal declares Turkey a republic and begins its westernisation. An earthquake in Japan kills over 300,000 people. The cricketer Jack Hobbs scores his hundredth century and Suzanne Leglen wins Wimbledon for the fifth time.

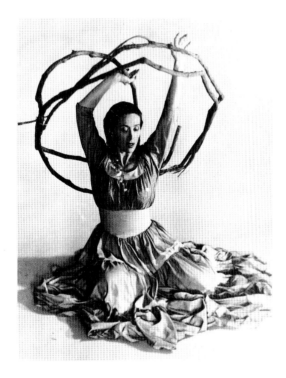

Young German girls
lose their inhibitions (right), *get back to Nature and in touch with their feelings as they dance naked in some northern forest. Isadora Duncan, the pioneering American-born promoter of dance, began something when she looked for inspiration to the figures on ancient Greek vases. The human body was not a matter for shame in the Classical World. The importance of the semi-conscious and of the instinctual is also becoming a commonplace in the wake of Freud and Jung, while the lure of the primitive is being felt in painting, sculpture and music. The search for physical and mental wellbeing through movement and dance is very much in the air in 1920s Europe, and is to be taken up and perverted by the Nazis with their 'Strength Through Joy' slogan in the 1930s. The true heir to Duncan is fellow-American dancer and choreographer Martha Graham* (above).

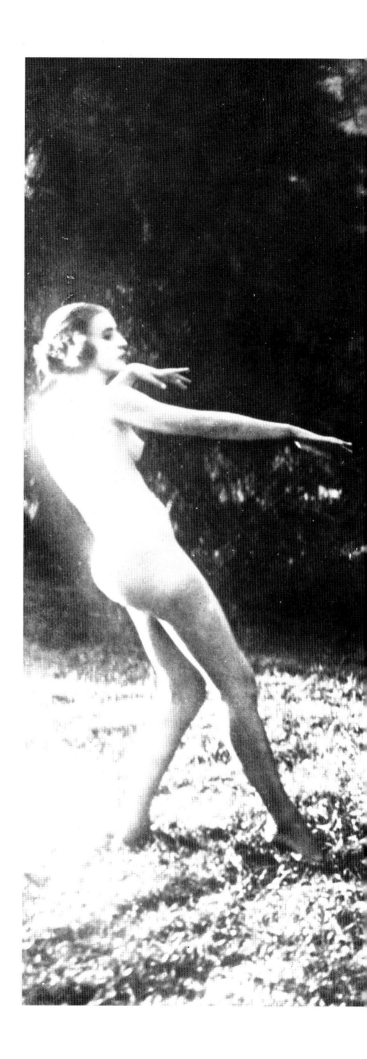

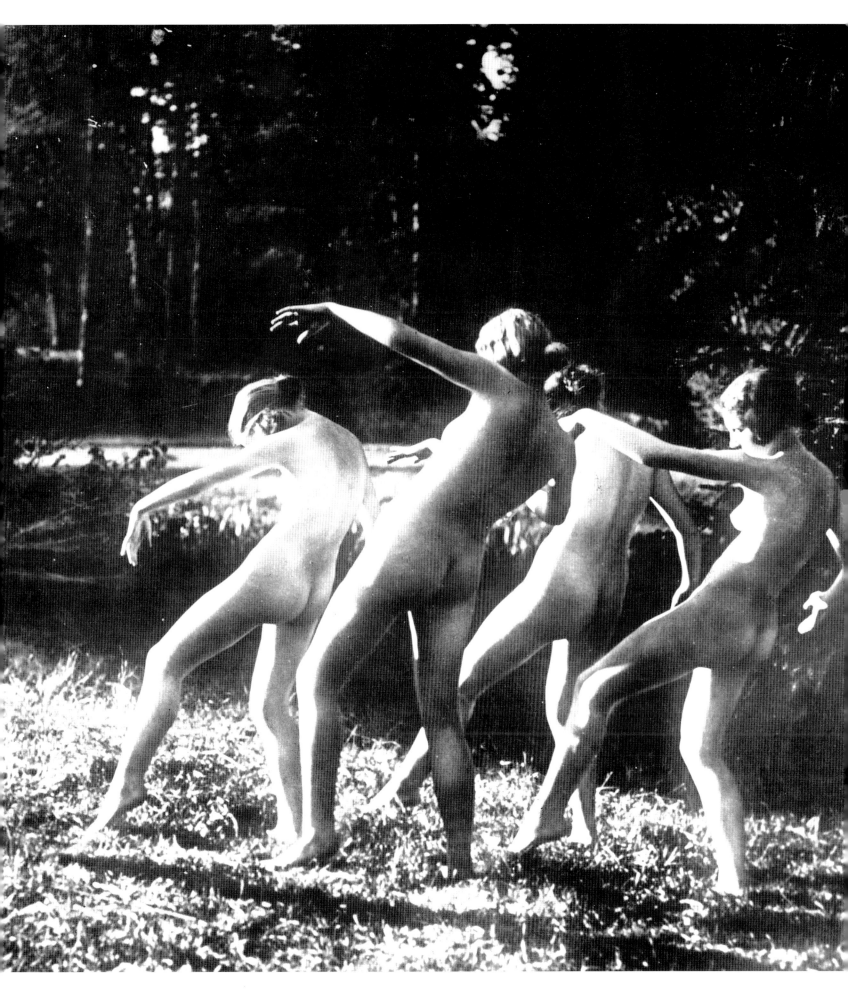

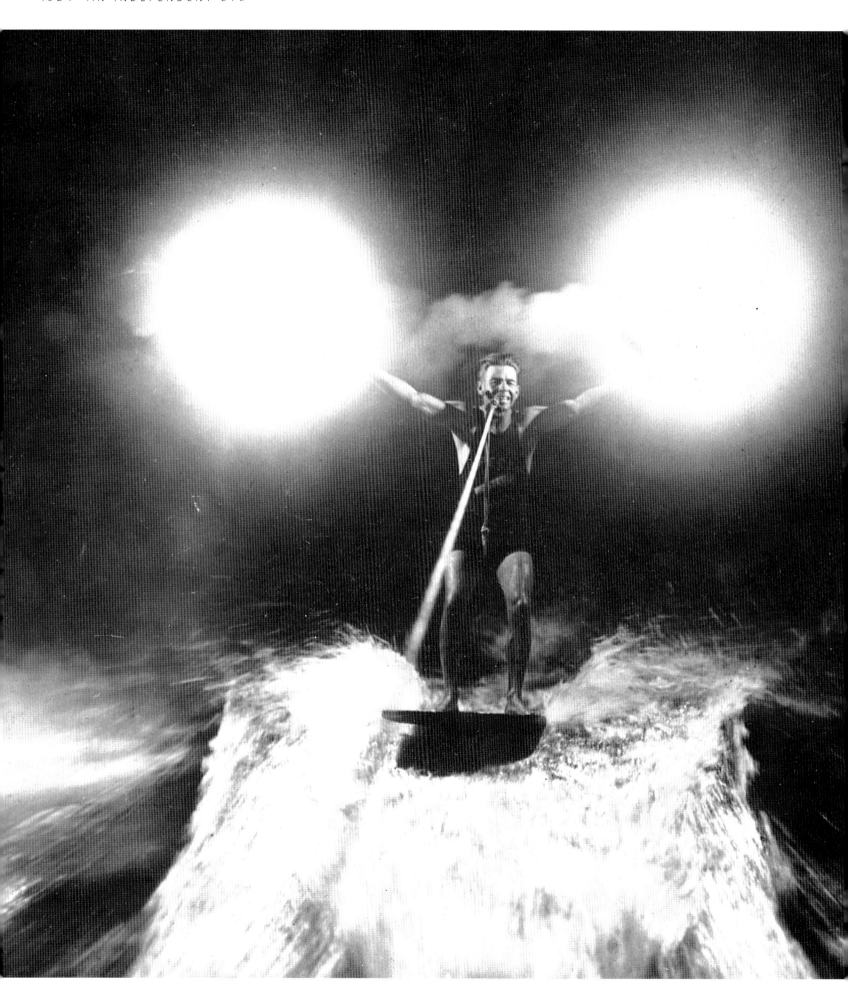

AN INDEPENDENT EYE · 1924

The first British Labour Government, led by Ramsay MacDonald, comes to power in January thanks to Liberal support, but is replaced by the Conservatives in October. Their victory owes a lot to the forged Zinoviev Letter purporting to be from Communist Russia to the Labour Party and encouraging it to stir up the workers and foment trouble. Lenin dies and Stalin soon becomes the most powerful figure in Russia, having Leon Trotsky denounced by the Communist Party in November. George Gershwin composes *Rhapsody in Blue* and E. M. Forster publishes *A Passage to India*.

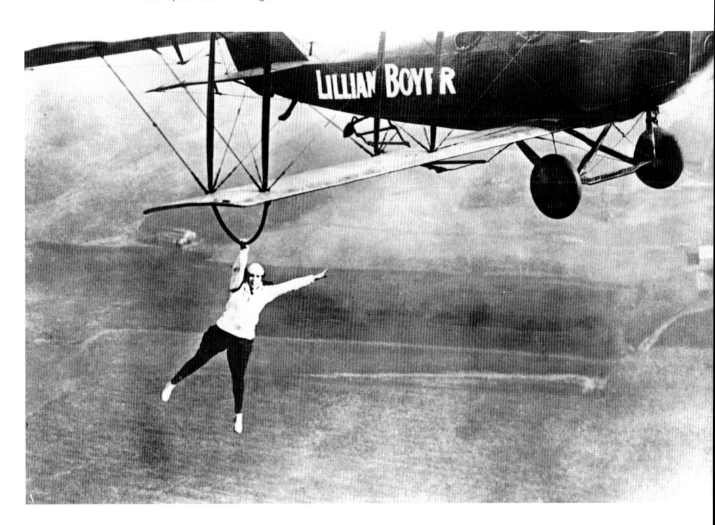

A flying stunt.
Lillian Boyer defies death a thousand feet up (above). *Air circuses featuring thrills like these are a new feature of the entertainment scene.*

Surfing in California.
This night-time surfboarder (left) *holds flares in either hand while clenching the tow rope in his teeth. The photograph was taken in the Pacific off Los Angeles, the home of the Hollywood film industry, and is typical of the publicity shots that the studios required of the stars – brash and flash, to catch the eye. Water-skiing is a later development, as is the craze for surfing proper on the ocean rollers.*

1925

Britain returns to the Gold Standard under Winston Churchill, the Conservative Chancellor of the Exchequer. Hitler is out of prison and Mussolini assumes full dictatorial powers. General Chiang Kai-shek becomes the leader of the Kuomintang Party in China (see 1911, p.31) on the death of Sun Yat-sen. The *Exposition des Arts Decoratifs* in Paris gives birth to the Art Deco style. *The Great Gatsby* by F. Scott Fitzgerald, *Carry on Jeeves* by P. G. Wodehouse and *The Trial* by Franz Kafka are published. Charlie Chaplin stars in *The Gold Rush*.

Mussolini with his pet lion cub.

Il Duce is notorious for his arrogant posturing, coining of empty slogans, and love of the grandiose gesture. A symbol of imperial strength such as the lion is bound to be an accessory close to his heart. It is easy to laugh at the Italian dictator's jowly portraits or pictures of him strutting and preening with his hands on his hips. In this one, the shape of his jaw seems echoed by that of his bowler. His regime may never reach the sub-human depths of the Nazis, but he is brutal and ruthless enough to political opponents or weaker states.

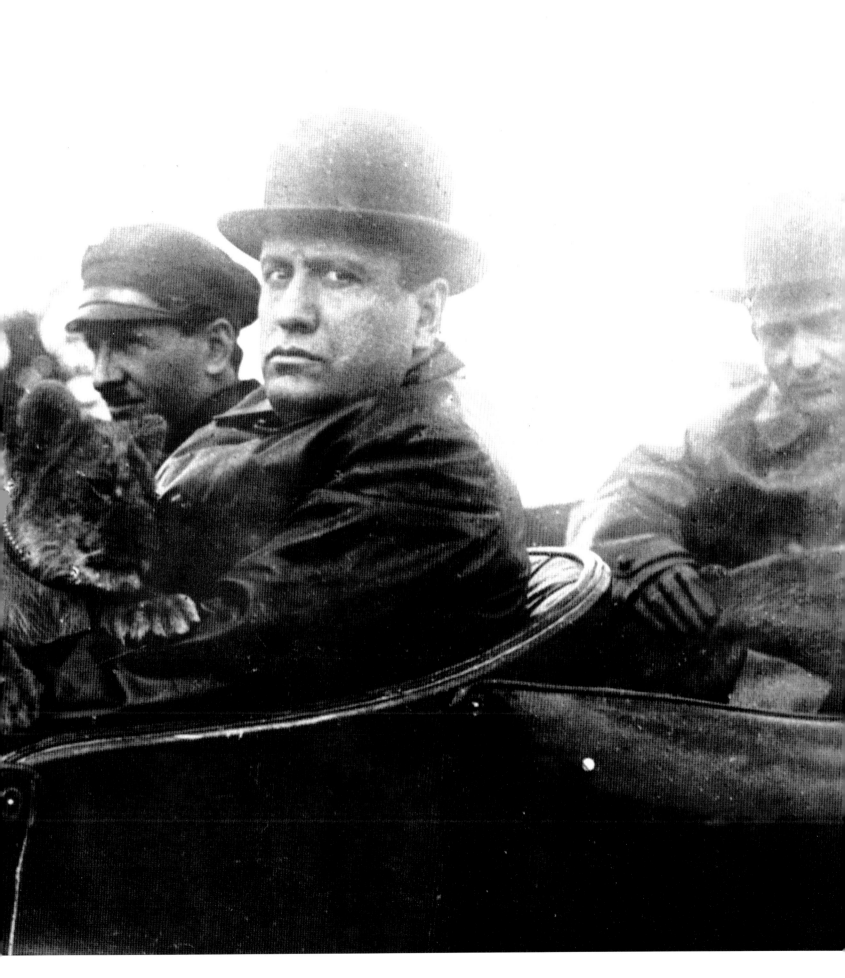

The General Strike, called by the Trades Union Congress in support of already striking miners in May, lasts nine days, after 300,000 middle class volunteers rally to the British Government's call to keep the docks open and transport working. Joseph Pisludski becomes dictator of Poland after a military coup. John Logie Baird transmits the first television picture in London. Franz Kafka publishes *The Castle* and A. A. Milne *Winnie-the-Pooh*.

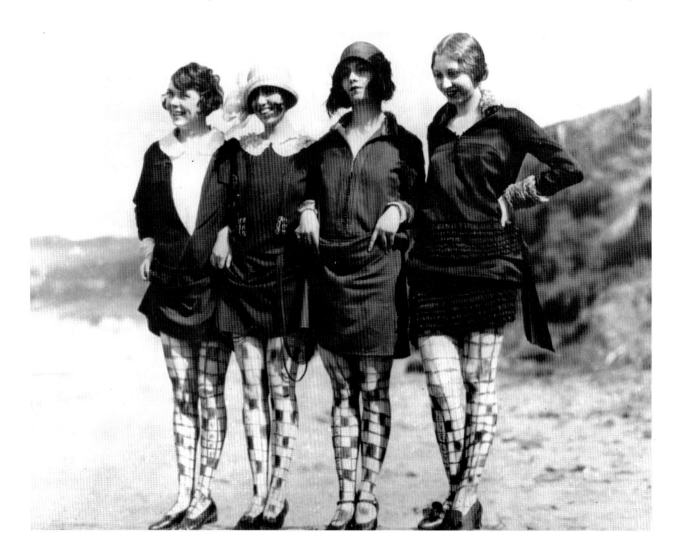

A glimpse of stocking?
These girls offer something more – no stockings at all (above).
Instead they have drawn charcoal designs on their legs, apparently in
homage to the grid-like pictures of the modern artist, Mondrian.

A bright 'eyedea'
from a 'bright young thing', as the 1920s flappers are also
known (opposite). Use an eyelash stencil alongside your eyebrow pencil.
If you can get your lashes to poke through the slits, then when you come
to apply your mascara you won't smudge your eyes. It's good for a laugh
even if you have forgotten to take off your fake fur coat first. Skirts are
short, hair is bobbed, powder compacts and lipsticks are as
much part of a girl's equipment as cloche hats
and long cigarette holders.

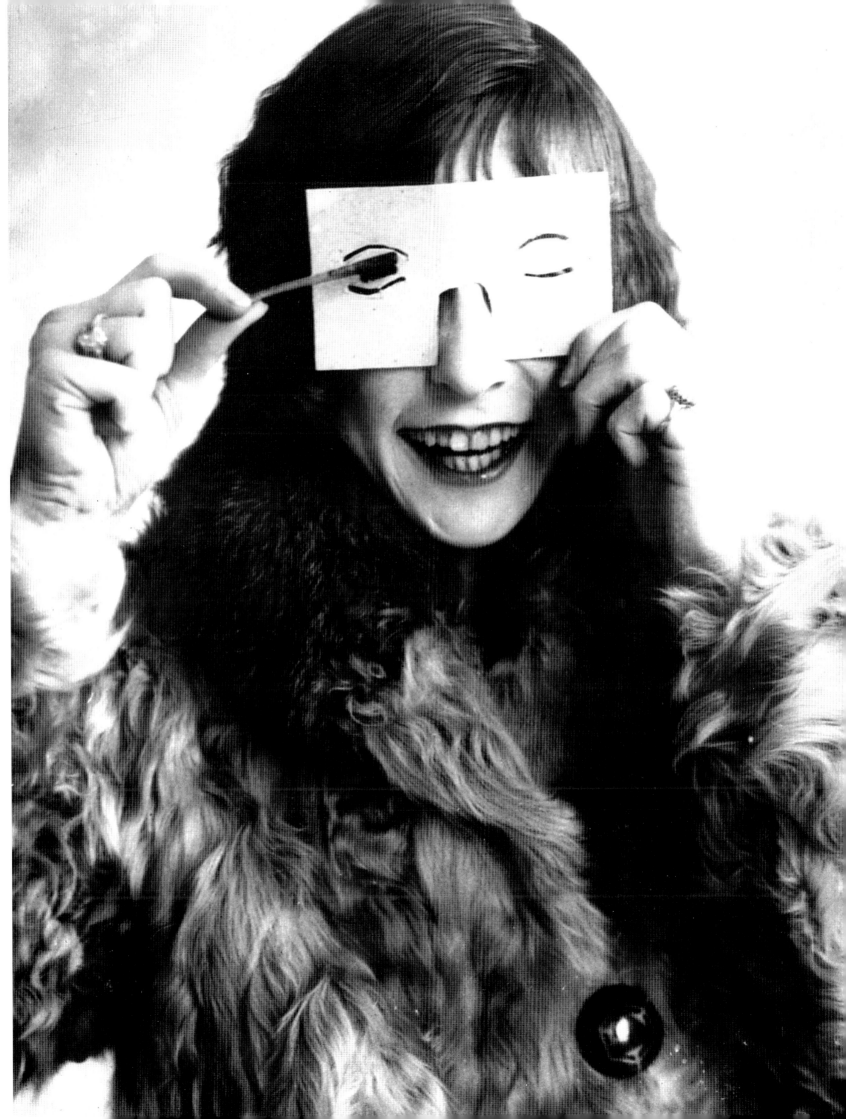

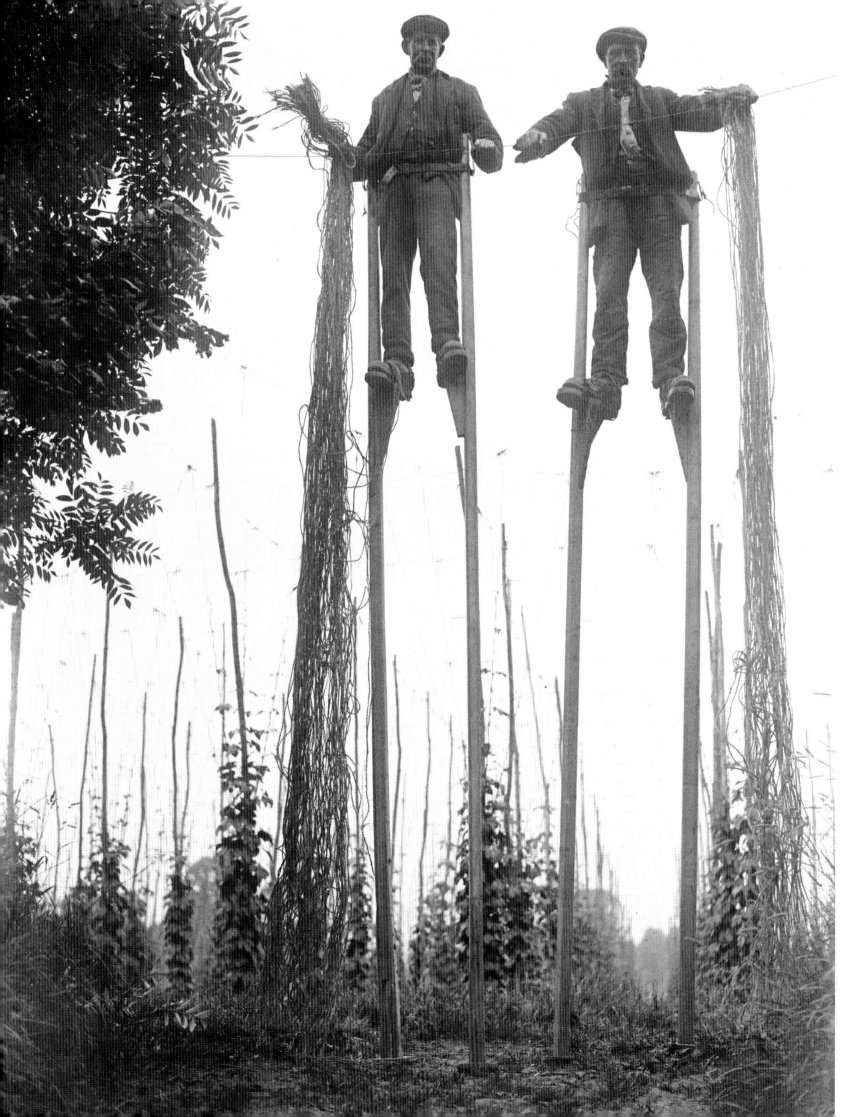

1927

In Britain the voting age for women is lowered to twenty-one. Civil war, involving Kuomintang forces, the armies of various independent warlords and the fledgling Communist Party, convulses China. Charles Lindbergh flies the Atlantic solo in his single-engined *Spirit of St Louis*, reaching Paris after thirty-three hours. Al Jolson's film *The Jazz Singer* signals the end of the road for silent movies.

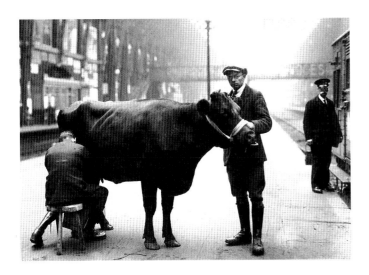
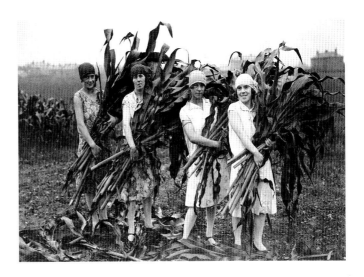
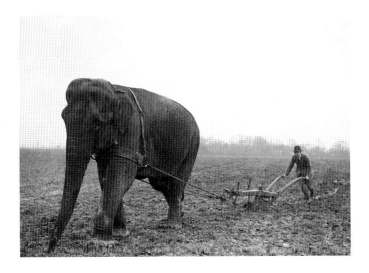
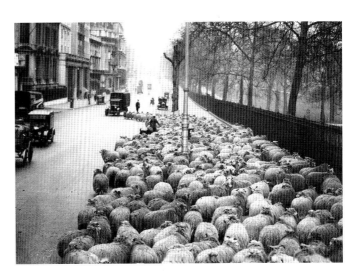

Farming fun.
A cow being milked at King's Cross Station (top left); *London girls with bundles of maize* (top right), *a new crop in Hertfordshire; a circus elephant ploughing* (above left); *and sheep being herded early one morning in Piccadilly* (above right), *on their way from keeping the grass down in Hyde Park to continue the job in Green Park, behind the railings.*

In a Kent hopfield.
Two workers on stilts with bundles of twine which they will tie to the wires stretched horizontally between the poles (opposite). *The hop bines or stalks will then grow up the twine. Hops give the bitter flavour to Britain's traditional beer. Whole families will come by train from the East End of London to strip the catkin-like fruits from the bines, sleeping in barns and sheds, and regarding the time away from their slums and tenements as a holiday outing, with pay.*

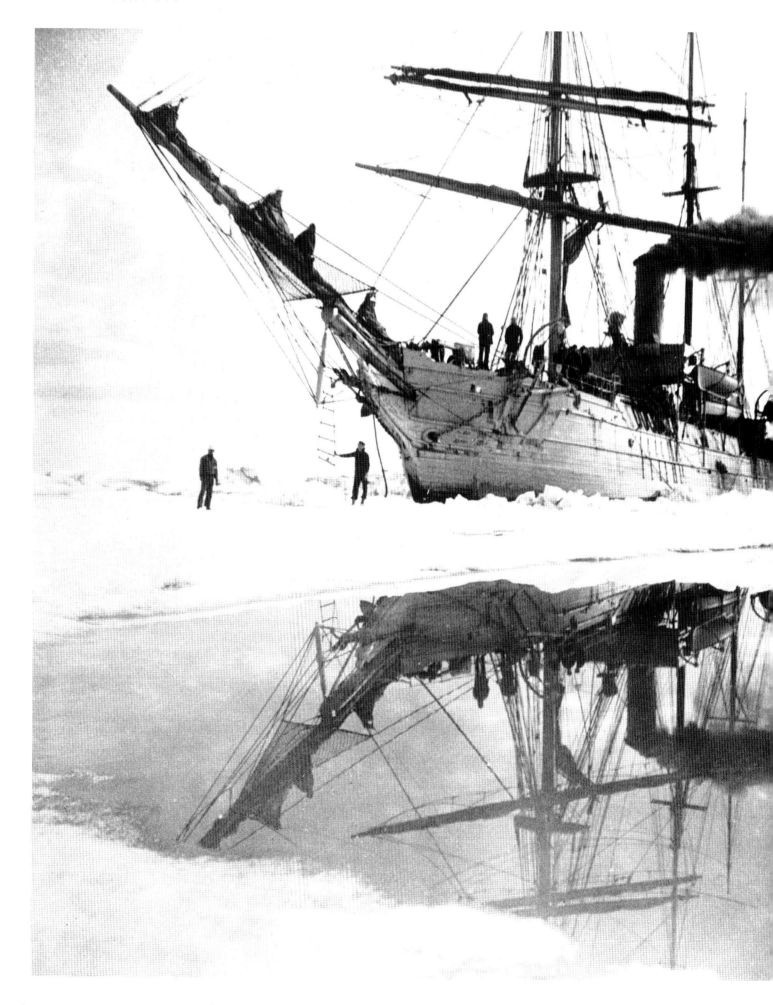

1928

The age for receiving state pensions is lowered to sixty-five in Britain. Alexander Fleming discovers the antibacterial Penicillin mould. Mickey Mouse makes his first appearance in Walt Disney's cartoon film *Steamboat Willie*. Bert Hinkler makes the first solo flight from England to Australia, taking fifteen days, and an American–Australian team of four fly across the Pacific for the first time in a Fokker mono-plane, arriving in Brisbane via Hawaii and Fiji ten days after taking off from the USA. Herbert Hoover succeeds Calvin Coolidge as US President. *Lady Chatterley's Lover* by D. H. Lawrence and *Decline and Fall* by Evelyn Waugh are published.

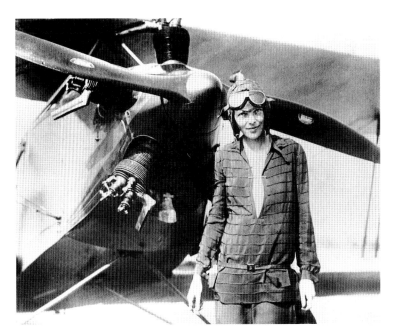

Amelia Earhart,
American aviatrix (above), in Newfoundland just before she becomes the first woman to fly the Atlantic, as a passenger. In 1932 she is the first woman to fly it alone. In 1937 she disappears on a flight over the Pacific.

The icebreaker *Bear*
carrying the first of US Admiral Richard Byrd's four Antarctic expeditions (left). He has flown over the North Pole in 1926 and will fly over the South Pole in 1929.

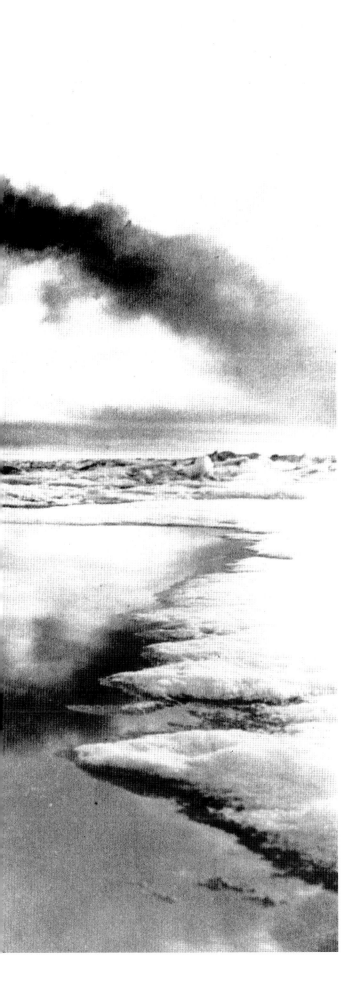

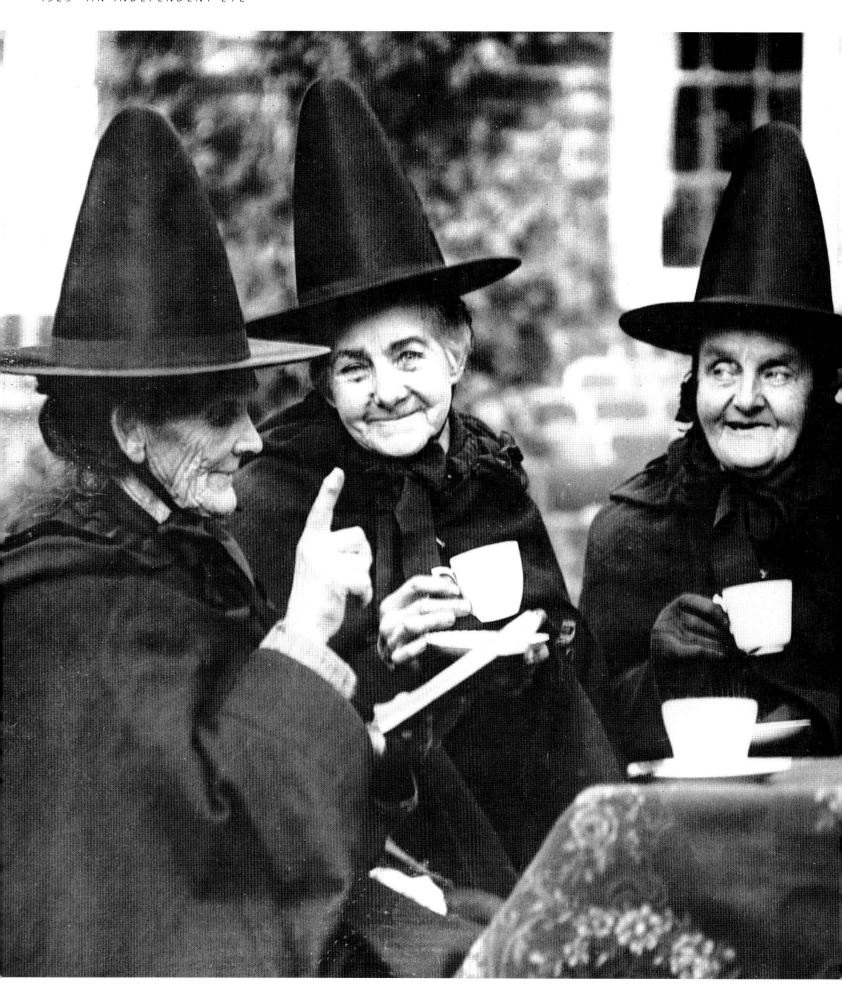

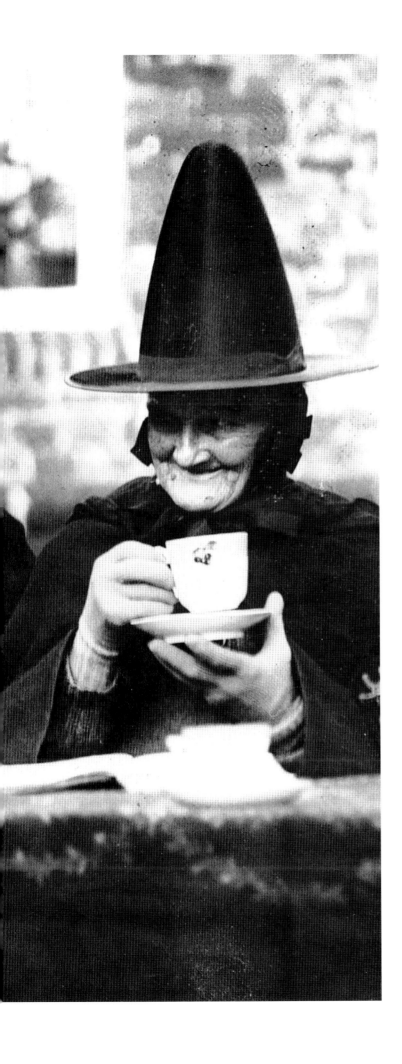

1929

Ramsay MacDonald forms a new Labour Government including the first woman Cabinet minister, Margaret Bondfield. British troops restore order after Arab–Jewish clashes in Jerusalem. In February Al Capone settles scores with Bugs Moran in Chicago's gangland war, killing seven of his O'Banion gang at the St Valentine's Day Massacre. In October the Wall Street Crash of the US Stock Market heralds the start of the world-wide Great Depression.

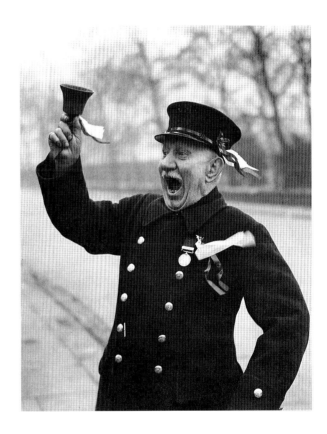

A Jacobean survival.

*Not a witches' coven, but elderly spinsters
living in the Hospital of the Holy and Undivided
Trinity at Castle Rising in Norfolk (left). These
almshouses and chapel were built in 1614 by Henry Howard,
Earl of Northampton, to house twelve such 'sisters' and a
'governess'. The long red cloaks bearing the Howard badge
and the pointed black hats are what have been worn since
the time of the charity's foundation. The Jacobean period
was an era when belief in witchcraft was potent, and our
image of a witch dates from then. (Above) The Chelsea
Pensioner's uniform isn't quite so old, though the Royal
Hospital there, where he lives, was founded by
Charles II. The ribbons show he is a supporter
of Chelsea FC.*

1930

By the end of this year there are over 4½ million unemployed in the USA and over 2 million in Britain. Soup kitchens and hunger marches become a regular part of the scene. The last Allied occupying troops leave the Rhineland and the Saar regions of Germany, where the Nazi Party polls 6½ million votes in the elections, making it the second biggest. Stalin imposes collectivism on agriculture in the USSR, killing many millions of 'kulaks' (better-off peasants) in the process. Gandhi launches his campaign of peaceful civil disobedience in British India. Amy Johnson flies solo to Australia from Britain, but the British R101 airship explodes at Beauvais in France on its first trip. The first sliced bread and frozen peas go on sale.

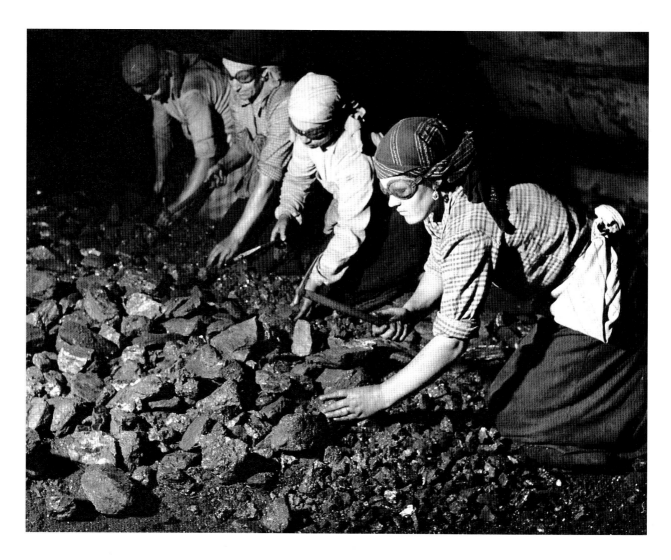

Women 'cracking' coal
down a mine, throwing out stone and slate, breaking up big lumps (above).
They wear goggles to protect their eyes from splinters. Judging by how clean they look,
this must be the start of the shift.

In a Kent coalfield,
three miners wear the minimum because of the heat down in the pit (opposite), *but no safety*
helmets or electric lamps. The photograph flatters the working conditions of many men, who had to hack,
doubled up, at narrow seams of coal. In 1925 the Government subsidy on coal was lifted, prices fell and
employers demanded wage cuts. The miners might have been earning good money – £4 a week – but
there were no pithead baths then; 1,300 were killed and 160,000 injured each year, not counting the
endemic lung disease caused by dust. So the cry was 'Not a minute on the day, not a penny
off the pay.' The General Strike in 1926 had really been to show solidarity with them.

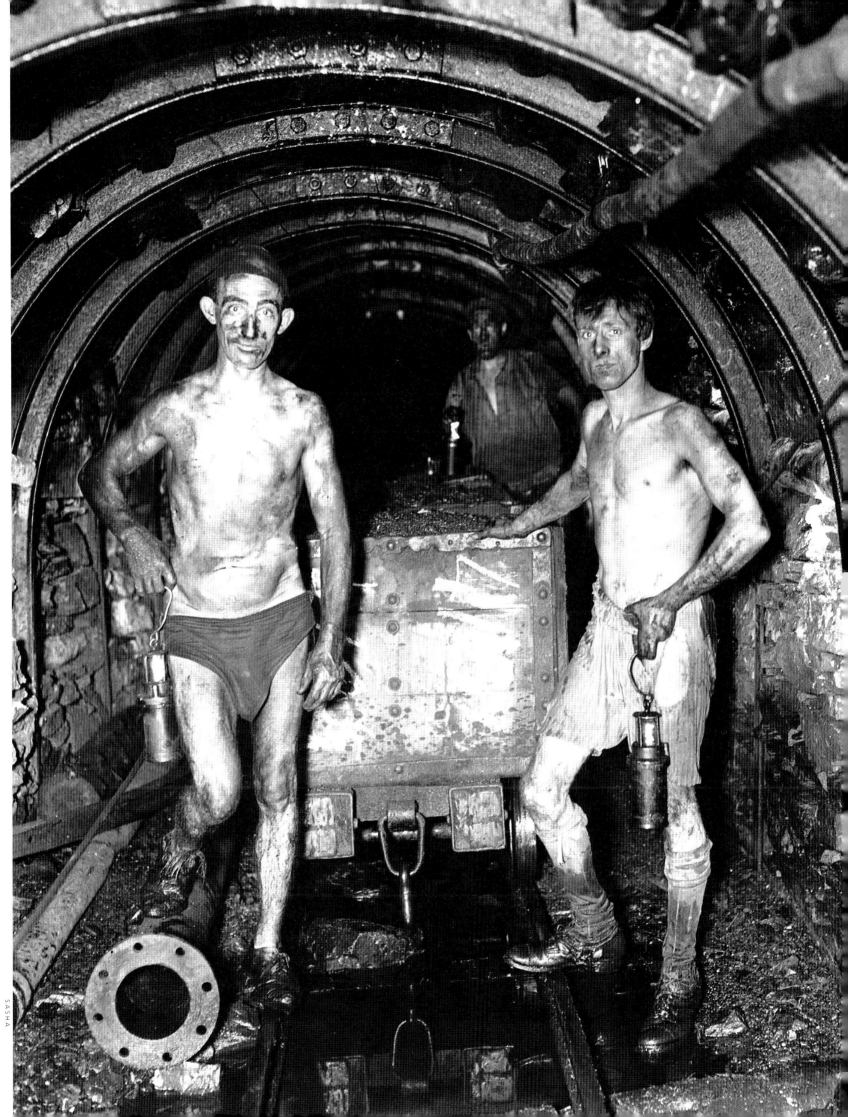

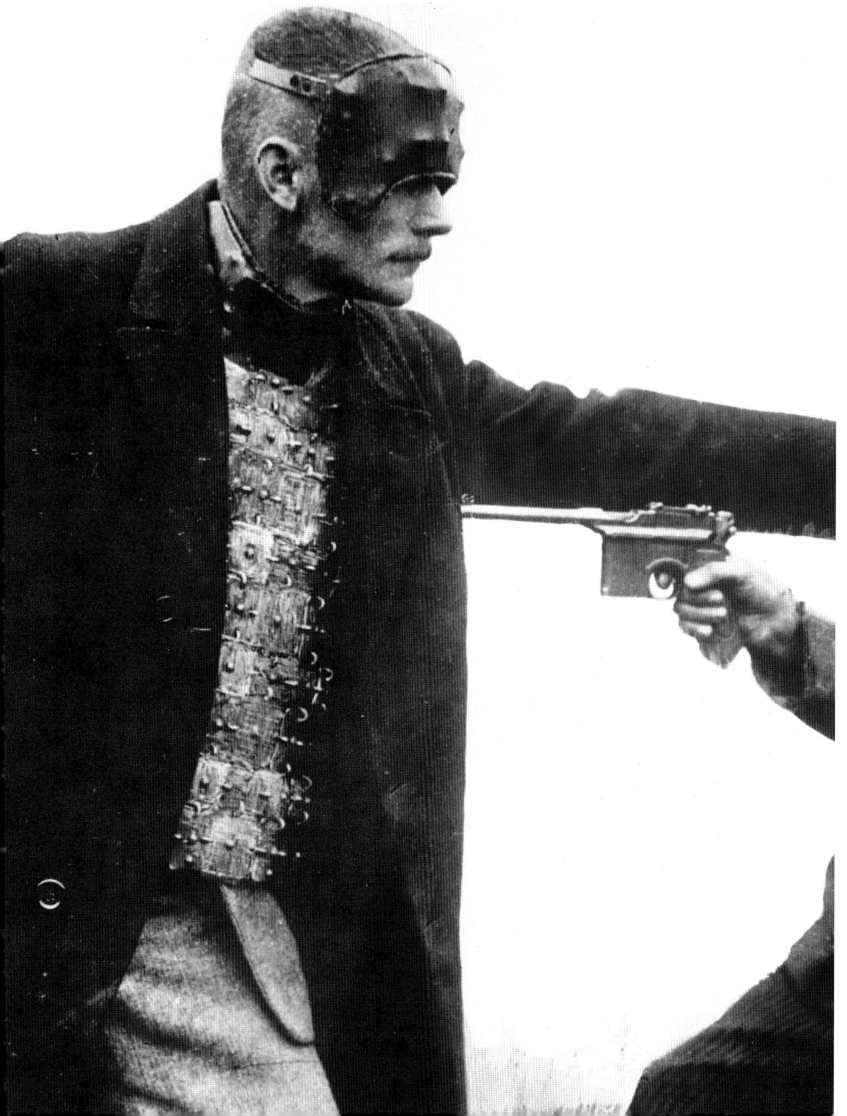

1931

MacDonald's Labour administration is replaced by a National Government of Conservative, Liberal and Labour in August, and he leaves the Labour Party. Government spending is cut back and Britain comes off the Gold Standard. But unemployment is only half Germany's 5 million, while America's reaches 8¹/₄ million. The Empire State Building is opened and Al Capone goes to prison for tax evasion, Spain becomes a republic and Japan seizes Manchuria from China. The films of *Dracula* and *Frankenstein* have their premieres.

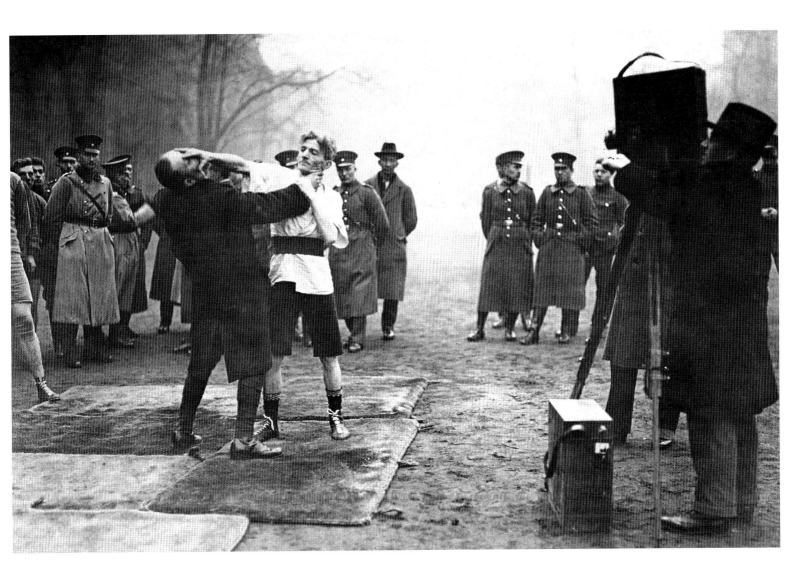

Streetfighting in Germany

*between rival bands of Communist and Nazi thugs
becomes a regular occurrence as they vie for power in the disturbed
atmosphere caused by the Great Depression. The German police need all
the new techniques and technology they can get to combat the threat to
civil peace. A bullet-proof alloy helmet and breastplate are demonstrated
(opposite), though it must be doubted whether the Luger pistol will
actually be fired. Police are also taught jujitsu unarmed combat
by a Swiss master and the lesson is filmed, perhaps to act as
a deterrent when shown later on the newsreels (above).*

1944

Monte Cassino monastery finally falls to the Allies in May and the road to Rome is open. It is taken on 4 June and the D-Day landings in Normandy follow two days later. General de Gaulle enters Paris on 26 August. The July Plot to assassinate Hitler narrowly fails. London is under a new threat from flying bombs – doodlebugs – and V2 rockets. Brussels is liberated on 5 September. The Russians are advancing on all fronts and take Bucharest, the capital of Romania. Belgrade, the capital of Yugoslavia, follows in October. The Germans counterattack in the Ardennes in December, unsuccessfully. The first Biro ballpoints go on sale in Argentina.

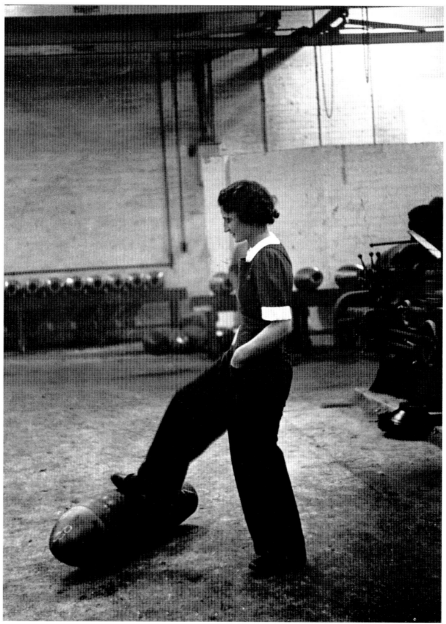

BERT HARDY

War effort.
Working on the nose cone of a Lancaster bomber (opposite),
each one of which represents a total investment of £120,000 including training its
five-man crew. One of the bombs it will carry is rolled across the shop floor by a nonchalant
munitions worker (above). Of the 16 million British women of working age, over 7 million do war
work, in uniform, industry or on the land. Their pay has risen by 80 per cent since 1938.

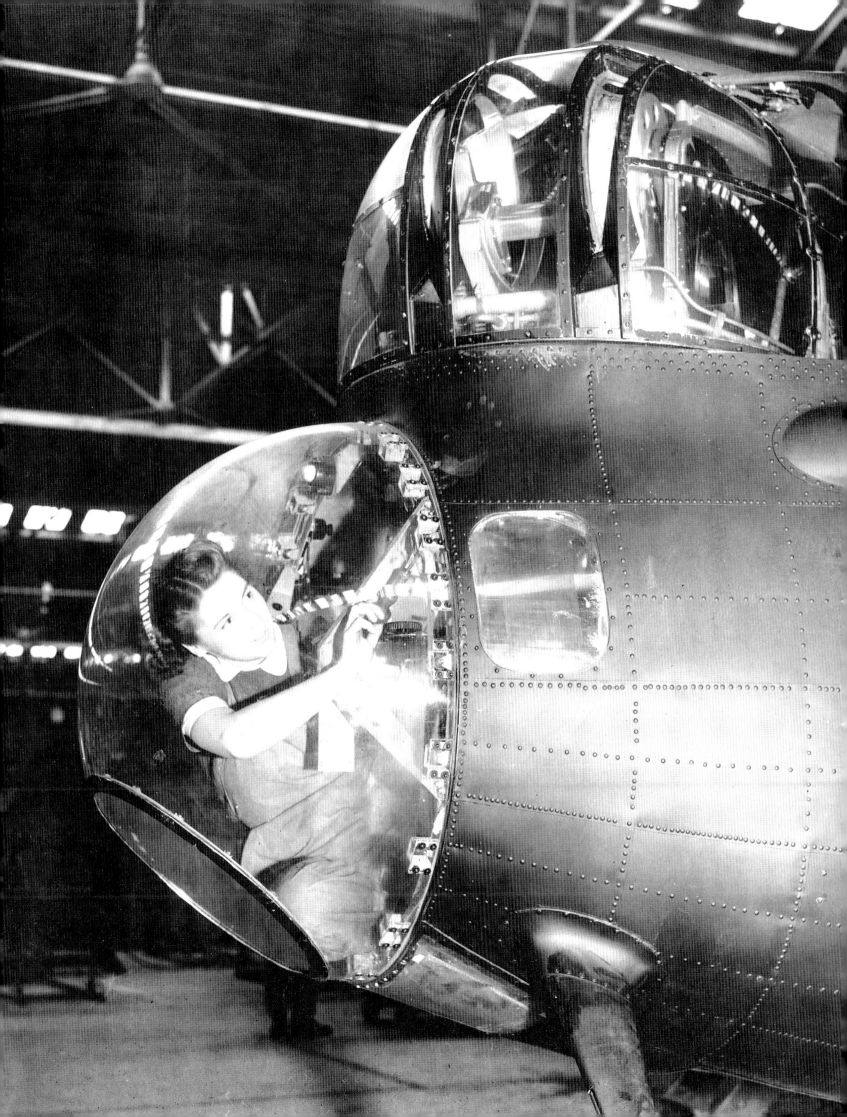

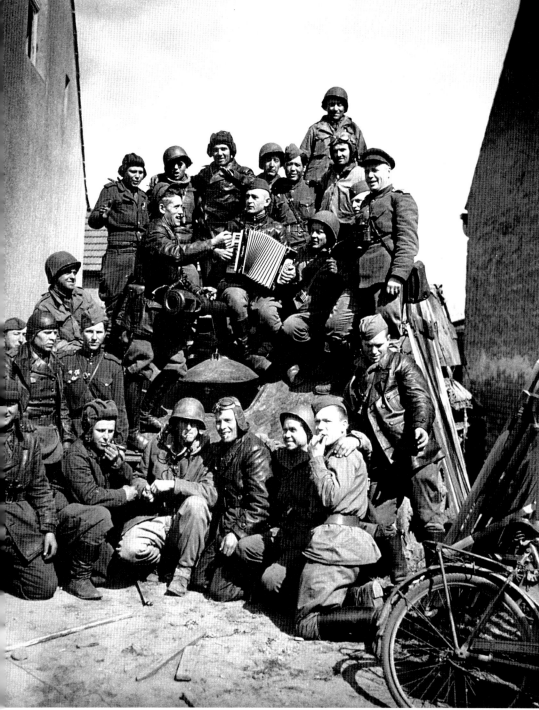

FRED RAMAGE

Russians and Americans

meet on the Elbe in April. All is fraternal greetings and accordion music in
this carefully posed shot, but Stalin is determined that Berlin shall fall to
his forces, not to GIs.

1945

Soviet forces enter Warsaw in January and Budapest in February, the same month that Dresden is needlessly flattened by Allied bombers, probably killing over 100,000. The full horror of the concentration camps is revealed in Poland and Germany. Some 7 million have entered them, mostly Jews; only 500,000 survive. Germany surrenders on 7 May. On 6 and 9 August atomic bombs are dropped on Hiroshima and Nagasaki in Japan, which surrenders on 14 August. Roosevelt has died on 12 April to be succeeded as US President by Harry Truman. In the British General Election, a big Labour victory means Clement Attlee replaces Winston Churchill as Prime Minister.

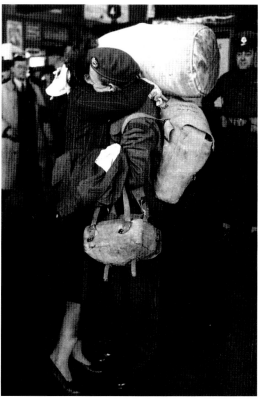

JACK ESTEN

Soldier's return,

that long-awaited moment when husband and wife
are reunited.

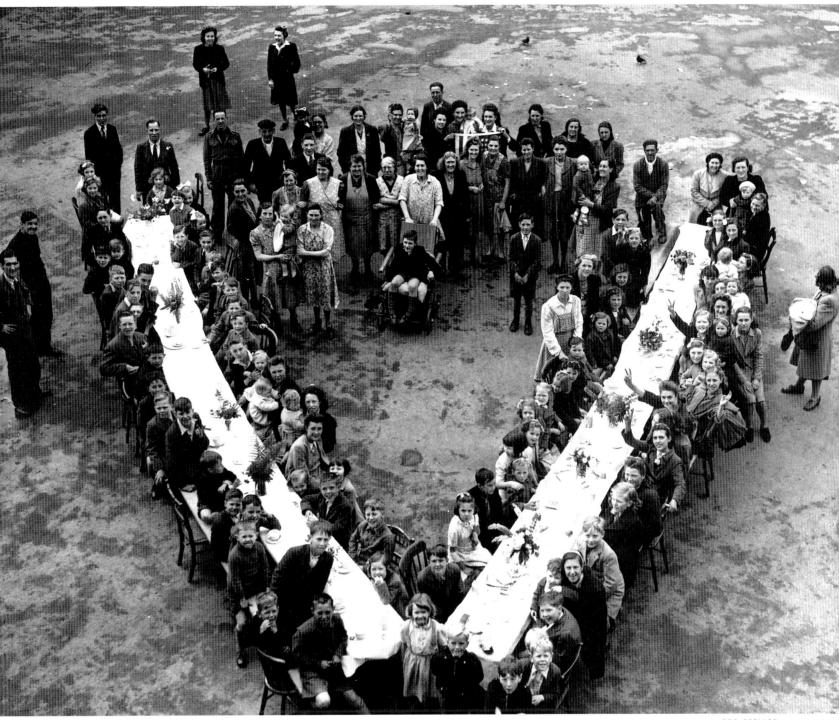

REG SPELLER

V for Victory

*finally in May and south Londoners celebrate
with an open-air banquet, as hoarded reserves can at
last be enjoyed.*

The United Nations General Assembly meets in London for the first time. Bread rationing is introduced in Britain, and the National Health Service is enacted. Although promised independence by Clement Attlee, India is racked by violence between the Hindu and Muslim communities. The latter demand their own independent state. There are also riots by Arabs in Jerusalem at the prospect of a Jewish state in Palestine. Chinese Communists declare war on the Kuomintang Nationalists. The first Vespa motor scooters go on sale in Italy.

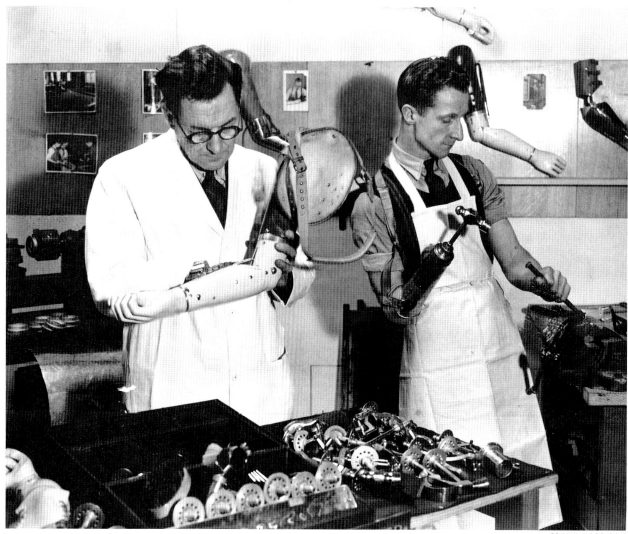

FRANK HARRISON

Arms and the man.

Two technicians (above), both of whom have lost forearms, work on artificial arms at an exhibition in Britain, sponsored by the ministries of Health and Labour. Perhaps their civil servants derive particular satisfaction from the symmetry implicit in this.

War's aftermath.

A man waits for a tram in Vienna (opposite), his new artificial limb in his rucksack. Perhaps he has not yet learnt to use it with confidence, or he is taking it back for repair, or to have it altered so it fits his stump better.

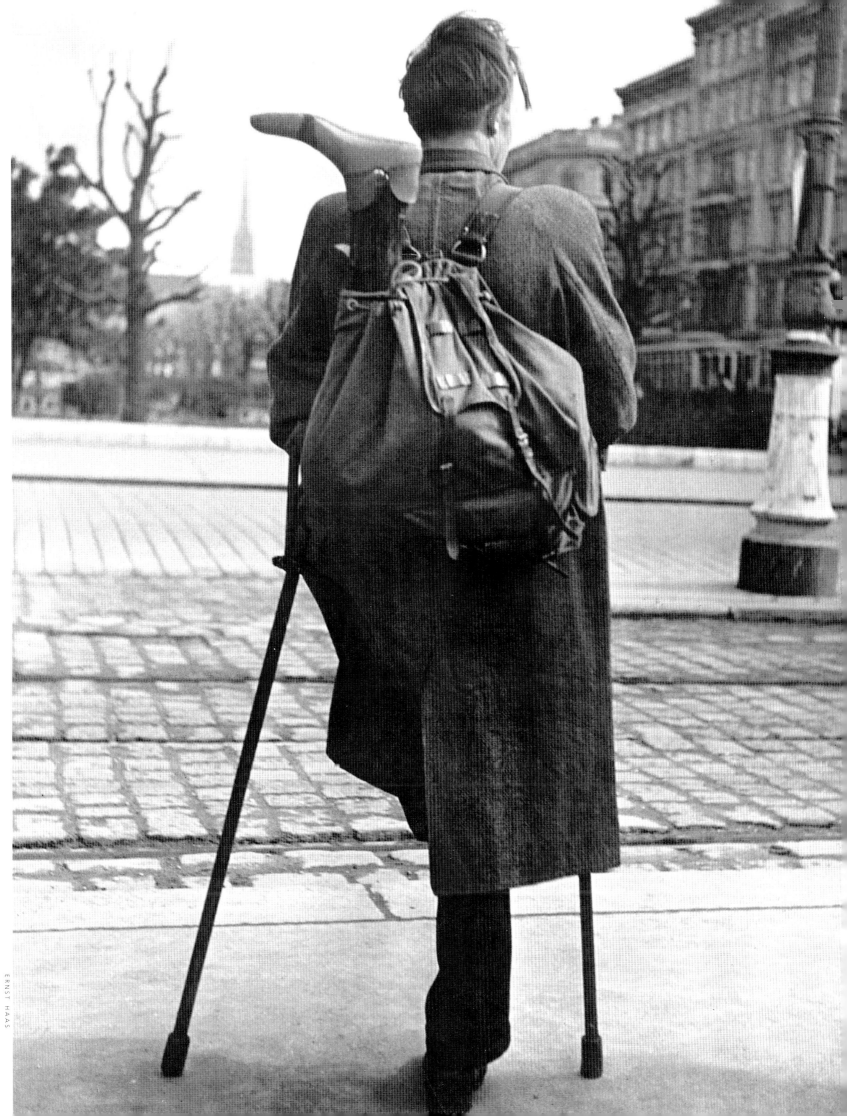

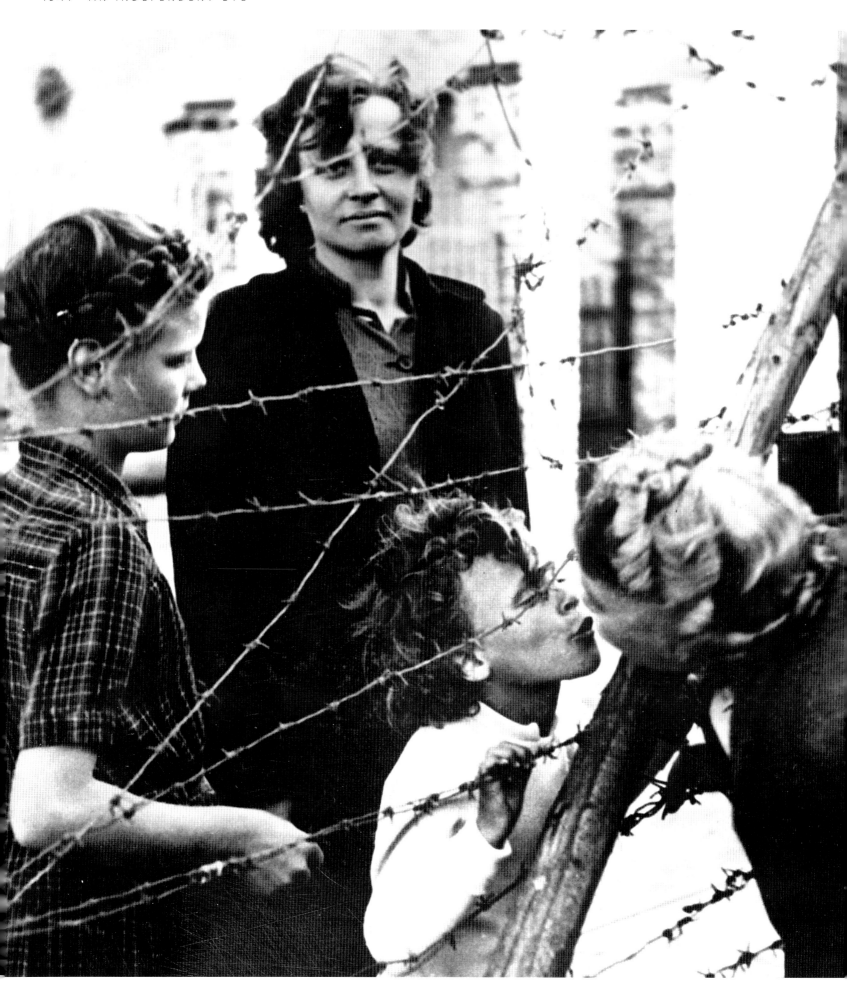

1947

Britain suffers a bitter and prolonged winter, while the coalmines are nationalised, as will be steel, railways, power, long-distance road freight, civil aviation. Rationing gets worse and the only relief is provided by the marriage of Princess Elizabeth to Lieutenant Philip Mountbatten. India and Pakistan become independent in August. The Marshall Plan, for financial aid from the USA to help Europe recover, is proposed. Russia steps up its measures to impose Communist puppet regimes on the countries of Eastern and Central Europe. The Dead Sea Scrolls are discovered. The Kalashnikov AK-47 rifle is introduced to the Soviet army.

Zones, borders, barricades
feature largely in post-war European life.
A Dutch woman (left) bends down to kiss a grandchild she
has not seen before through the fence dividing the mining town
of Kerkrade between Holland and Germany. The multi-lingual
sign warns that anyone climbing the wire is liable to be shot. The
man with the brush is painting a border line in Berlin (above) so
that police from the Russian-controlled area of the city will
no longer have any excuse if they cross into the British
zone in pursuit of black marketeers. Here is
the Iron Curtain being made tangible.

Burma becomes independent and Gandhi is assassinated. The Communists take over in Czechoslovakia. The State of Israel is proclaimed and comes under immediate attack from surrounding countries. When Russia blocks road and rail traffic into Berlin, an airlift of essential supplies begins from the West. Harry Truman wins the presidential election in America. The National Party wins the South African elections with a mandate to introduce Apartheid. The Morris Minor, Land Rover and Citroën 2 CV are launched, as are the first long-playing records, and the first transistor.

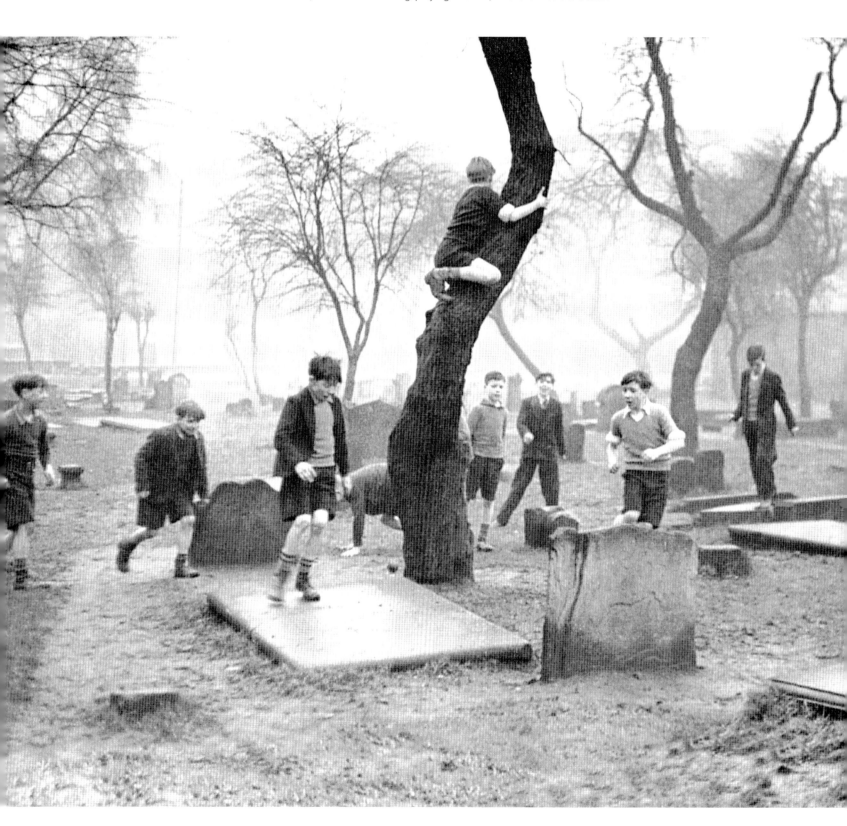

Defying death.
*Boys from the Gorbals in Glasgow use a cemetery
as an adventure playground, the only open area available to them,
symbolising the irrepressible upsurge of new life in spite of all
the killing that has gone on.*

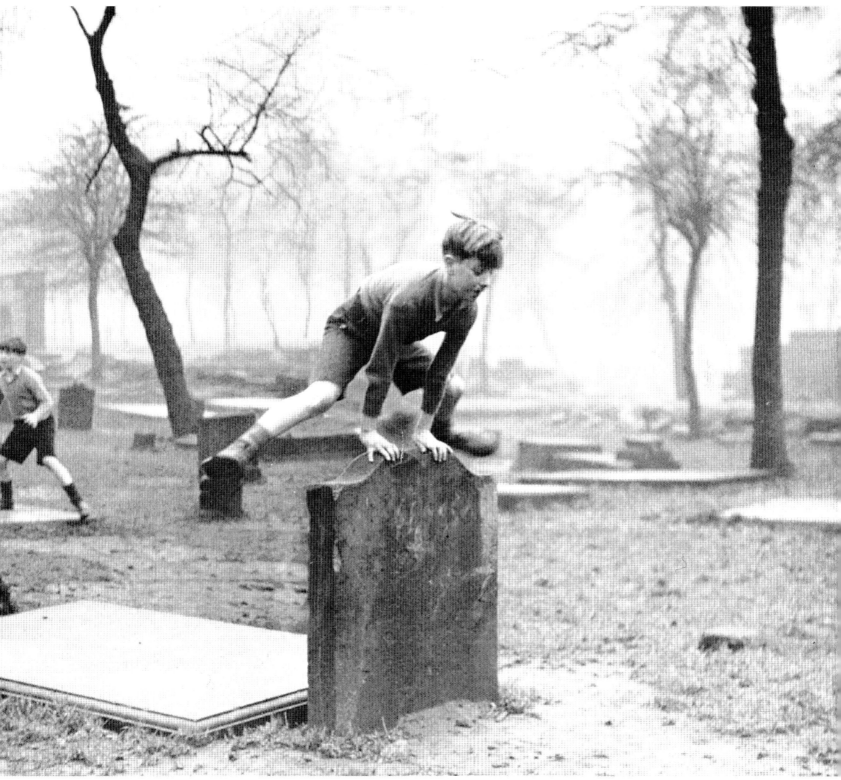

BERT HARDY

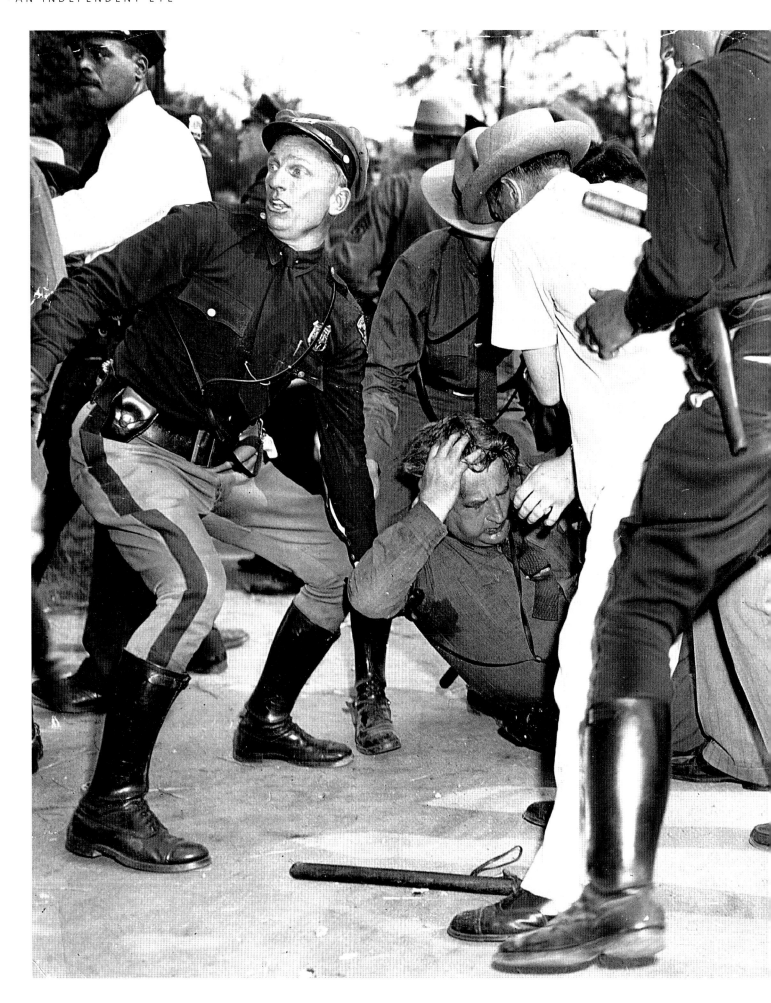

Mao Tse-tung and the Chinese Communists defeat the Nationalists, whose remnants retreat to Taiwan. Holland recognises the independence of Indonesia. The Berlin blockade is lifted by the Soviets. Clothes and sweet rationing end in Britain, and the pound is devalued by 30 per cent. The German Federal Republic is formed in the west, and the German Democratic Republic in the east. The de Havilland Comet, the world's first jet airliner, makes its maiden flight. Orson Welles stars in *The Third Man*, and Ealing Studios produce *Kind Hearts and Coronets*, *Passport to Pimlico* and *Whisky Galore*. *Nineteen Eighty-Four* by George Orwell is published. His *Animal Farm* appeared in 1945.

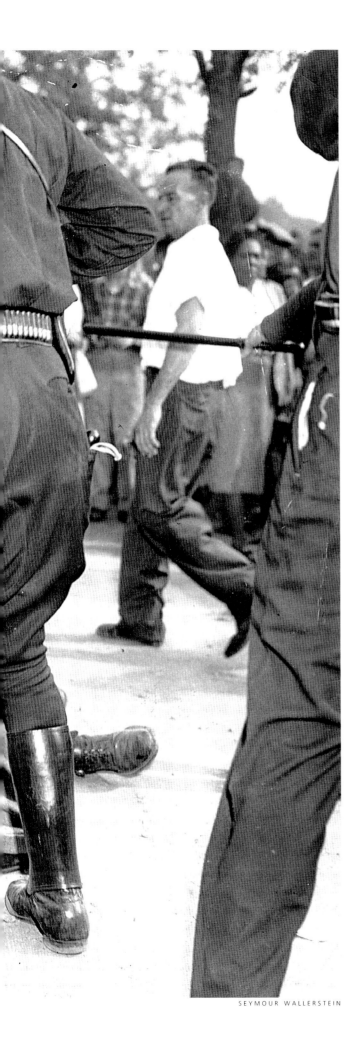

SEYMOUR WALLERSTEIN

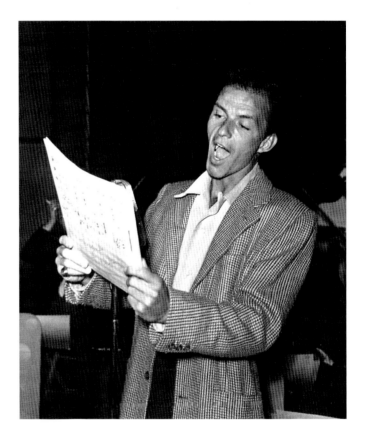

Swoonlight Sinatra,
'the skinny kid with big ears' from Hoboken,
New Jersey, also simply known as 'The Voice',
rehearses at the London Palladium.

The Red menace.
New York State troopers gather round one
of their own (left), hit by a stone thrown by a
protester trying to stop a Paul Robeson concert. The
black Communist singer has just returned from a tour of
the Soviet Union. Anti-Communist feelings are running high
in the USA and the next year Republican Senator Joseph
McCarthy will whip them to a frenzy with his wild accus-
ations aimed at prominent Democrats and intellectuals.

Attlee forms a new Labour Government after a very close General Election. Communist North Korea invades South Korea. United Nations forces, largely American, move to support South Korea and push the invaders back. Chinese forces come to the aid of the North Koreans, with Soviet 'advisers'. The Chinese invade Tibet. The first credit card, Diners' Club, comes into use in New York. *The Kon-Tiki Expedition*, by Thor Heyerdahl, is published.

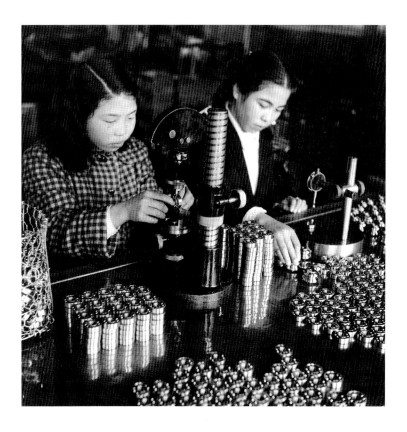

Only in Japan.

Fifteen hundred young men (right), plunged in total darkness, try to find two prize-winning batons. This extraordinary lottery, held as part of a cultural festival, is briefly illuminated by the photographer's flash. More prosaically, these girls manufacturing machine parts (above) are helping Japanese industry back on its feet, ready for the huge leap forward it is to take in the 1950s.

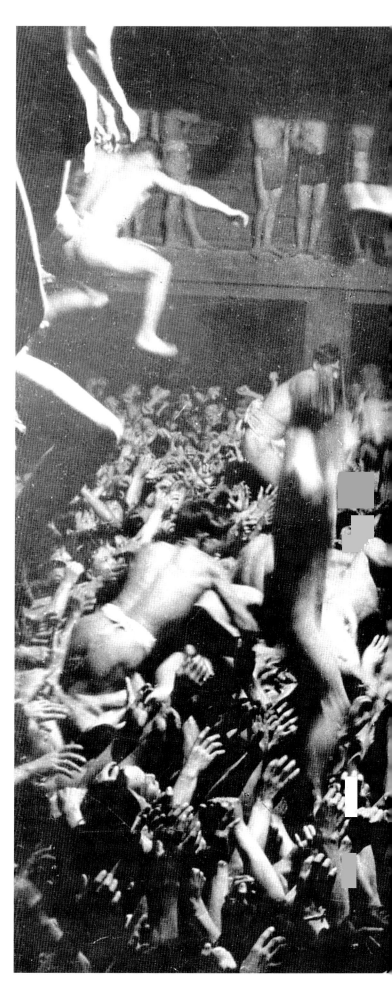

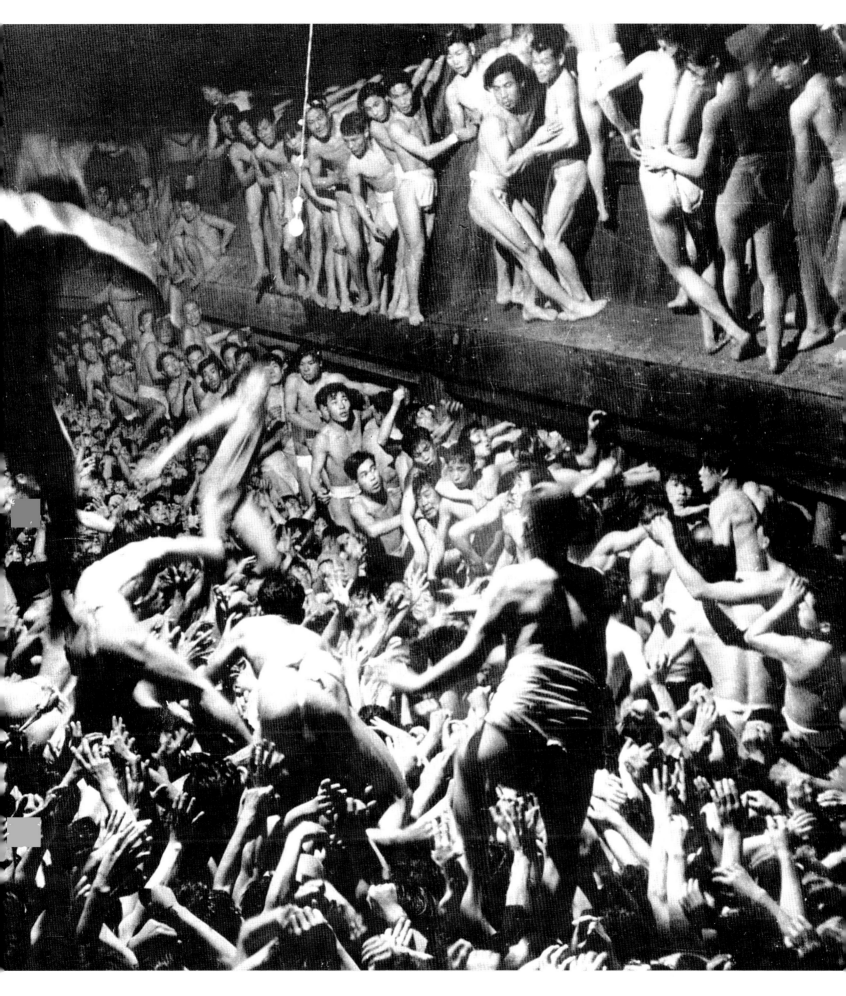

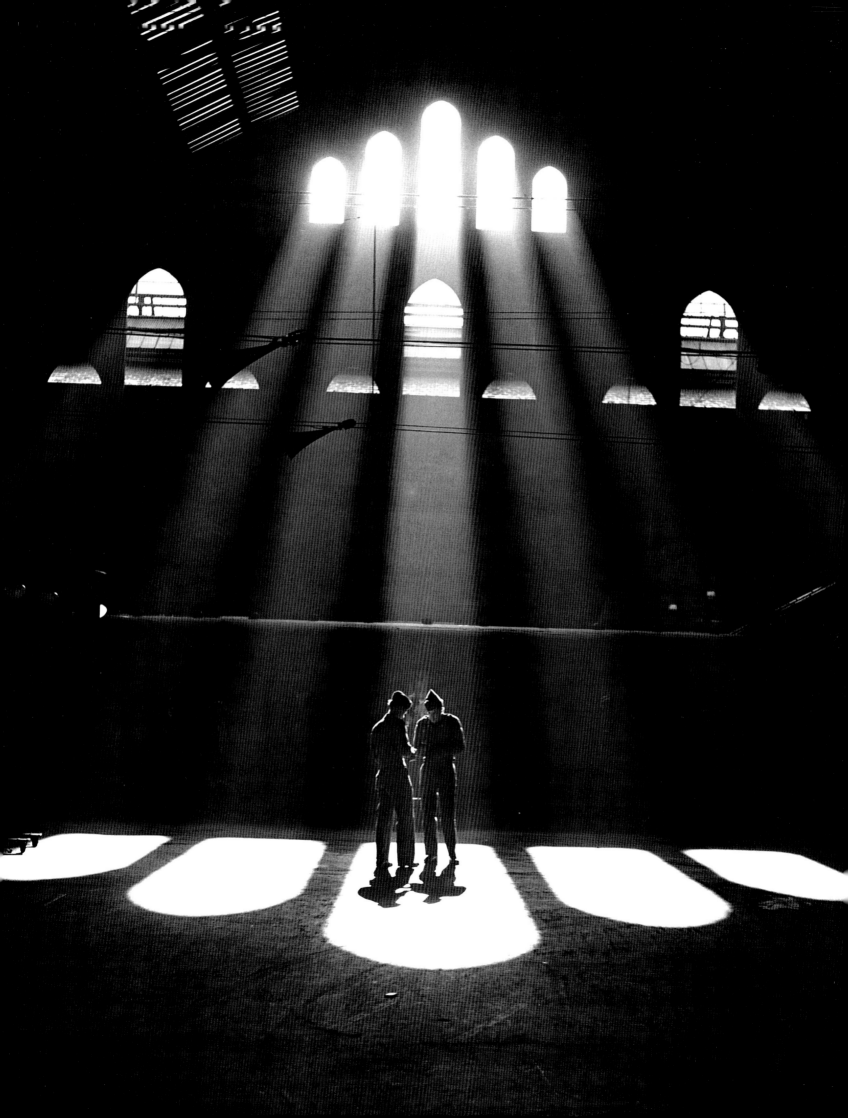

The Festival of Britain is mounted in London, a hundred years after the Great Exhibition held in the Crystal Palace in 1851. The Conservatives win the General Election and Churchill is back in power. Soviet spies, Burgess and Maclean, flee to Russia. Fighting goes on in Korea but General MacArthur is relieved of his command after first threatening to drop an atomic bomb, then to invade China. British forces occupy the Suez Canal Zone in Egypt. J. D. Salinger's novel, *The Catcher in the Rye*, is published.

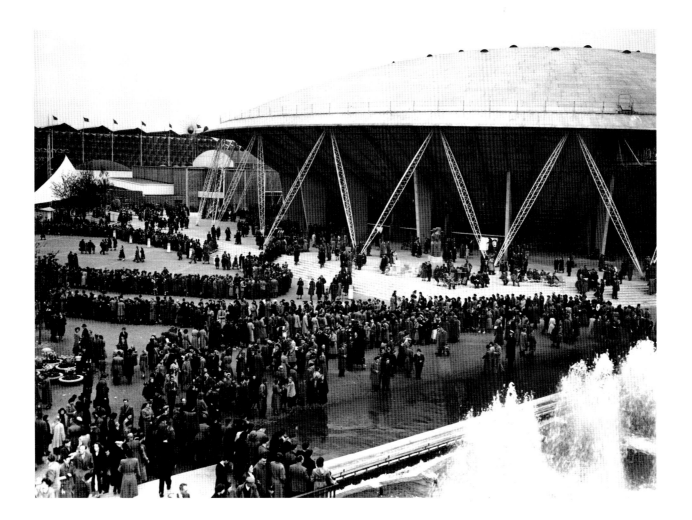

Station sunlight

catches two British soldiers in its beams at Liverpool Street, London's busiest terminus (opposite). *Architecturally, its red-brick Gothic could not be in greater contrast to the Dome of Discovery, the most original of the buildings erected for the Festival of Britain on London's South Bank* (above). *Crowds queue here for the opening ceremony of the Festival, brainchild of the Labour politician Herbert Morrison, whose grandson Peter Mandelson will be responsible for the Millennium Dome, a few miles down the river and fifty years on (see 1999, p. 206).*

King George VI dies of lung cancer. Republican Dwight Eisenhower ceases being Supreme Commander of Allied Forces and is elected US President. The Malayan Emergency, caused by Communist terrorists, is at its height. There are anti-British riots in Egypt and King Farouk abdicates. The Mau Mau Emergency begins in Kenya, with attacks on white settlers and the terrorising of much of the African population. Britain explodes its first atomic bomb, and the USA its first hydrogen bomb. *The Diary of Anne Frank* is published.

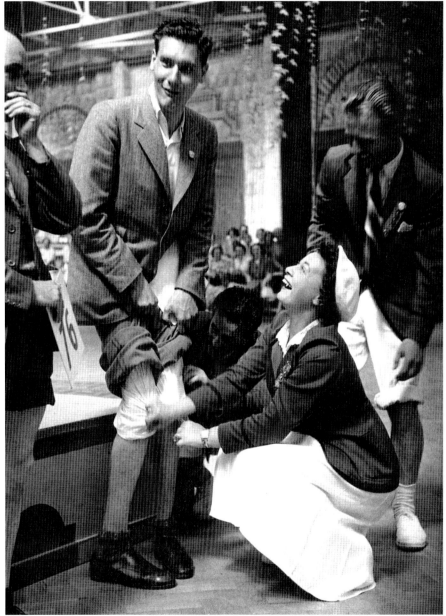

BERT HARDY

Billy Butlin
set up his first holiday camp at Skegness on the Lincolnshire coast in 1936,
his motto a quotation from Shakespeare: 'Our true intent is all for your delight.'
For the 'redcoat' camp assistants this sometimes means parading in swimsuits and Marilyn Monroe
masks (opposite), and sometimes rolling up a contestant's long johns in a knobbly knee
competition (above). However, opera and Shakespeare are also provided. Butlin built three
camps during the war, partly paid for by the government which housed troops in them.
With foreign holidays still expensive rarities, he is doing a roaring trade.

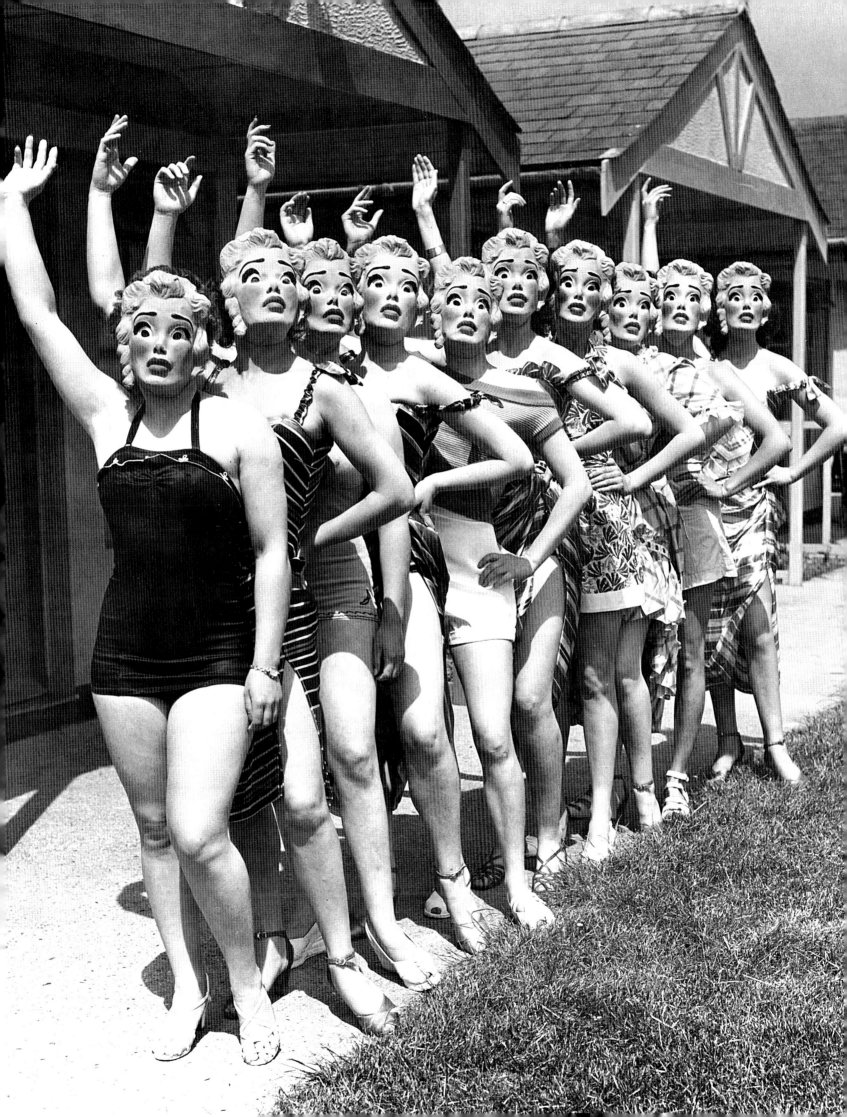

1953

Queen Elizabeth is crowned and on the same day, 2 June, the news comes through of the first ascent of Mount Everest by the British team. The Korean War ends, but in Vietnam the French are fighting guerrillas from the north led by Ho Chi Minh. Soviet forces suppress a revolt in East Berlin, then Stalin dies. *The Mousetrap* by Agatha Christie opens, *Under Milk Wood* by Dylan Thomas is broadcast and Ian Fleming publishes his first James Bond novel, *Casino Royale*. British scientists discover the structure of DNA, the key to heredity.

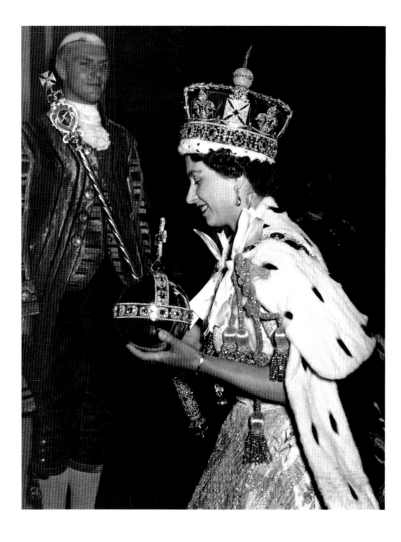

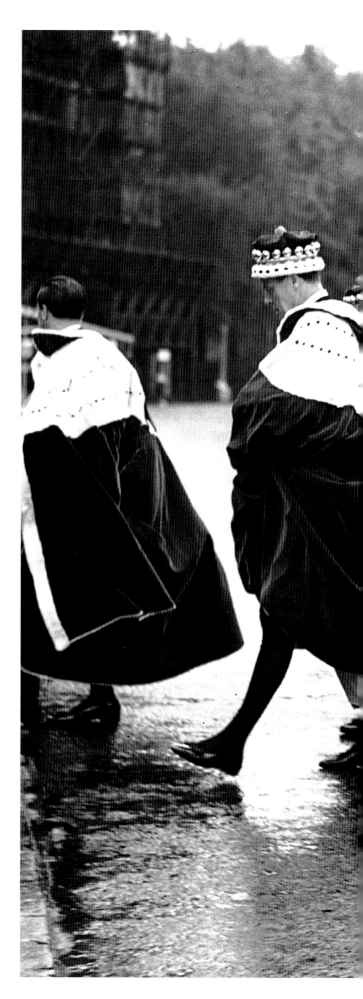

Crown, orb and sceptre.
*The Queen smiles, perhaps with relief (above), as
she carries the symbols of sovereignty into Buckingham Palace
after her Coronation. Outside Westminster Abbey after the
ceremony peers hurry across the road in the rain (right), on
their way to the House of Lords where they can disrobe
and doff their coronets.*

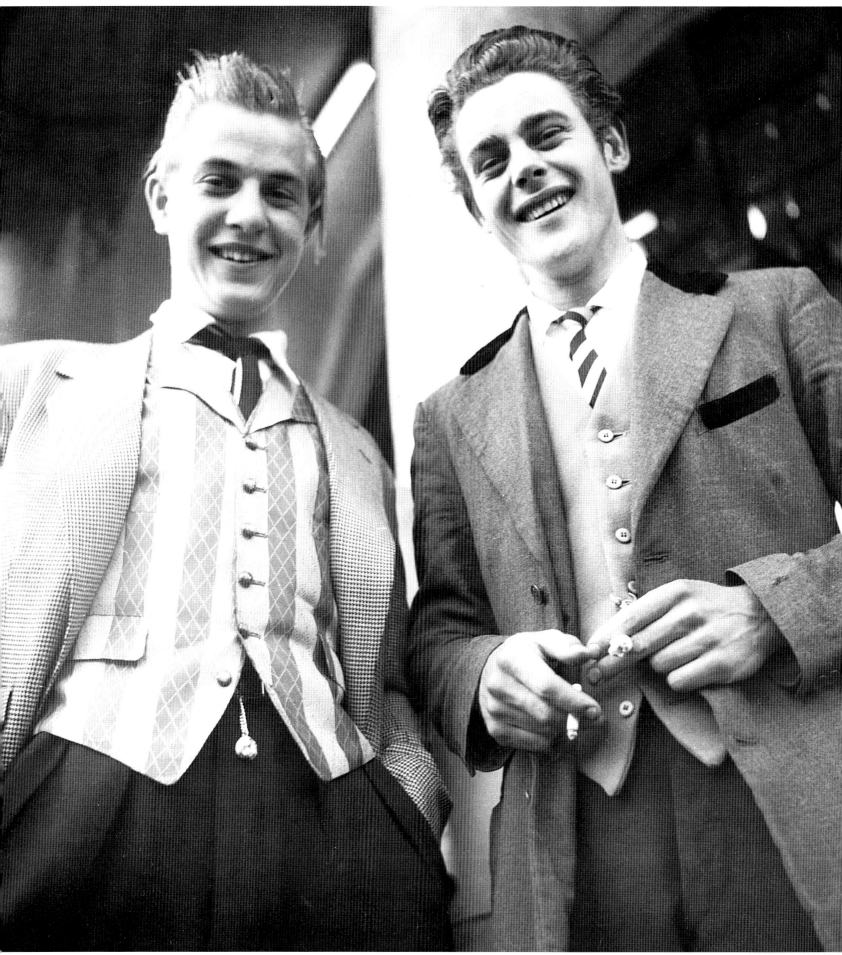

1954

Comet airliners are crashing for no apparent reason and have to be withdrawn. This gives the US aeronautical industry its chance, as the Boeing 707 makes its maiden flight. Roger Bannister runs the first four-minute mile. Rationing ends in Britain after fourteen years. The French withdraw from Vietnam and the country is divided, with the northern half under the Communists in Hanoi. French rule is also coming under attack in Algeria. The Salk polio vaccine goes on trial. *Lucky Jim* by Kingsley Amis, *Lord of the Flies* by William Golding and *The Lord of the Rings* by J. R. R. Tolkien are published.

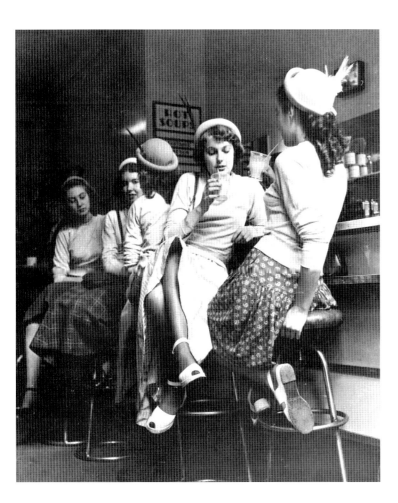
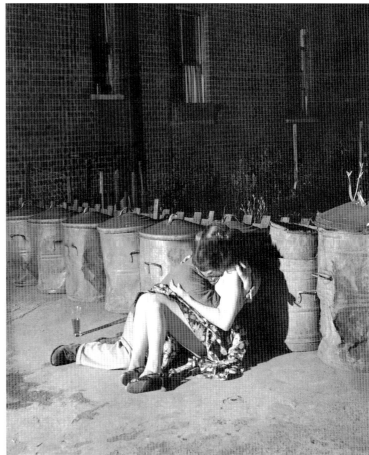

BERT HARDY

Teddy Boys
ape the Edwardian gentlemen with fancy waistcoats and
velvet collars (opposite). Greased hair and crêpe-soled brothel creepers complete the
outfit. The girls sucking on their milkshakes (above left) are the first butterflies to escape
the drab post-war chrysalis, heralding a new era of teenage
affluence and independence.

Chelsea at night.
A young couple have also escaped from some vaguely artistic party,
to embrace among the dustbins (above right).

1955

Anthony Eden replaces Churchill as Prime Minister. Unrest between Greek and Turkish communities in Cyprus reaches new heights. EOKA, the Greek Cypriot terrorist organisation, tries by bomb and murder to bring about union with Greece. Princess Margaret does not marry Peter Townsend. Martin Luther King leads bus boycotts in Montgomery, Alabama. Bill Haley's 'Rock Around the Clock' tops the charts in the USA and Britain. Fans riot at an Elvis Presley concert, and Chuck Berry's first single, 'Maybelline', reaches the Top 10.

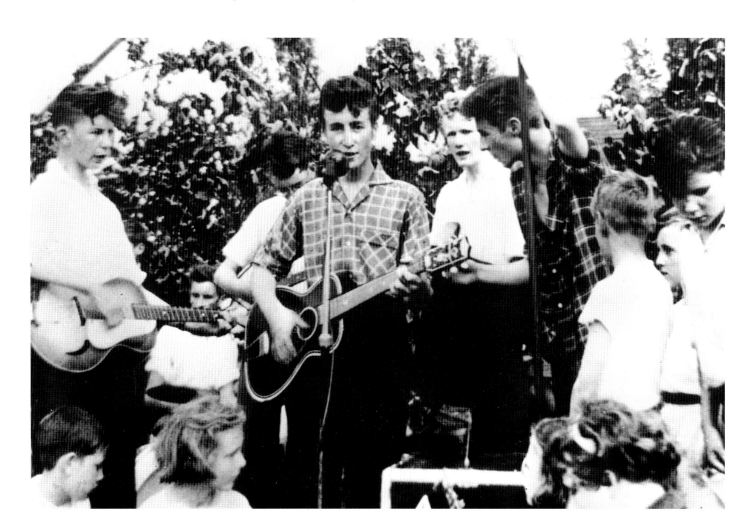

Jazz, skiffle and pop.
The first stirrings of the popular music revolution, heavily influenced by American models, are abroad. A fifteen-year-old John Lennon plays with his skiffle group, the Quarrymen (above), complete with a bass made out of an old tea chest, a broom handle and a piece of string. A very young Shirley Bassey (opposite) poses in her home in the Tiger Bay area of Cardiff.

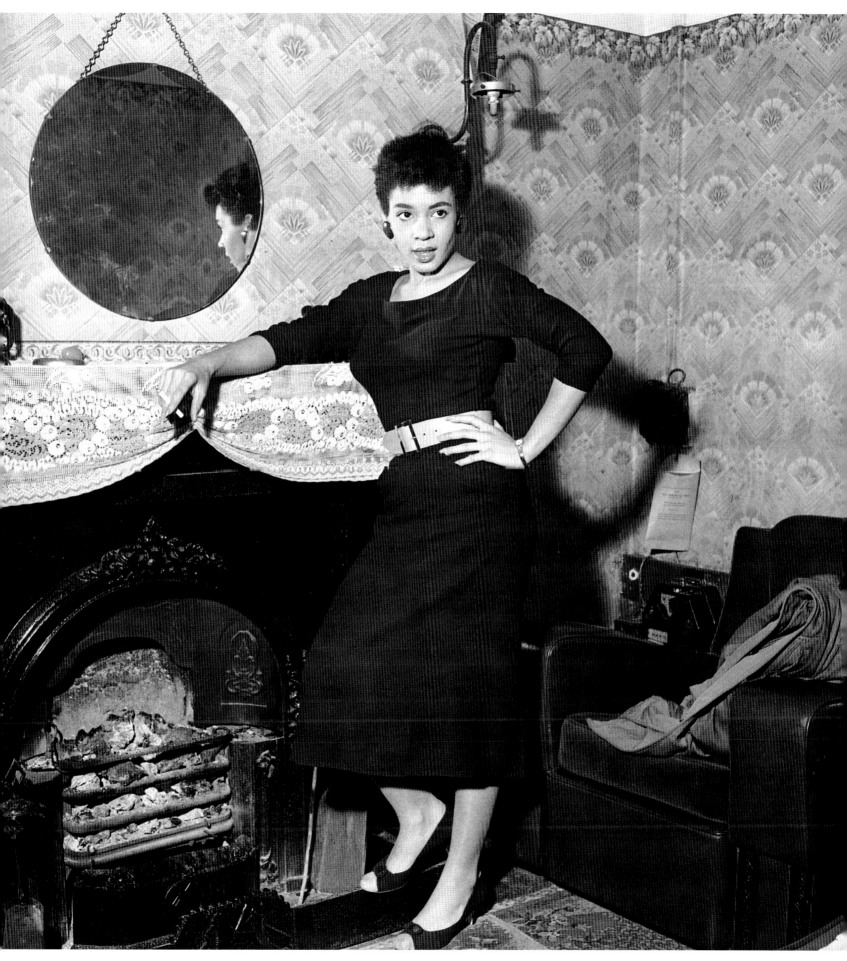

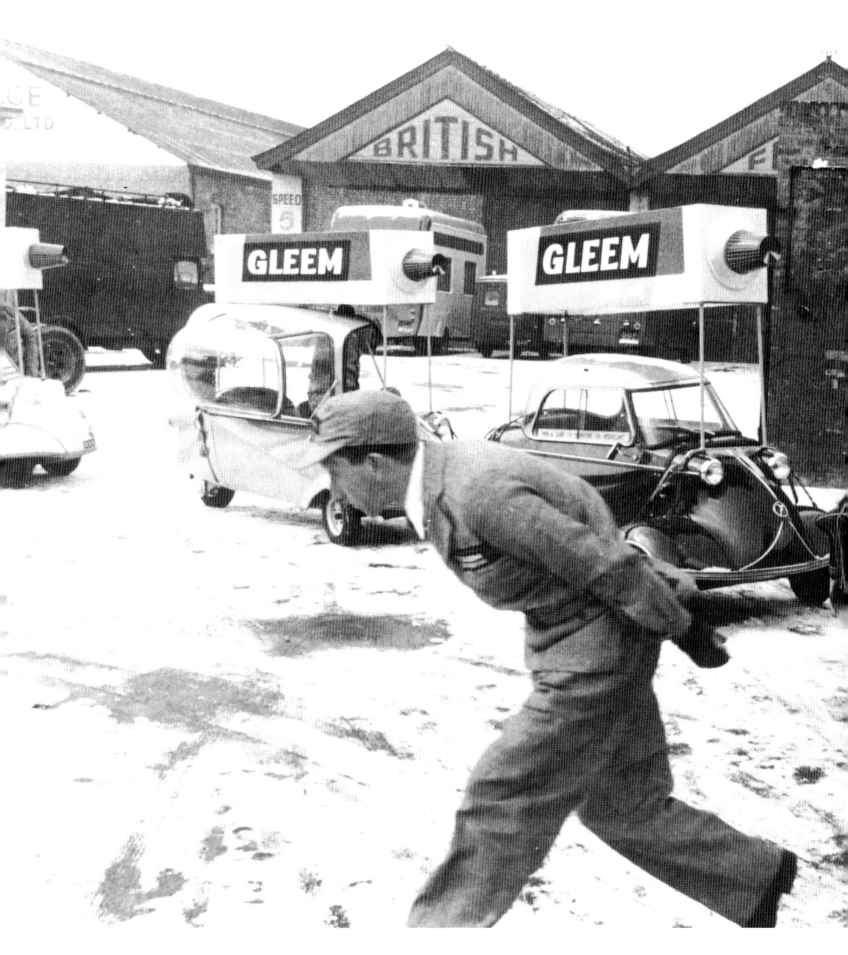

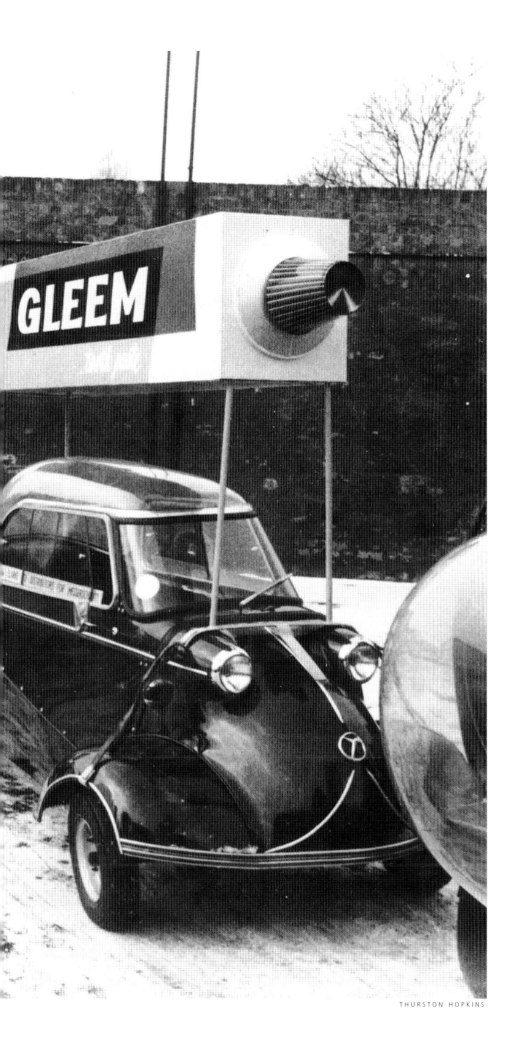

1956

The Greek Cypriot leader, Archbishop Makarios, is deported by the British, while unrest and killings continue on the island. Nikita Khrushchev, the Soviet leader, attacks each stage of Stalin's career in a speech to the 20th Party Congress. Nasser effectively nationalises the Suez Canal. Britain and France, in secret collusion with Israel, go to war with Egypt, but do not have US backing so are soon forced to withdraw. At the same moment, partly inspired by Krushchev's speech, the Hungarians rise up against the Communist regime in their country, and are then subdued by Soviet tanks. John Osborne's play, *Look Back in Anger,* opens in London.

A new toothpaste
*gets a pythonesque launch.
Messerschmitt bubble cars, looking like
sawn-off cockpits from some of the designer's
earlier products, are made even more bizarre by
the boxes teed up above them. The car on the
left has its roof tipped over, showing how
the driver gains entry.*

THURSTON HOPKINS

121

1965

Winston Churchill dies. Ian Smith's white government in Southern Rhodesia unilaterally declares independence. A stable regime under General Mobutu is set up in Zaire (Congo). American planes bomb North Vietnam and by August there are 125,000 US soldiers deployed in South Vietnam. Black civil rights activities grow in the United States, backed by new legislation. The drive for black voter registration is centred on Selma, Alabama. Martin Luther King leads a march of 25,000 from there to the state capital, Montgomery. There is race rioting at Watts in Los Angeles, with thirty-four people killed. The film *The Sound of Music* has its premiere.

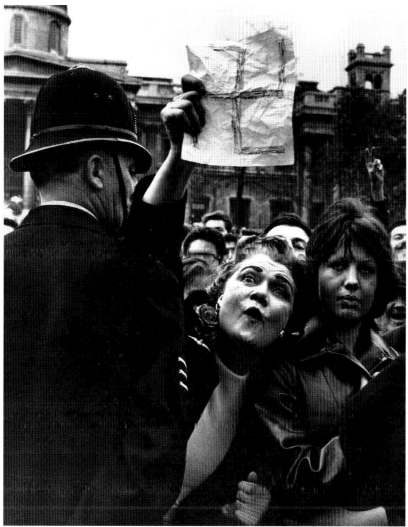

DON McCULLIN

An English Fascist
at a Trafalgar Square meeting. Her hatred may be real enough, but she will have to learn to get her swastika the other way round before she becomes a true heir to the Nazis (above).

White Supremacist
Ku Klux Klansmen may look ridiculous in their hoods and white sheets, with their grand Goblin, Great Titan and Kleagle titles, but the violence they dish out to 'uppity niggers' in the southern states of America is real enough. Their lynchings, fire bombings and beatings may have reached a peak in the 1920s but the organisation continues, as this photo of a Klan mother and baby (also hooded) in South Carolina testifies (opposite). *Klan hatred encompasses Roman Catholics and Jews as well as blacks.*

1966

Labour wins a landslide victory in the British General Election. England wins the Football World Cup, defeating West Germany in the final at Wembley. The Moors Murderers, Ian Brady and Myra Hindley, are jailed for life. Freddie Laker takes on the airline giants, offering a cheap transatlantic service. Mao Tse-tung announces the Cultural Revolution, setting the youth of China against their elders and unleashing years of chaos and persecution. Florence is flooded and many works of art are damaged. Mrs Indira Gandhi becomes Prime Minister of India.

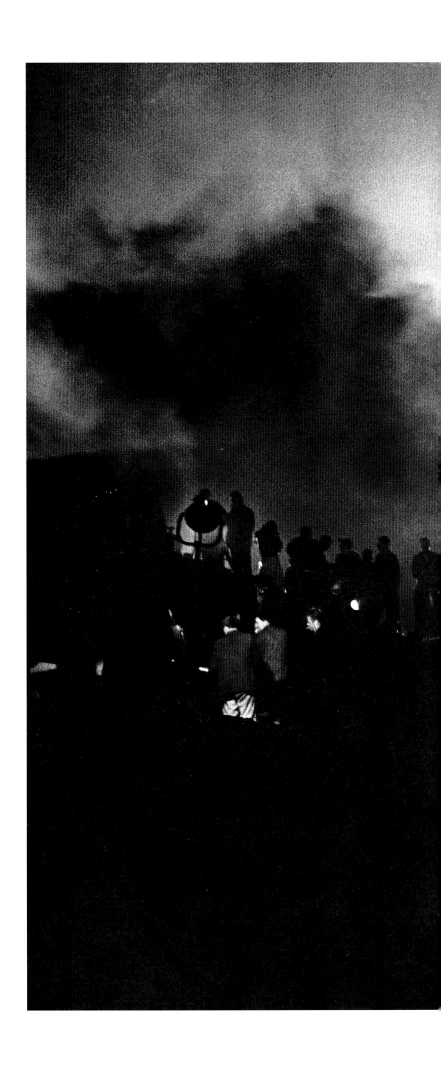

A slag heap

by the Welsh village of Aberfan, near Merthyr Tydfil, collapses on the local school. Heavy rain has made it unstable and it engulfs 147, mostly children. Almost an entire generation of the village is dead, under 2 million tons of mine waste and sludge. If it had happened a few hours later, the school would have been empty, closed for half-term. Some of the 2,000 rescue workers are outlined against the night sky by floodlights.

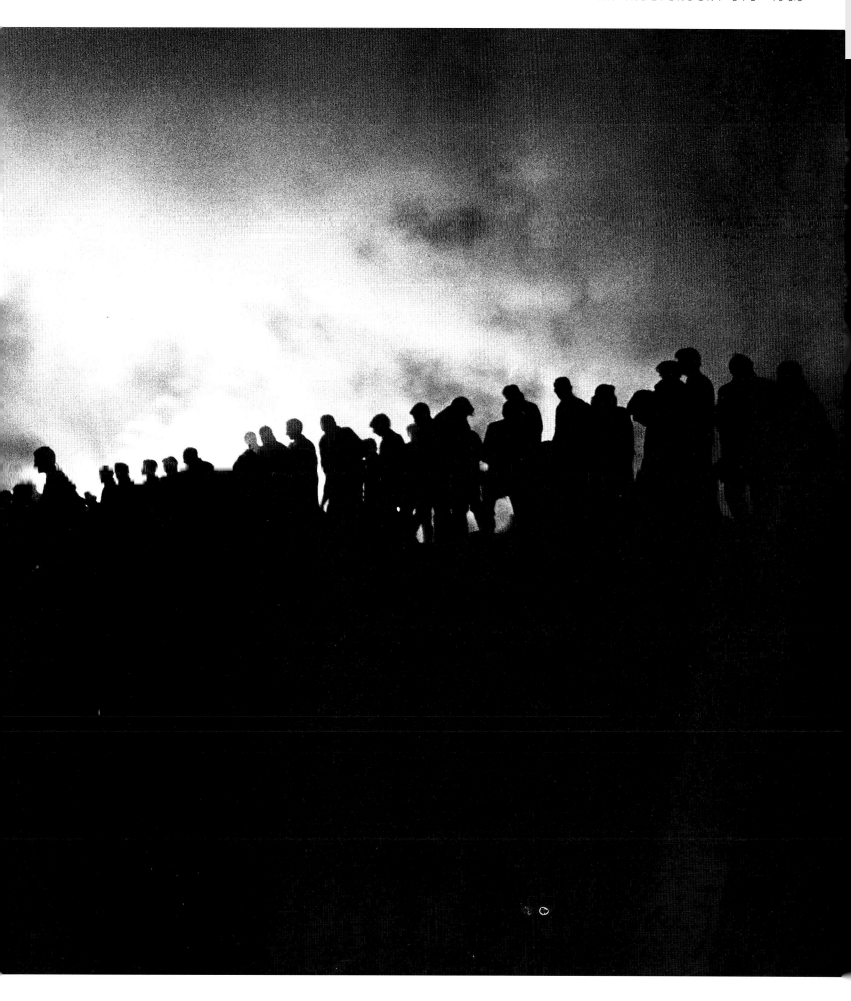

1967

Britain withdraws from Aden and applies for membership of the EEC for a second time, and de Gaulle again exercises France's veto. The Abortion Act is passed, and the pound is devalued by 15 per cent. Israel routs Egypt, Jordan and Syria in the Six-day War, after aggressive moves by Colonel Nasser. Most of the West Bank of the Jordan, the old city of Jerusalem and the Golan Heights fall to Israel. In Greece, the army seizes power and the regime of the Colonels begins. During ground testing of the first Apollo spacecraft three US astronauts are burnt to death. The cult revolutionary hero Che Guevara is killed in Bolivia and Dr Christiaan Barnard carries out the first successful heart transplant in South Africa. In Detroit there are four days of race riots and forty dead; for the hippies in Haight-Ashbury, San Francisco, the Summer of Love passes in a haze of pot and LSD.

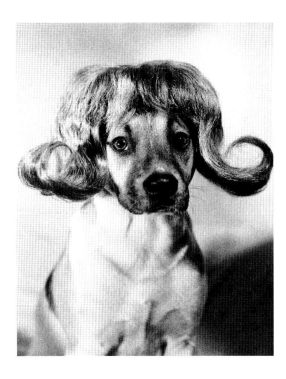

The dog breeders'
year climaxes at Cruft's Show in London.
Here two chihuahua owners exchange pleasantries
before they meet in the ring (right), the one on the right
proving an observable fact of life: that very small dogs
often have very large owners. The dog in the wig (above)
seems to be looking with a mixture of pity
and disgust at whoever has perpetrated such
an indignity on it.

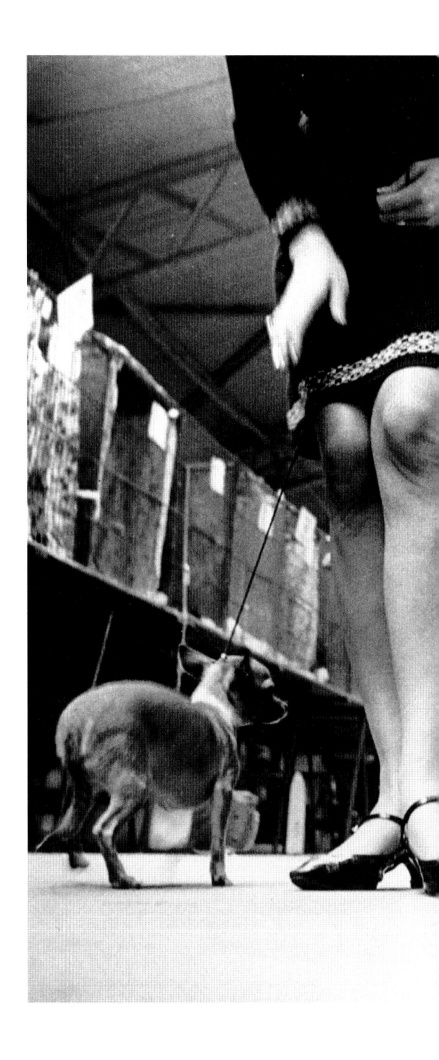

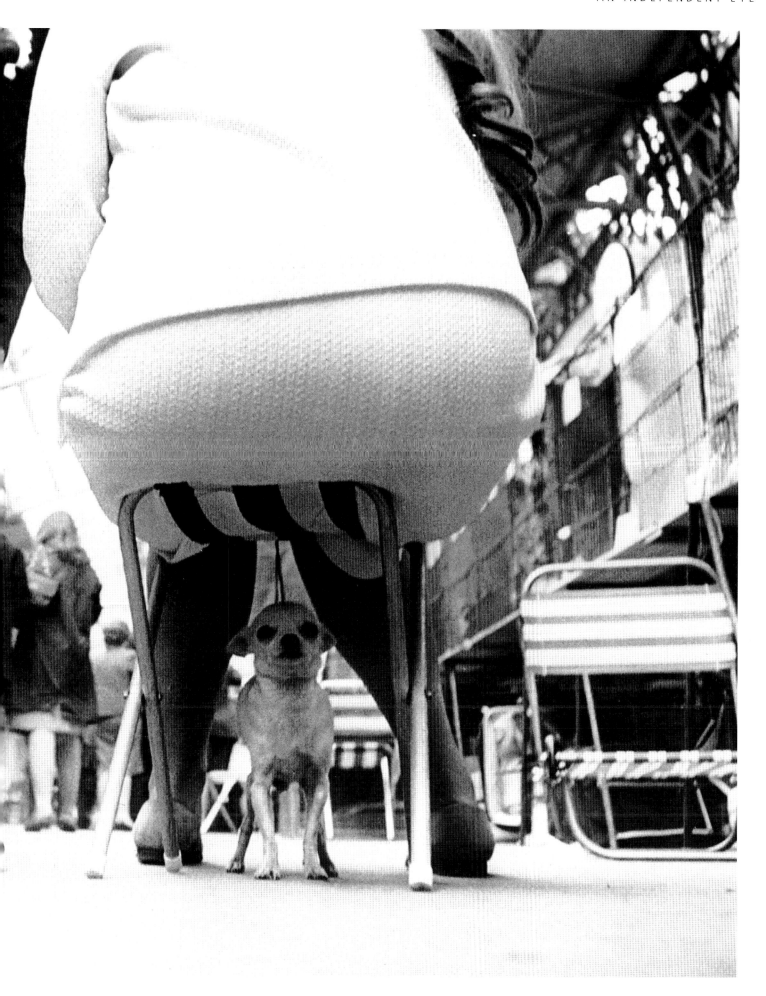

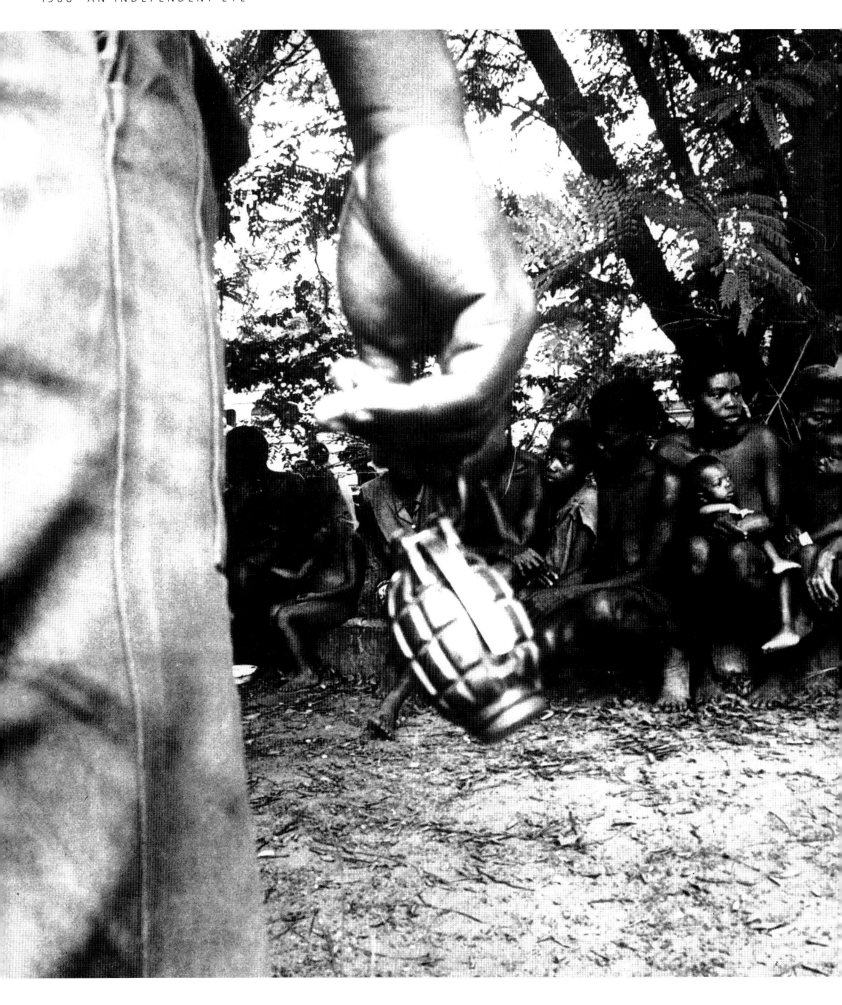

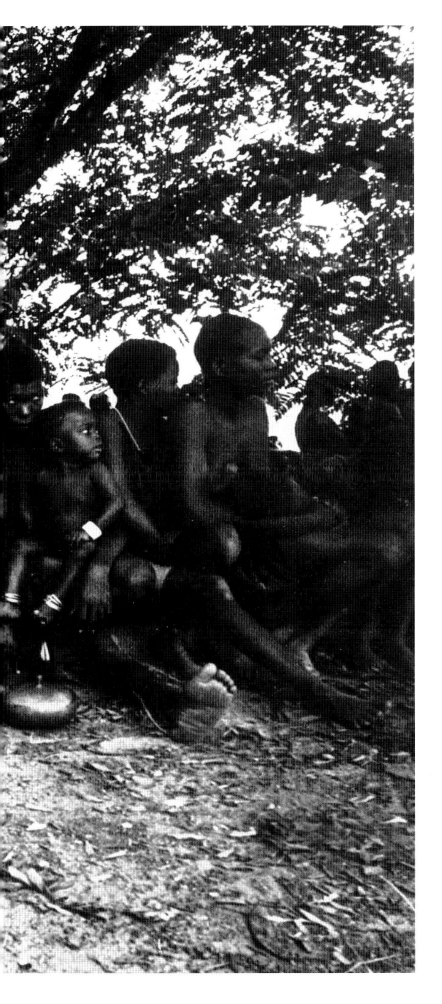

After US offensives in 1966 and 1967 and with half a million US troops in Vietnam, the Viet Cong launch their Tet Offensive, overrunning Hué and even capturing the US embassy in Saigon for a few hours. Viet Cong casualties are horrendous but US opinion starts to turn against the war. Republican Richard Nixon is elected US President. Robert Kennedy and Martin Luther King are assassinated. Alexander Dubcek, new leader of Czechoslovakia, brings in liberal measures, which in turn bring in Soviet tanks to enforce a crackdown. US astronauts orbit the Moon while Stanley Kubrick's *2001. A Space Odyssey* is premiered.

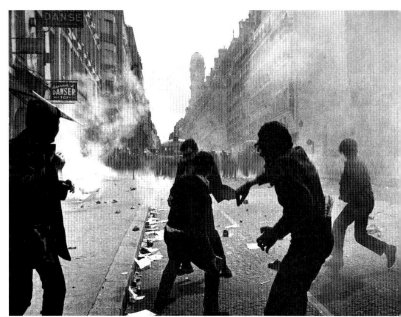

Students on the streets

in Paris in May (above), *responding to police tear gas with paving stones. The rioting by left-wingers is large scale, but they never get the support of the workers which would turn their protest into a threat.*

Ibo women and children

are guarded by a Nigerian soldier dangling a hand grenade by its release pin (opposite). *The civil war in Nigeria began in 1967 when the eastern part of the country split off under its leader, Colonel Ojukwu, and declared itself the Independent Republic of Biafra. The Ibos of Biafra met with success at first, but by now Nigerian forces have gained the upper hand. A big international aid operation is being mounted to fly in supplies to the beleaguered Biafrans.*

Troops are sent into Northern Ireland to try and stem sectarian violence sparked by Protestant attacks on Catholic civil rights marchers. Neil Armstrong and Buzz Aldrin become the first men on the Moon. The Franco-British supersonic jet airliner Concorde has its first flight, as does the Boeing 747 jumbo jet. France formally withdraws from NATO, Georges Pompidou becomes French President and Willi Brandt becomes German Chancellor. Colonel Gadaffi seizes power in Libya. The Woodstock pop festival takes place in the USA while BBC TV shows Kenneth Clark's *Civilisation* series and *Monty Python's Flying Circus*.

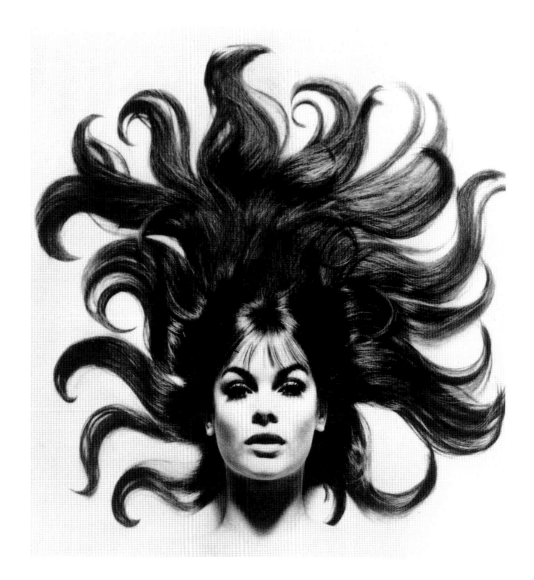

Flower people,
flower power are phrases on people's lips. Flower petals have been arranged round a model's eyes to give a startling look (opposite), like the 'sun' hairstyle displayed round the face of the decade, the model Jean Shrimpton (above). In the fashion world, effects must go to extremes to attract attention, among all the exposed flesh, beautiful people and psychedelia.

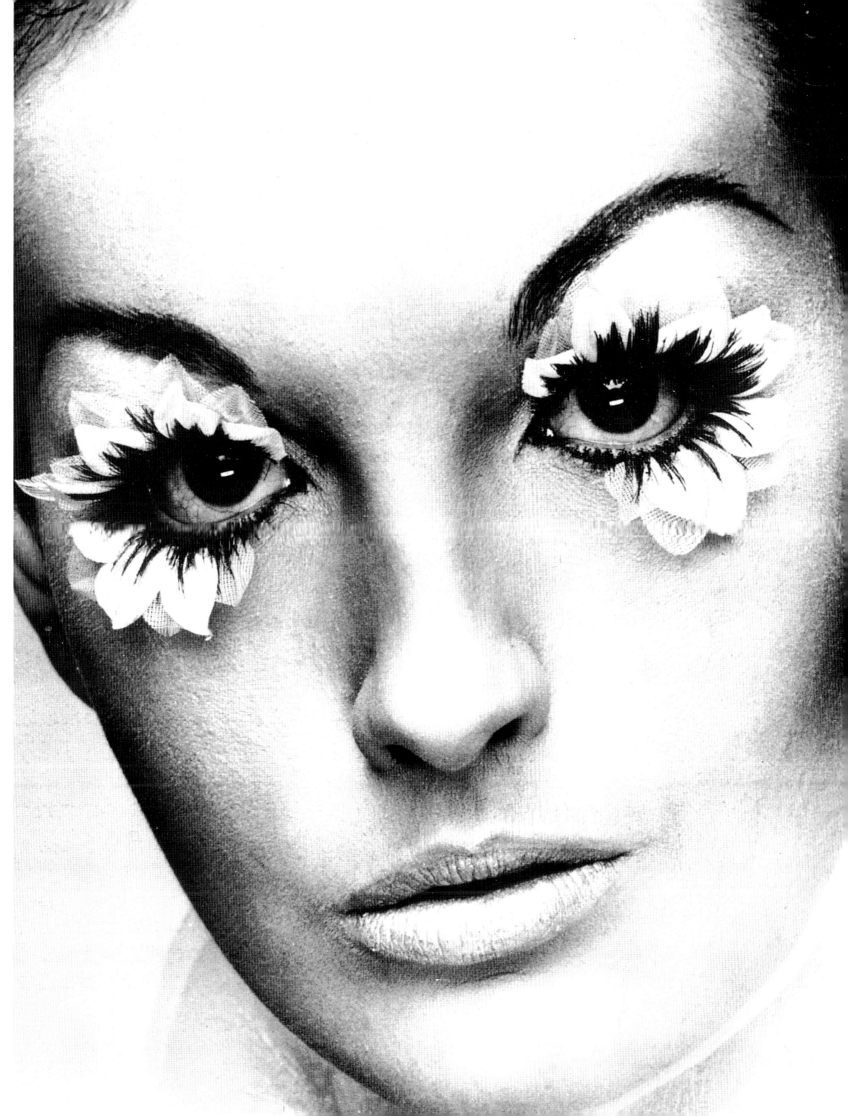

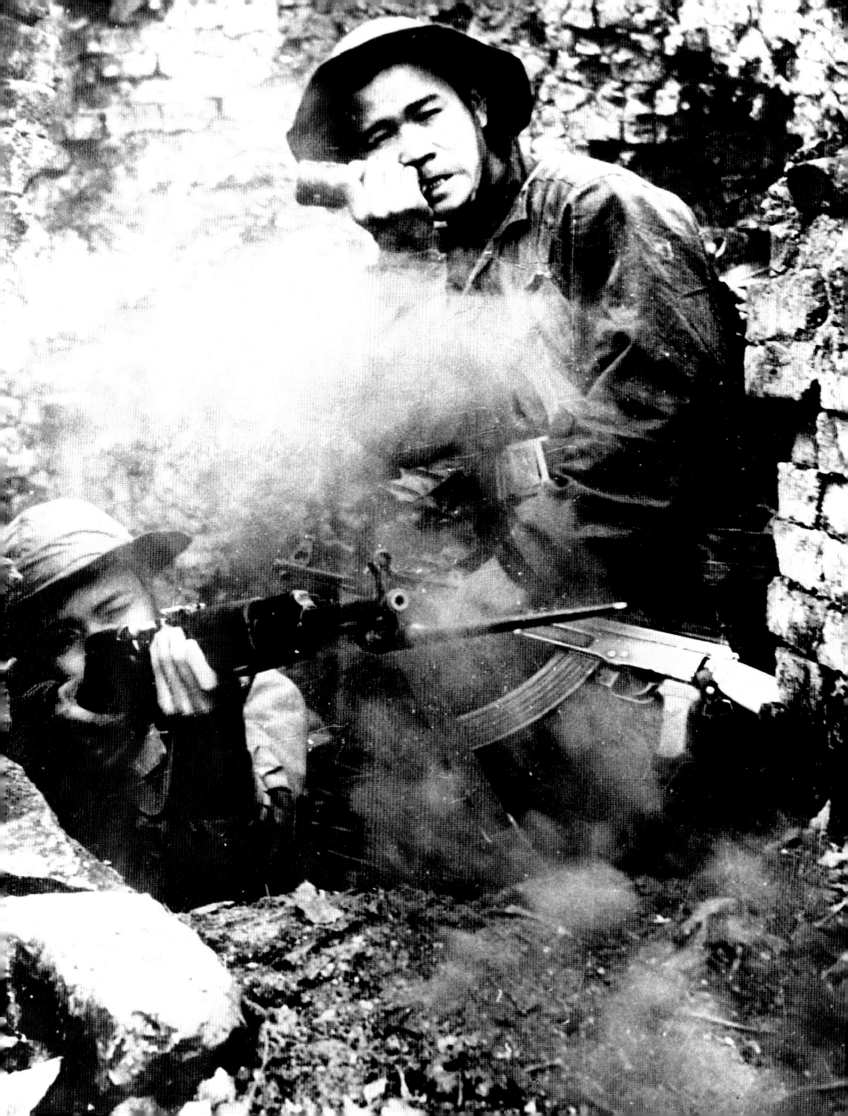

Edward Heath leads the Conservatives to victory in the General Election. Student anti-war demonstrators are shot dead at Kent State University, Ohio. The USA bombs Cambodia and Laos as the Vietnam War spreads. Palestinian terrorists blow up three British, Swiss and American hijacked airliners in Jordan. Nasser and de Gaulle die, as do Janis Joplin and Jimi Hendrix. The crew of Apollo 13 survive an explosion in space, using the small landing module engines to steer back to earth. The floppy disk takes over from magnetic tape as the computer's means of storing information.

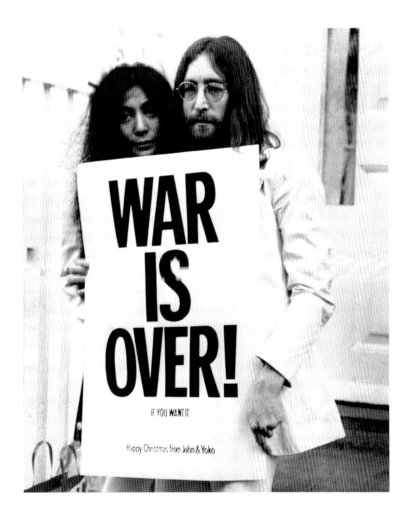

John Lennon's and Yoko Ono's

Christmas message (above) *hasn't got through to these Viet Cong soldiers, 'somewhere in South Vietnam'* (opposite), *photographed by an East European journalist. They are armed with AK-47s and the one on the right is pulling out the release pin of a grenade with his teeth. It is the USA's determination to continue the Vietnam War that is being eroded by the peace protesters.*

Decimal currency is introduced in Britain. The introduction of internment without trial for suspected terrorists is mishandled in Northern Ireland. Idi Amin comes to power in Uganda. Civil war breaks out in East Pakistan and 7 million flee over the border to India. US Lieutenant Calley is convicted of the massacre of civilians at the Vietnamese village of My Lai in 1969. US astronauts drive on the Moon in a special buggy. Three Russians die returning from space. Hot pants are the new fashion, and *The French Connection* and *A Clockwork Orange* the new films.

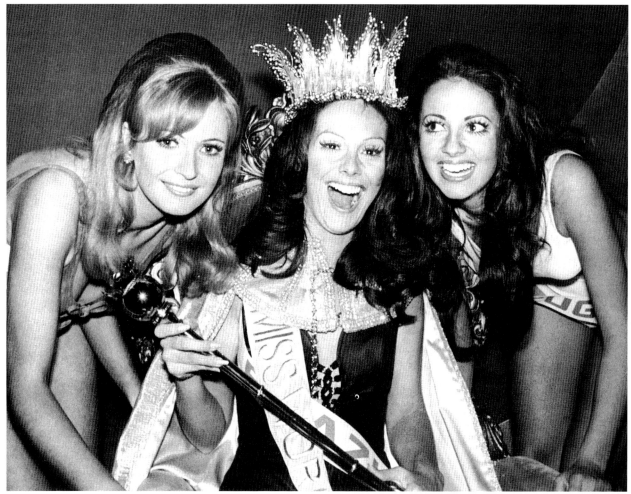

FRANK BARRETT

The Miss World Contest,
*outside and inside the Albert Hall. Miss Brazil (above)
wears the crown she has just won, with the runners-up,
Miss Britain (left) and Miss Portugal (right). Outside, women's libbers
protest at what they regard as the voyeuristic exploitation of the meat
market taking place within. One of them has donned the uniform of a
'sex object', though it is too cold to dispense with her sheepskin
Afghan coat, a garment redolent of this era (opposite).*

CHRIS DJUKANOVIC

Thirteen civilians are killed in Londonderry on Bloody Sunday when paratroopers open fire during an anti-internment march. The Northern Irish Parliament at Stormont is suspended and direct rule by Westminster begins. A British miners' strike results in a three-day week being imposed. After a war between India and Pakistan, the new state of Bangladesh is formed from what was East Pakistan. Idi Amin expels the Asians from Uganda and many come to Britain. Nine Israeli athletes taken hostage at the Munich Olympics die in a gun battle between Palestinian terrorists and German police. The Baader–Meinhof terrorist gang are arrested in Germany. President Nixon visits China, bombs North Vietnam, and signs the Strategic Arms Limitation Agreement with Russia. The pocket calculator appears.

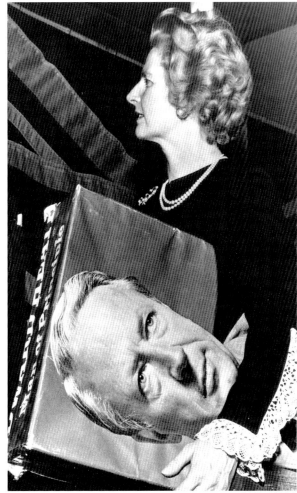

PAUL DELMA

Two politicians,

Margaret Thatcher, Conservative Minister of Education
and Science (above), with a picture of Edward Heath, the man
she is to displace from the leadership of her party. She is on the
way up, while 'Tricky Dicky' Nixon is on the way down. Seen here
electioneering in Ohio (right), he may win a second term, but
the Watergate Affair has broken and the full scope of his
involvement will soon be revealed.

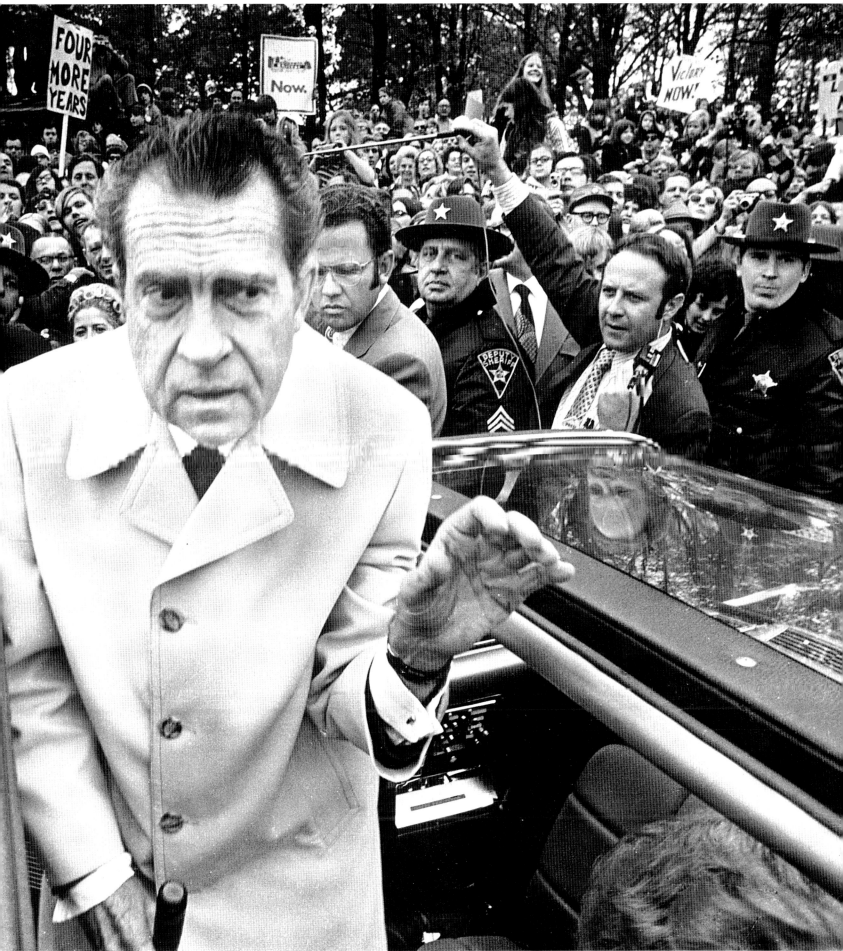

FOUR MORE YEARS

Now.

Victory NOW!

DEPUTY SHERIFF

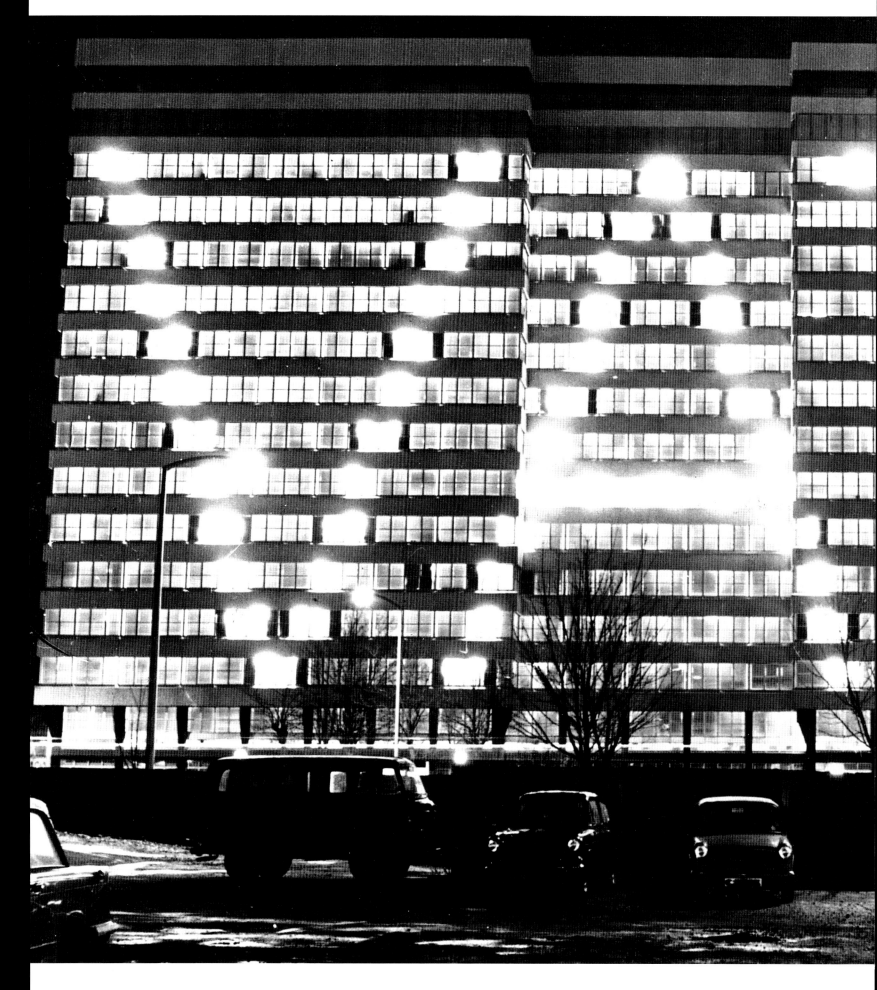

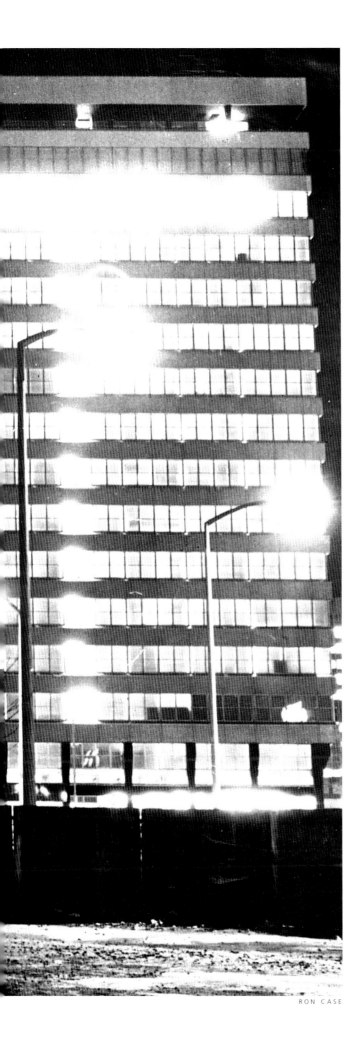

RON CASE

Britain, Ireland and Denmark join the EEC. Egypt and Syria launch a surprise attack on Israel, the Yom Kippur War. Israel absorbs the attack but oil prices rise by 70 per cent. UK miners start an over-time ban and there is another three-day week as well as a 50 mph speed limit. The Vietnam peace treaty is signed in Paris. The Spanish Prime Minister is assassinated by Basque terrorists. Socialist President Allende of Chile is ousted by General Pinochet. Glam rock is this year's style in pop music, with androgynous male singers in make-up.

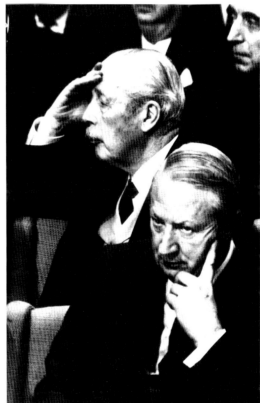

DAVID NEWELL SMITH

In Brussels,
the two prime movers of Britain's entry to the EEC, Harold Macmillan and Edward Heath (above), look suitably pensive after the momentous step.

Value Added Tax
must replace purchase tax now Britain is in the EEC and a local photographer arranges that the VAT headquarters in Southend spell out the initials by pulling down some of the blinds (left).

Edward Heath calls a General Election against a background of unprecedented trades union unrest. Labour forms a minority government. An attempt at power sharing between Catholics and Protestants in Northern Ireland collapses in the face of a strike fomented by hard-line Protestants. The IRA mount a bombing campaign in mainland Britain, culminating with twenty-one killed in two Birmingham pubs. Labour gains a small majority in a second Election. Nixon resigns as President as a result of the Watergate scandal and is succeeded by Gerald Ford. Suspecting a Greek coup there, Turkey invades Cyprus and occupies part of the island. A coup in Portugal ousts its right-wing government. Lord Lucan vanishes and Alexander Solzhenitsyn is expelled from Russia.

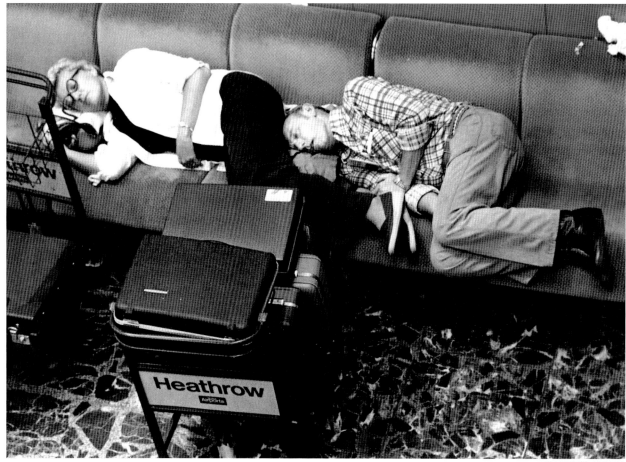

MALCOLM CLARKE

Foreign holidays

*for all is the cry and Spanish hoteliers are out to make
the most of it, despoiling their Mediterranean coast with monotonous
concrete high rises, like this one in Benidorm* (opposite), *to cater for the
package tourists. The French air traffic controllers aren't far behind them,
regularly striking for higher wages at the peak of the holiday
season and inflicting delays on thousands of passengers,
like these at Heathrow* (above).

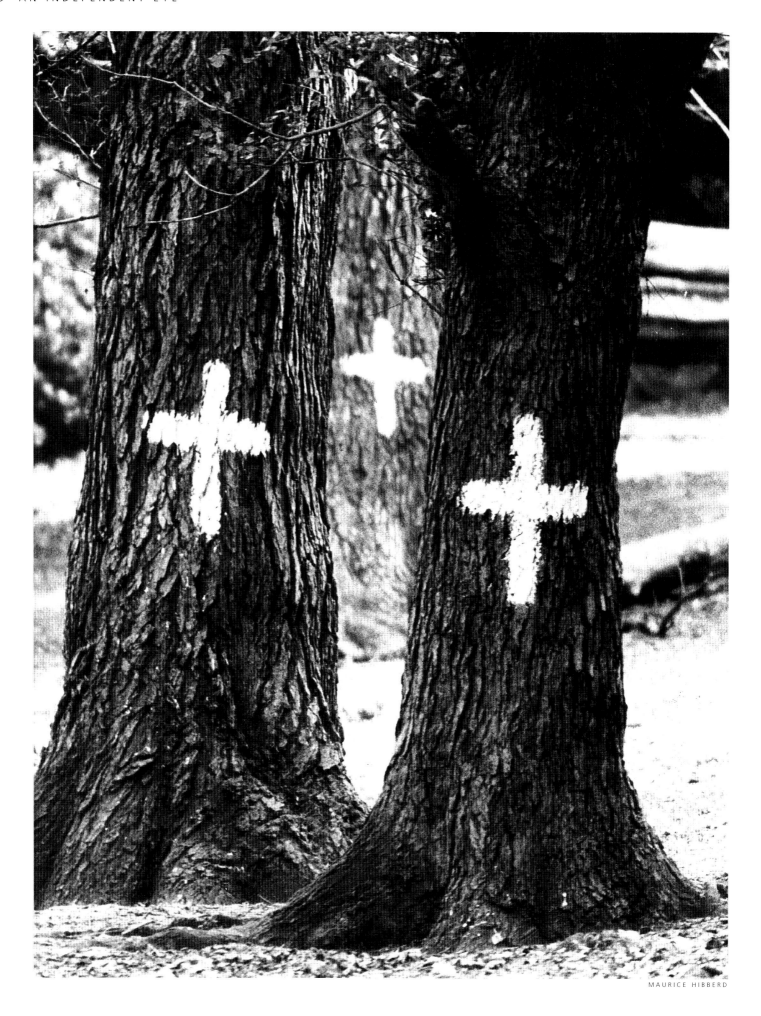

MAURICE HIBBERD

1975

Britain votes in a referendum to stay in the EEC. Margaret Thatcher becomes leader of the Conservative Party. Portugal finally withdraws from Angola, where civil war continues, as it does in the Lebanon. General Franco, the Spanish dictator, dies and Juan Carlos becomes King of Spain. The Communist North Vietnamese seize South Vietnam and the Communist Khmer Rouge seize Cambodia.

 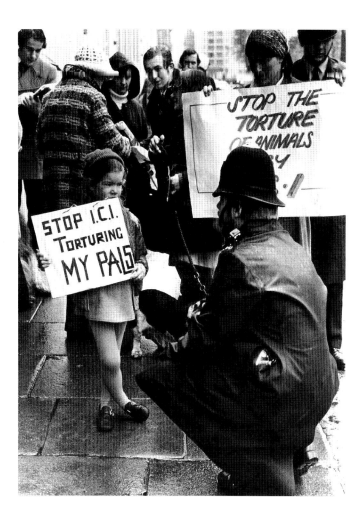

STEVE BENBOW

Emotive issues.
*A seal covered in oil lies on a Welsh beach where
a slick has come ashore (above left). A child carries a slogan protesting at
a chemical company using animals in its experiments (above right).*

Dutch elm disease
*strikes in Richmond Park and infected trees
are marked with a white cross before they are felled (opposite). It is in
English hedgerows, those that the farmers are not ripping out, that the
absence of elms will be most noticed.*

1976

Harold Wilson hands over the premiership, and an acute sterling crisis, to James Callaghan. Britain and Europe suffer a prolonged drought. Both Chou En-lai and Mao Tse-tung die, and in the subsequent power struggle the Gang of Four, including Mao's widow, are arrested. Democrat peanut farmer Jimmy Carter becomes US President. Israeli commandos release over 100 hijacked airline passengers from Palestinian terrorists at Entebbe airport in Uganda.

'A crime against the conscience and dignity of mankind'
is how the UN Security Council condemns South Africa's Apartheid laws in this, the year of the Soweto killings. These two pictures point up the blinkered idiocy of the regime. The demand that all teaching in black secondary schools should be in Afrikaans, the language of the Boers, triggers the rioting in the country's largest township near Johannesburg, which leaves 100 dead.

THE DIVISIONAL COUNCIL OF THE CAPE

WHITE AREA

BY ORDER SECRETARY

DIE AFDELINGSRAAD VAN DIE KAAP

BLANKE GEBIED

OP LAS. SEKRETARIS

MAX SCHNEIDER

1977

The Grunwick photograph processing plant in London, where workers have been sacked, is picketed for a year, sometimes by eighteen thousand people, becoming the focal point for labour unrest and radical agitation. Eight hundred thousand 'boat people' flee Vietnam. Fighting with local independence movements escalates in Rhodesia. President Bhutto of Pakistan is ousted by a military coup led by General Zia ul-Haq. A Palestinian airliner hijack at Mogadishu is foiled by a German anti-terrorist squad. Black leader Steve Biko is murdered while in South African police custody. SF takes over Hollywood with *Star Wars* and *Close Encounters of the Third Kind*.

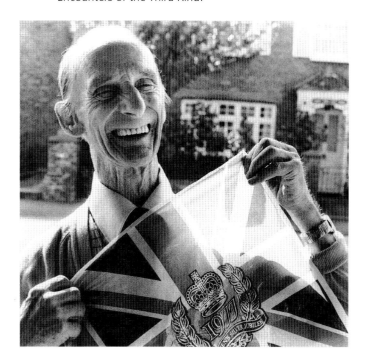

The Punk Rockers

arrive (right), a generation young enough and ignorant enough to appropriate a deeply reviled symbol as some sort of fashion accessory, combining it with lengths of chain and safety pins which hint at bondage and masochism. Maybe the original punks thought to convey their nihilism and contempt for the Establishment by using swastikas, but most who wear their depressing uniform are simply following the trend. This one softens the offensiveness of his outfit by adding a Union Jack, a gesture perhaps to the Jubilee, celebrating the Queen's twenty-five years on the throne, like Mr Fred English's flag in the picture above.

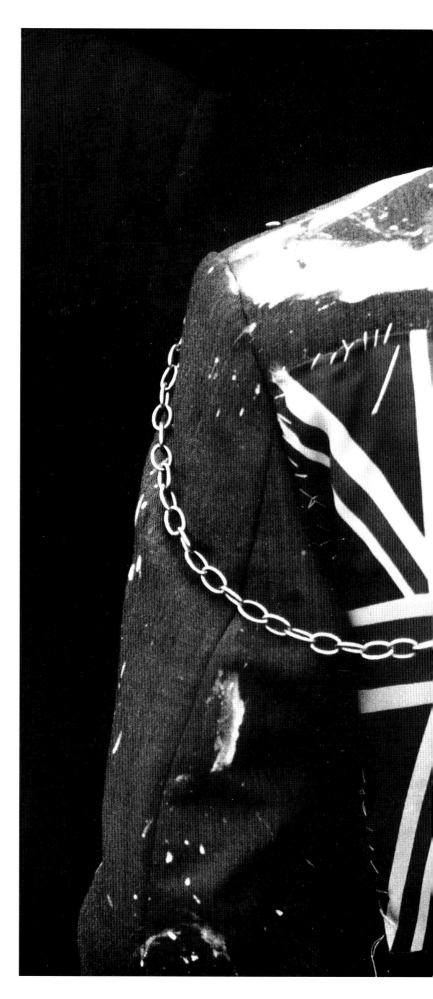

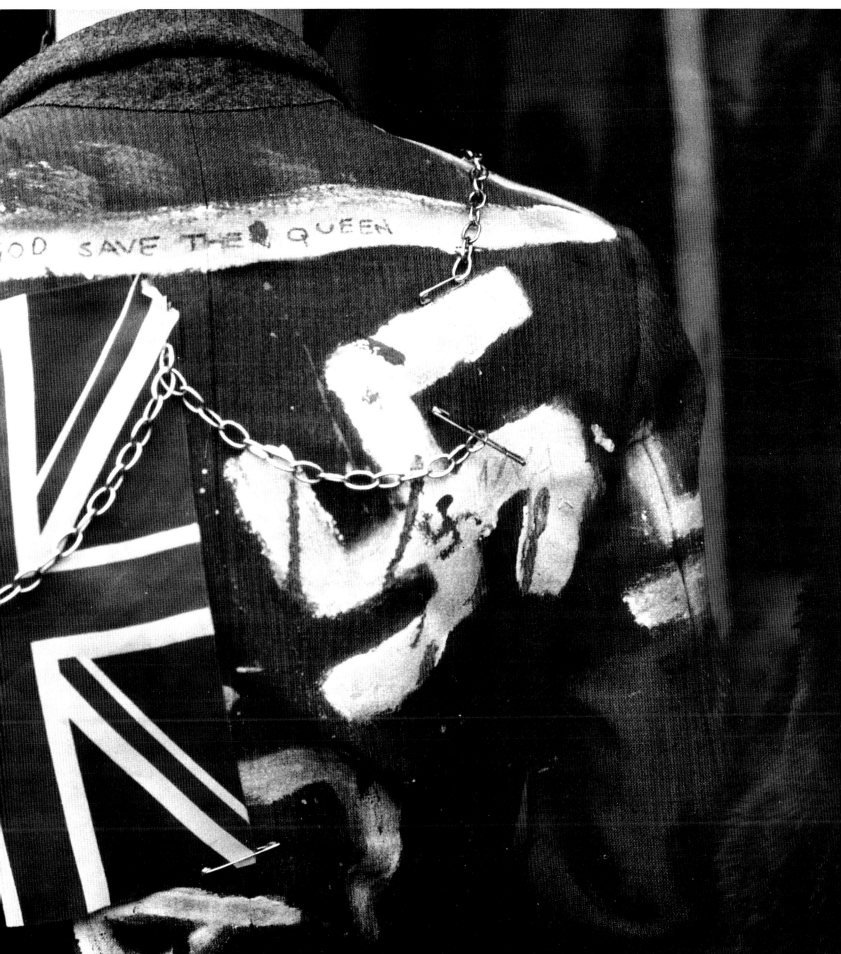

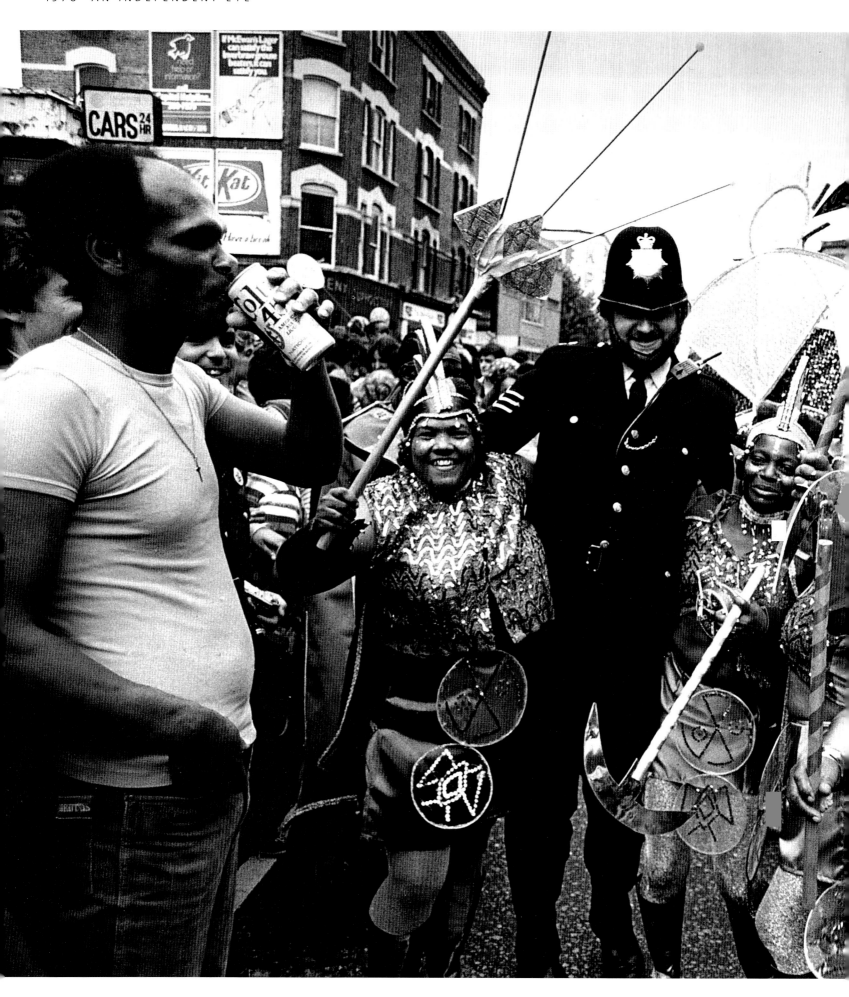

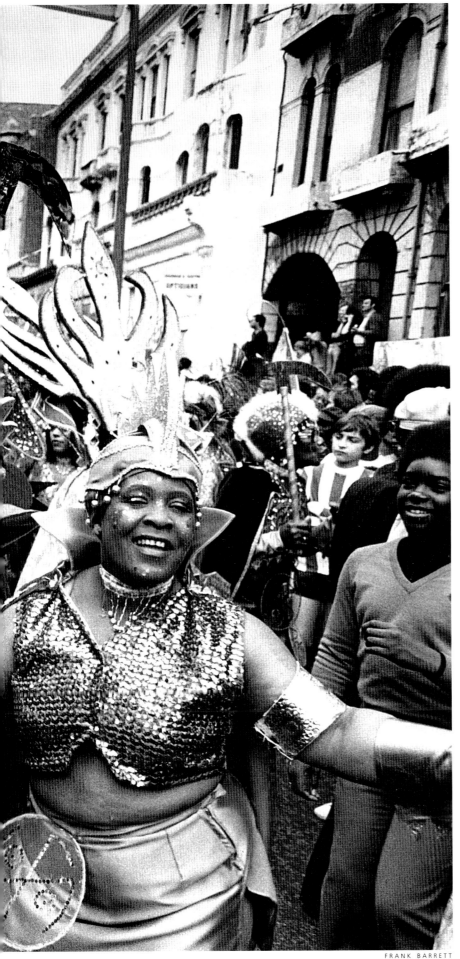

1978

Britain has 2 million unemployed and Jim Callaghan's pay freeze crumbles before the assault of organised labour. A pro-Communist regime emerges in Afghanistan and there is much opposition to the rule of the Shah in Iran. A former Italian Prime Minister, Aldo Moro, is kidnapped and killed by Red Brigade terrorists. Deng Xiaoping emerges as the new ruler of China, and starts to bring an end to Maoist excesses and to liberalise the economy. A Polish Pope, John Paul II, is elected. Egypt and Israel sign a peace treaty at Camp David, Maryland. The first 'test-tube baby' is born.

The Notting Hill Carnival,
and a policeman poses with some costumed dancers from the parade. This annual event at the August Bank Holiday weekend has grown over the years to become by far the biggest of its kind in the country, attracting hundreds of thousands to listen to the rock and steel bands, drink rum, eat goat, and savour the herbal fragrances in the air.

FRANK BARRETT

1979

A public-sector workers' strike brings a 'Winter of Discontent' to Britain with schools closed, bodies unburied, rubbish uncollected. Labour falls and Margaret Thatcher comes to power. The Lancaster House Conference in London arranges for elections to be held in Zimbabwe (formerly Southern Rhodesia). The Shah flees Iran and Islamic fundamentalist Ayatollah Khomeini comes to power. Russia invades Afghanistan. Idi Amin is ousted from Uganda and the rule of Pol Pot and the Khmer Rouge ends in Cambodia, with millions dead. The USA suffers its worst nuclear scare at Three Mile Island power station, Pennsylvania.

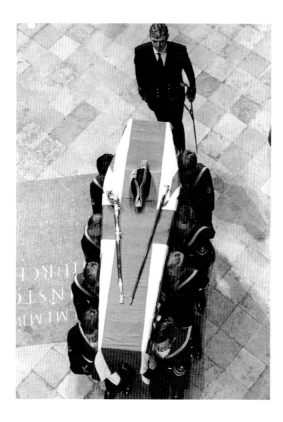

Dirty protest.

A cell at the Maze Prison in Belfast decorated by its IRA occupant with his own excrement in protest at not being granted political status (right). He will also be refusing to wash or to wear prison clothing, making do with a blanket instead. A typical 'political' act of the IRA is to plant a bomb on Lord Mountbatten's boat in Sligo, killing him and two boys, and badly wounding three relatives. His coffin is carried by naval ratings (above).

1980

A minority Arab group seizes the Iranian Embassy in London, which is then stormed by the SAS. British inflation reaches 21.8 per cent. Robert Mugabe is elected the first Prime Minister of Zimbabwe. American hostages are held by revolutionary Iranian students in the Teheran Embassy. A US special forces rescue attempt ends in disaster. Iraq invades Iran. A bomb blast in Bologna, the work of a neo-Fascist group, kills seventy-six. The Solidarity Movement emerges in Poland, led by Lech Walesa. Ronald Reagan wins the US Presidency. Smallpox is officially declared eradicated from the Earth.

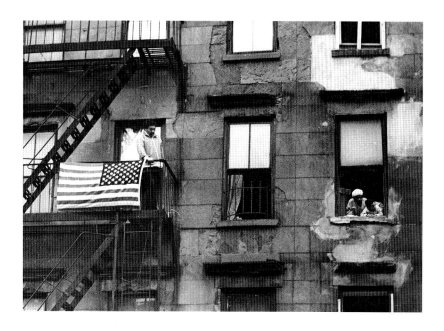

A Guardian Angel

*rides on a New York subway train covered
in graffiti, offering protection from muggers and
pickpockets (right). The volunteer body to which he
belongs is keen to avoid the label of vigilante, but its
existence is a testimony to the failure of the forces of law
and order to keep the lid on New York's violence and
crime. The city has many ideal breeding grounds for
these, like the slums known as Hell's Kitchen in
Manhattan (above).*

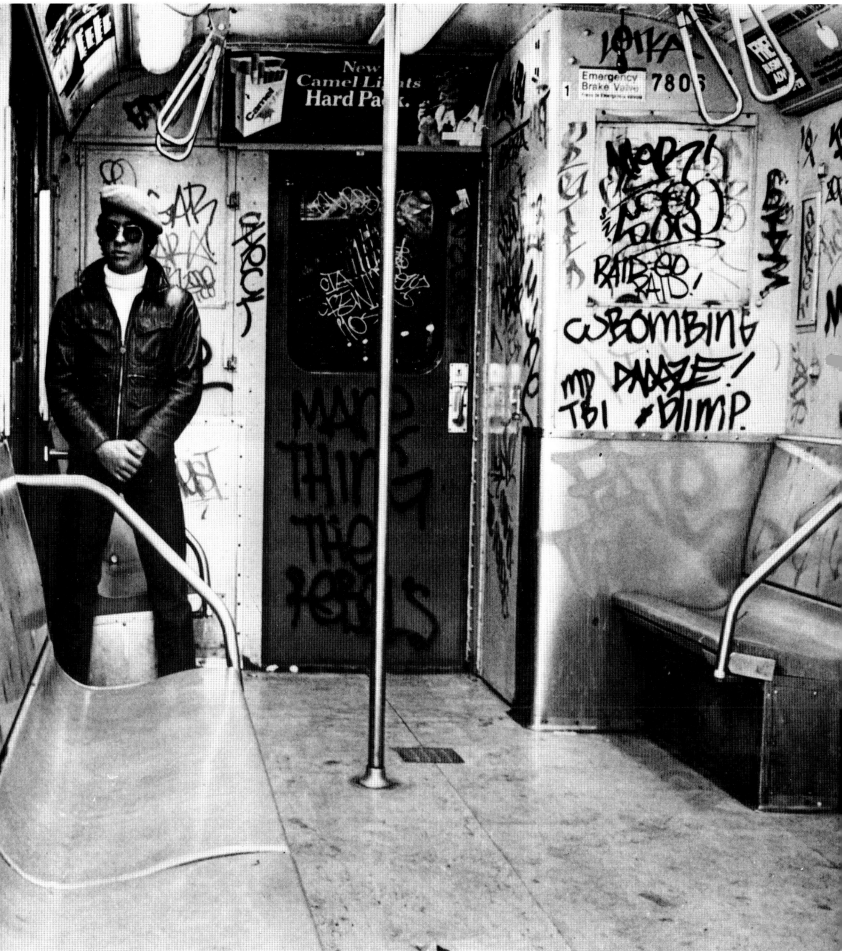

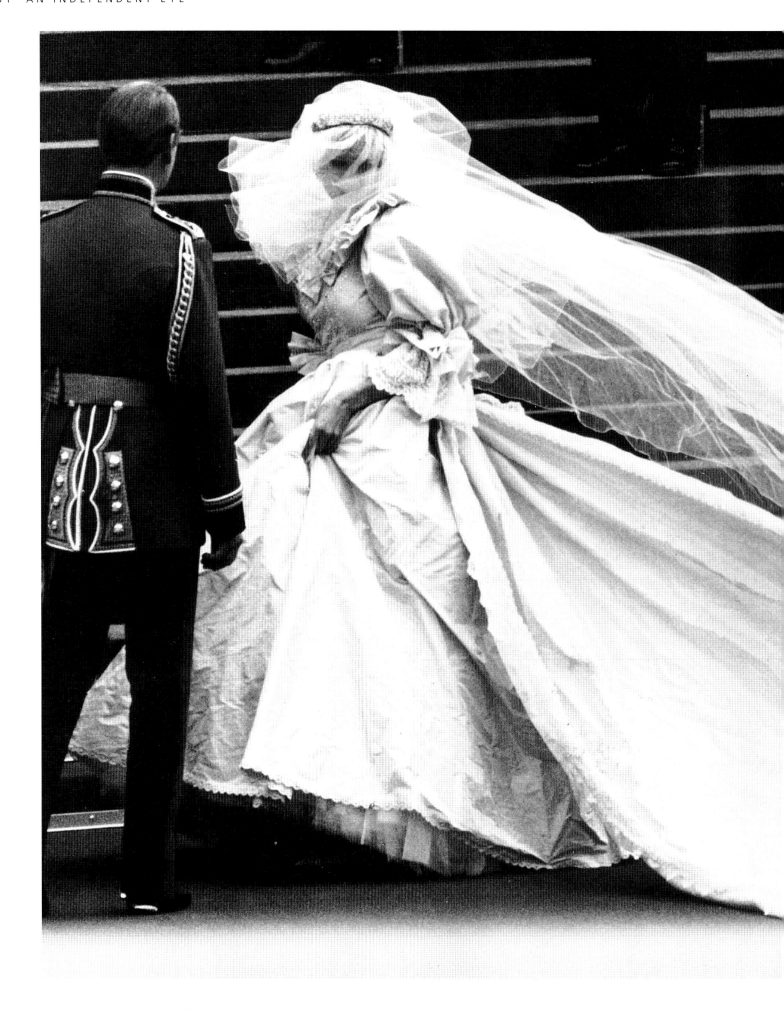

1981

Mrs Thatcher slashes public spending and raises indirect taxation, while unemployment goes above 13 per cent. Labour chooses left-winger Michael Foot as its leader and four prominent members leave to form the Social Democrat Party. There is rioting in Brixton, Southall and Toxteth, Liverpool. IRA hunger striker Bobby Sands dies in jail in Belfast. President Sadat of Egypt is murdered by Islamic fundamentalists. Ronald Reagan and the Pope survive assassination attempts. The US hostages from the Teheran Embassy are released. An attempted right-wing coup in Spain is foiled by King Juan Carlos. IBM introduces a desktop computer to sell alongside Apple's. Aids is officially recognised as a world threat.

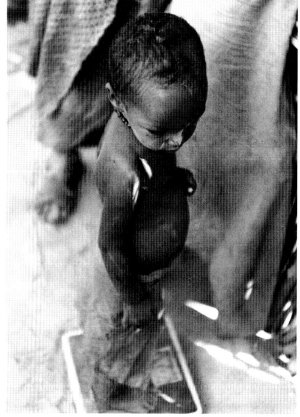

ARTHUR JONES

A gust of wind

*helpfully arranges Princess Diana's long veil
as she pauses to look back (left), at the foot of the steps outside
St Paul's Cathedral, before her wedding. This 19-year-old former
kindergarten assistant is being watched by 1.2 billion as she does
so. Later, just before her divorce from the Prince of Wales, she is
to look back again and ruefully calls hers 'a crowded marriage'.
One of her best legacies is the compassion she displays towards
the sick, the old, and victims worldwide, like this Somali child
displaced from home by war and famine (above).*

1982

Argentina invades the Falklands on 2 April; British troops land on 22 May and enter Port Stanley on 14 June. IRA bombs in Hyde Park and Regent's Park kill soldiers. Israel invades the Lebanon to root out the Palestine Liberation Organisation there after the Israeli ambassador in London is killed. Lebanese allies of Israel massacre Palestinians in Sabra and Chatila camps. Solidarity is outlawed in Poland. Yuri Andropov takes over as Russia's ruler on the death of Leonid Brezhnev.

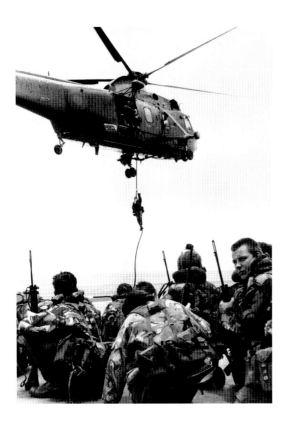

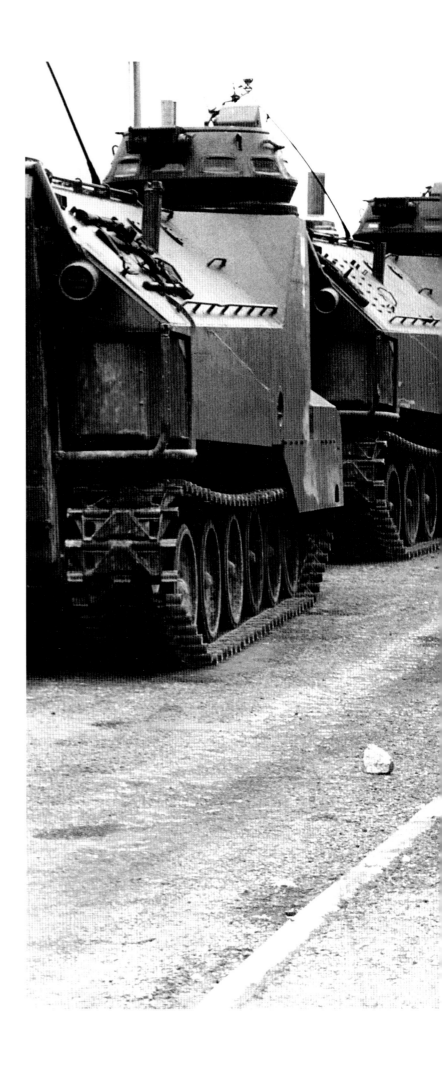

Argentinian armour

lined up in Port Stanley after the invasion of the Falkland Islands (right). Britain responds immediately to this desperate ploy by the struggling military dictatorship of General Galtieri, by sending a naval task force. (Above) Royal marine commandos wait on the deck of the aircraft carrier HMS Hermes before being airlifted ashore by helicopter.

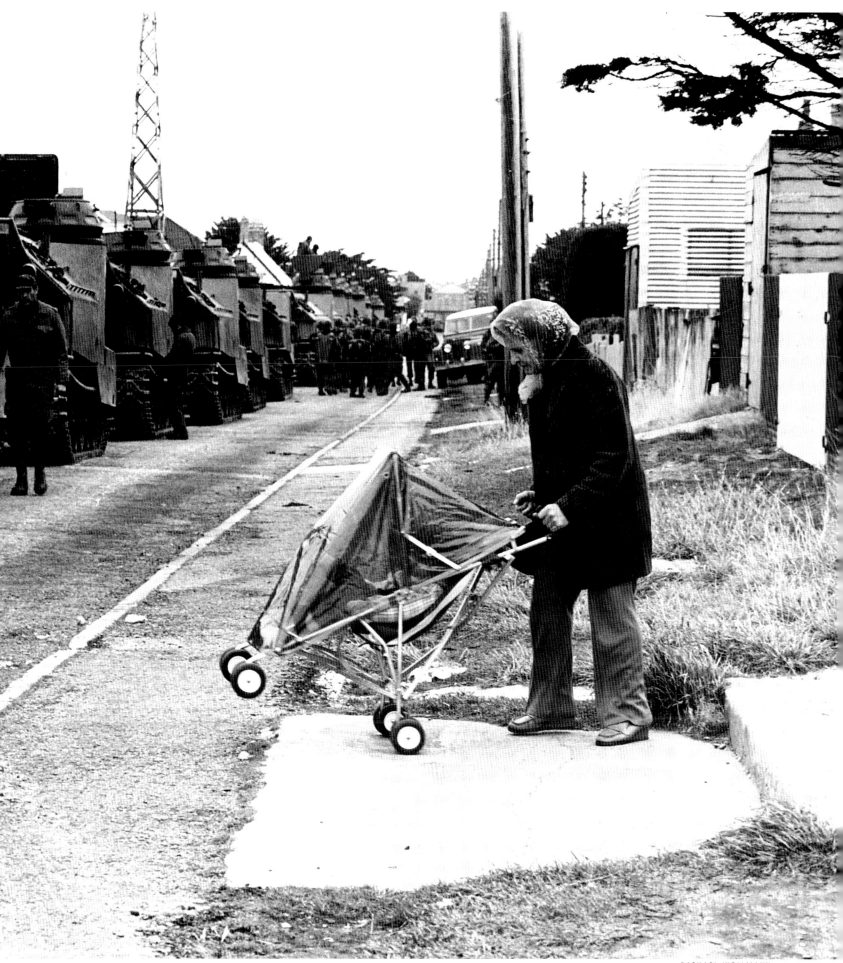

RAPHAEL WOLLMANN

1983

The Conservatives win the General Election and Neil Kinnock replaces Michael Foot as Labour leader. For the first time, Britain becomes a net importer of manufactured goods. Beirut is riven by fighting between different religious and political groups. Hundreds of US and French troops from the UN peacekeeping force are killed by suicide bombers. US Cruise missiles arrive in Britain despite protests. An IRA bomb outside Harrods in London kills five. The IRA also kidnap the racehorse Shergar and it is never seen again.

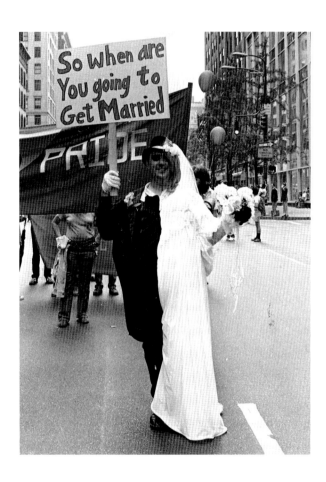

A gay rights march

in New York, with parents of lesbians and gays participating (right). This takes place annually to commemorate the founding of the Gay Alliance after the police attack on the Stonewall Inn, a gay bar in Greenwich Village, in 1969. The figure above seems to be answering the question he holds up on his placard by implying that, with his dual sexuality, he does not have to.

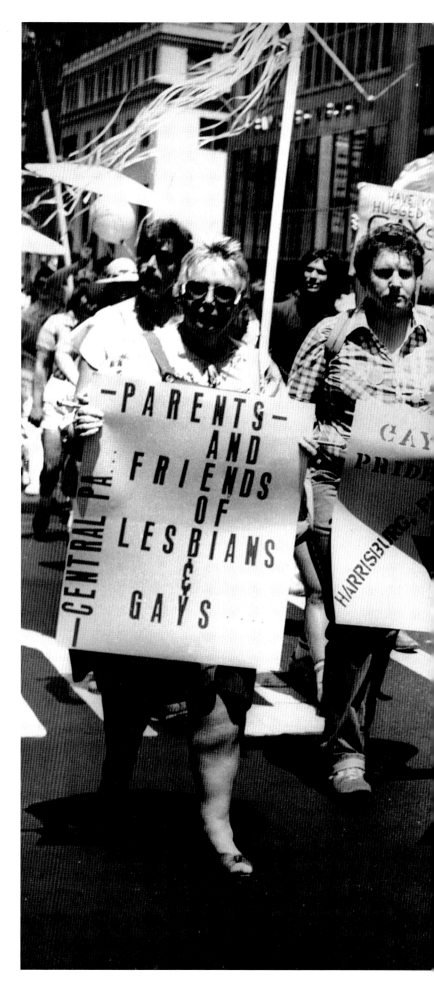

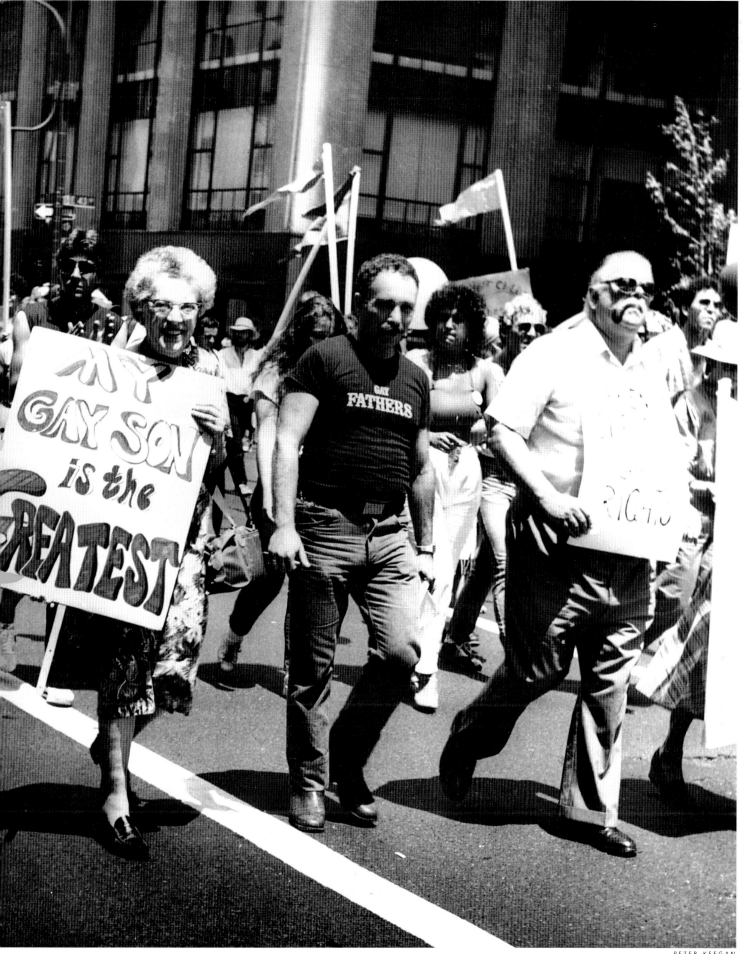

PETER KEEGAN

1984

Eight hundred thousand council houses are sold to their tenants in Britain, and British Telecom becomes the first big state-owned industry to be privatised. An IRA bomb explodes at the Conservative Party Conference in Brighton, killing four. Jerzy Popieluszko, a pro-Solidarity Catholic priest, is murdered by Polish security men. Konstantin Chernenko succeeds Andropov as Russian leader. Mrs Gandhi, the Indian Prime Minister, is killed by her Sikh bodyguards.

Famine in Ethiopia

brought on by war, drought and the outrageous half-baked Marxist regime of President Mengistu, probably kills a million this year (opposite). It is also graphically portrayed on television. The Irish rock singer Bob Geldof (above), formerly of the Boomtown Rats, makes the cause of the starving his own, raising many millions of pounds through records and concerts for his Live Aid charity.

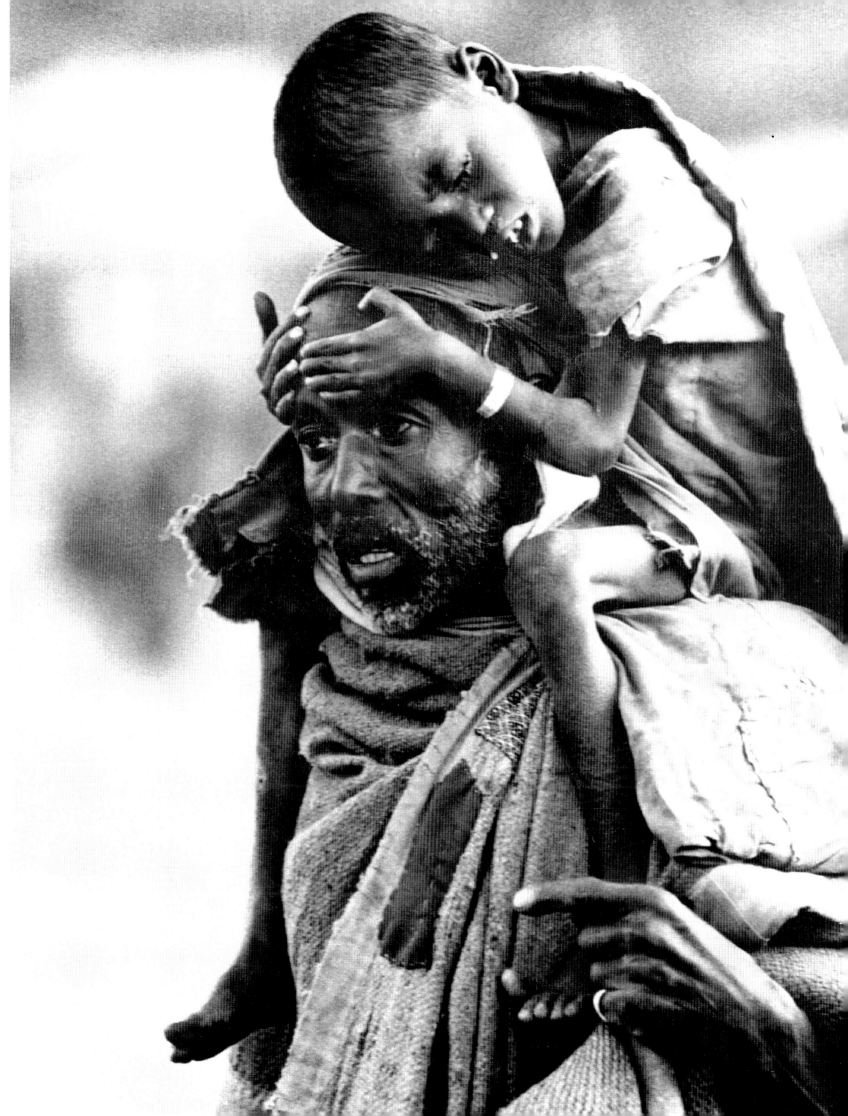

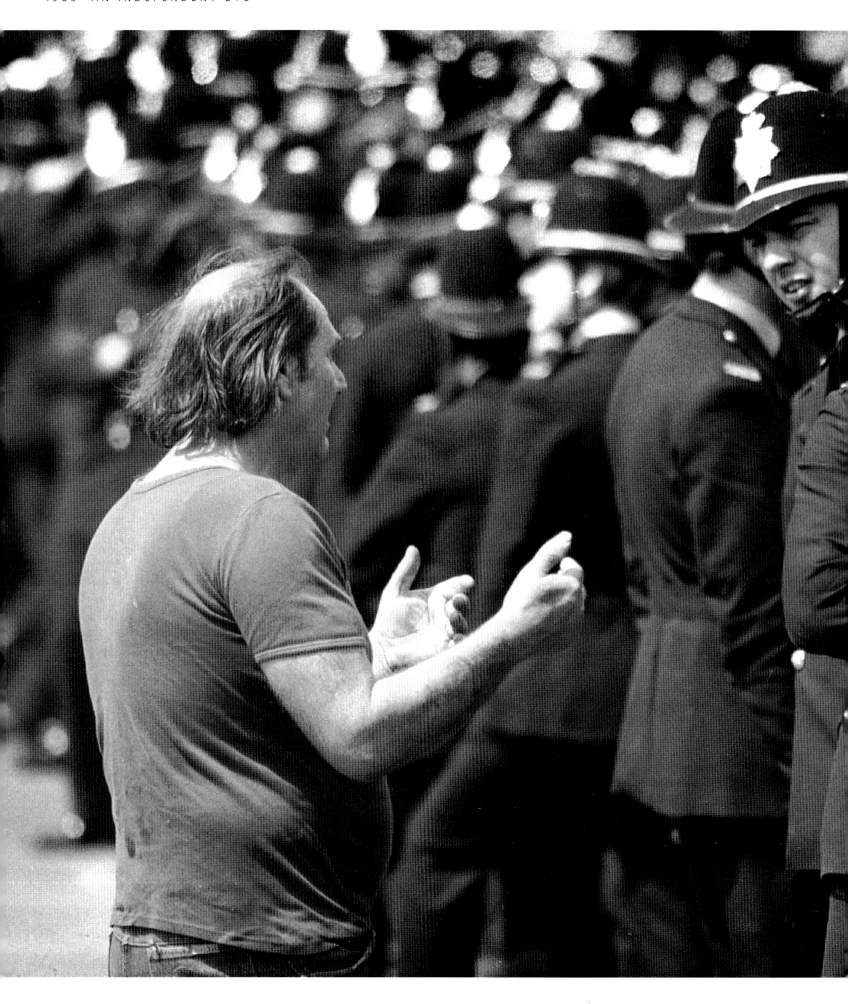

1985

Mikhail Gorbachev becomes the new Soviet leader and has his long 'fireside chat' with President Reagan at the Geneva summit. A fire at Bradford City football ground kills fifty-two and another forty-one are killed in Brussels when Italian and Liverpudlian fans riot. Boris Becker becomes Wimbledon tennis champion, aged seventeen. CDs are replacing vinyl records and cassette tapes.

A striking miner

talks to policemen (left). *Arthur Scargill* (above) *called out his members in March 1984 without balloting them, which immediately alienated the Nottinghamshire pits. The weather was getting warmer, there were big stockpiles of coal at the power stations, the new laws against secondary picketing had teeth, the police response was well coordinated, and long term, natural gas and oil looked well able to take the place of coal. His timing and tactics all wrong, Scargill stares defeat in the face by March this year.*

1986

The 'Westland Affair' leads to the resignation of two Cabinet ministers, Leon Brittan and Michael Heseltine, in a row over financing a new helicopter. The London Stock Exchange reform, the 'Big Bang', takes place. Sacked printers fail to stop Rupert Murdoch producing the *Sun* and *The Times* at his new plant in Wapping. The world's worst nuclear accident takes place at Chernobyl power station in the Ukraine. US planes bomb Libya for supporting terrorism. A space shuttle explodes on take-off, at Cape Canaveral, killing seven astronauts. The Swedish Prime Minister, Olof Palme, is assassinated.

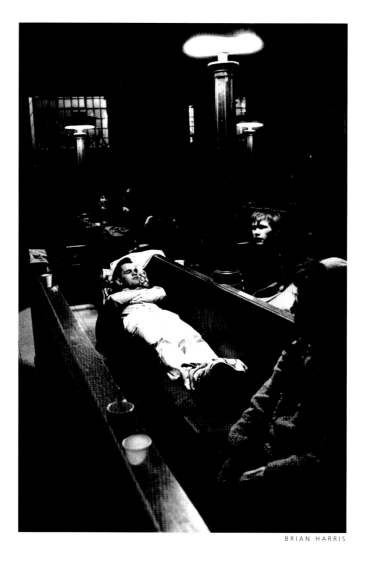

BRIAN HARRIS

An old lady

who has come to take advantage of the charity
offered by the Crisis at Christmas organisation (opposite). *The*
numbers of homeless down-and-outs living on the streets of big cities,
like these young people given a roof over their heads in St James's
Church, Piccadilly (above), *is a cause for concern. Some point the*
finger at an uncaring ethos abroad in Thatcher's Britain; others
give more weight to the fragmentation of the family
under a multitude of pressures.

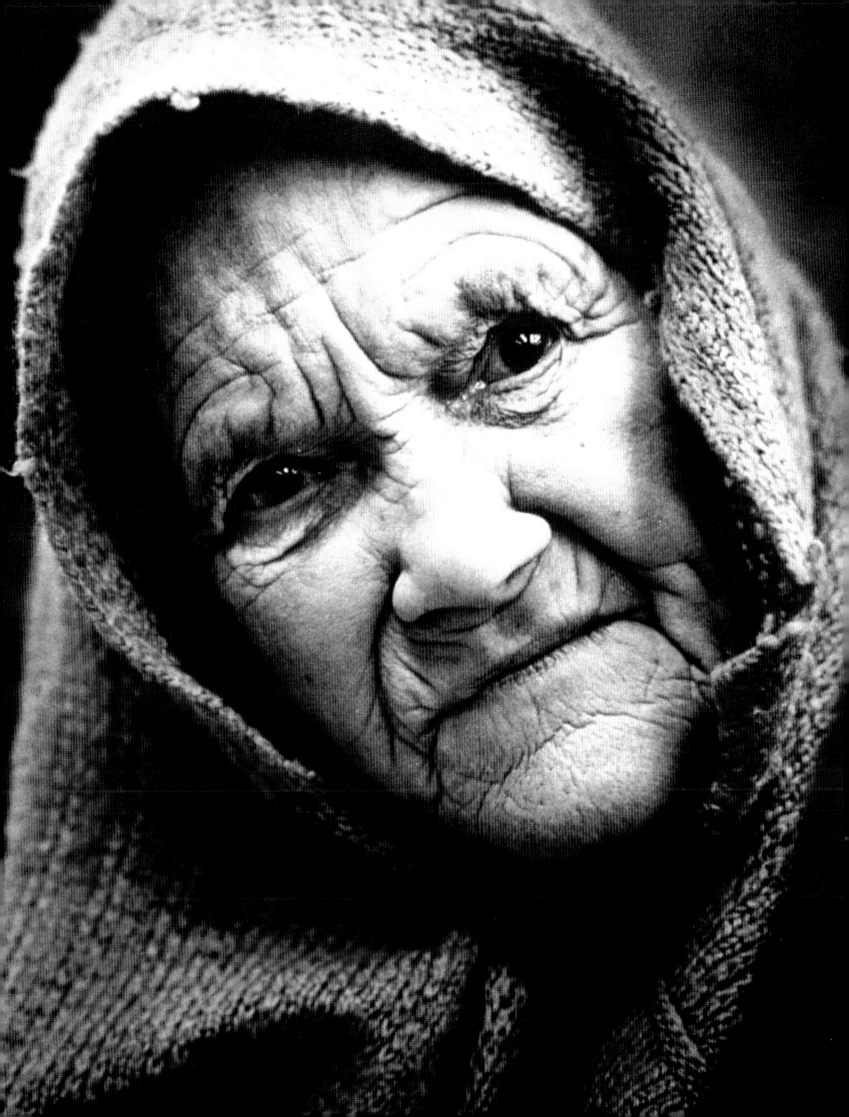

1987

Stock markets round the world collapse on 'Black Monday', 19 October. A fire in King's Cross underground station kills thirty. The 'Great Storm' sweeps southern England. West German Matthias Rust lands his small plane in Moscow's Red Square undetected, giving President Gorbachev the excuse to replace his defence minister with someone willing to back his drive for detente. The USA's 'Irangate' hearings reveal how profits from the sale of arms to Iran are being used to support right-wing Contra rebels in Nicaragua. Reagan and Gorbachev sign the INF Treaty to cut nuclear arms stockpiles.

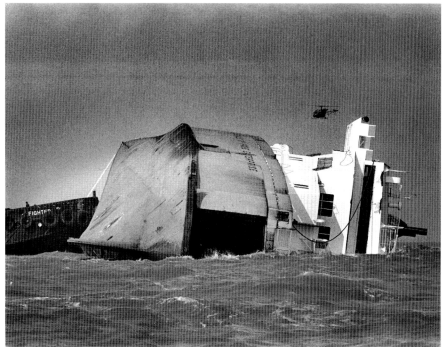

BRIAN HARRIS

The *Herald of Free Enterprise*
lies on a sandbank just outside Zeebrugge harbour in Belgium (above). Failure to shut the loading doors of this roll-on roll-off ferry results in 184 deaths. Given the ship's name, we can see in this a portentous warning about the economic reversal about to hit Britain.

The Conservatives' landslide
victory in the General Election this year sees them win many unlikely seats, but not even the irrepressible Lady Olga Maitland can take the East End stronghold of Bethnal Green and Stepney away from Labour (right).

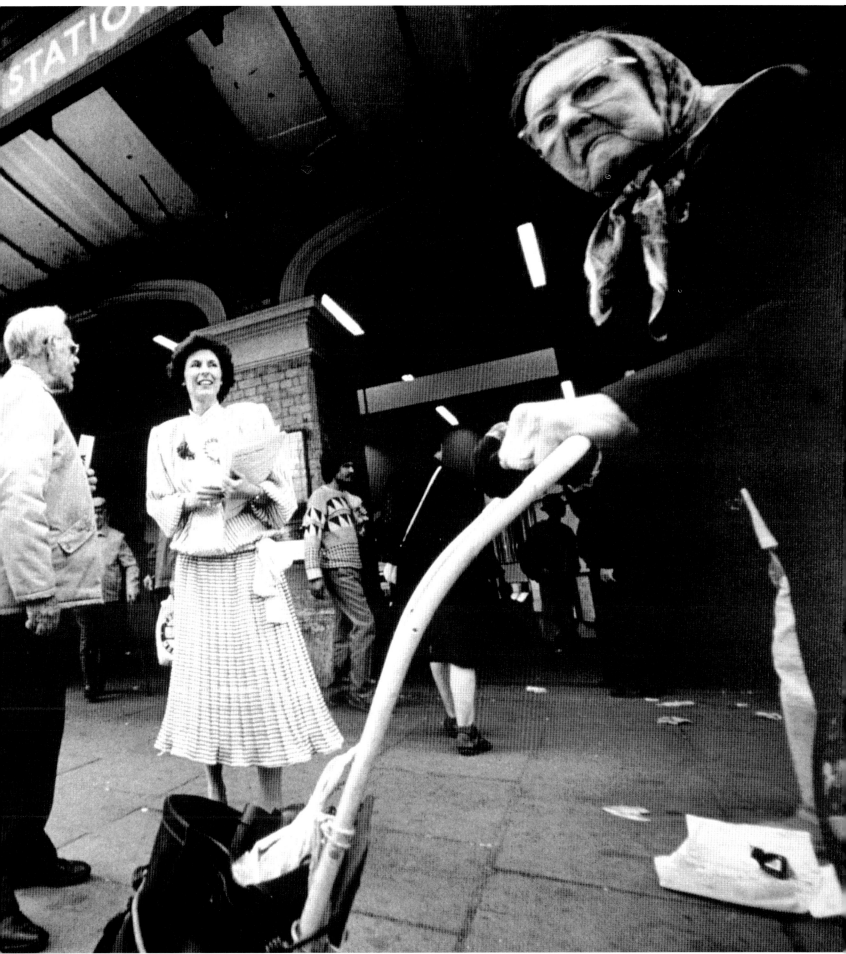

JOHN VOOS

1988

Fire on the Piper Alpha oil rig in the North Sea kills 166. An earthquake in Armenia kills 10,000. The country is also fighting neighbouring Azerbaijan. A US warship shoots down an Iranian airliner by mistake and kills 290. George Bush is elected US President. The Palestinians' Intifada uprising against Israel begins. Pakistan's dictator Zia ul-Haq is killed in a plane crash, allowing Benazir Bhutto to be elected Prime Minister.

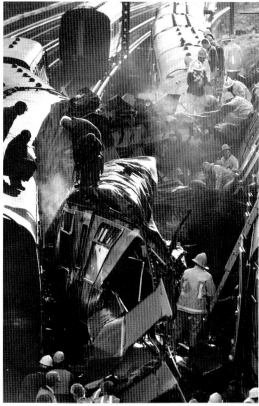

PETER MacDIARMID

Air and rail disasters,
ten days apart. A crash between two rush-hour commuter trains at Clapham Junction in December kills thirty-six people (above). Then a terrorist bomb brings down an American jumbo jet over the Scottish border, killing 270. A victim's foot protrudes from a smashed roof at Lockerbie, where more than forty homes are hit by falling debris (right).

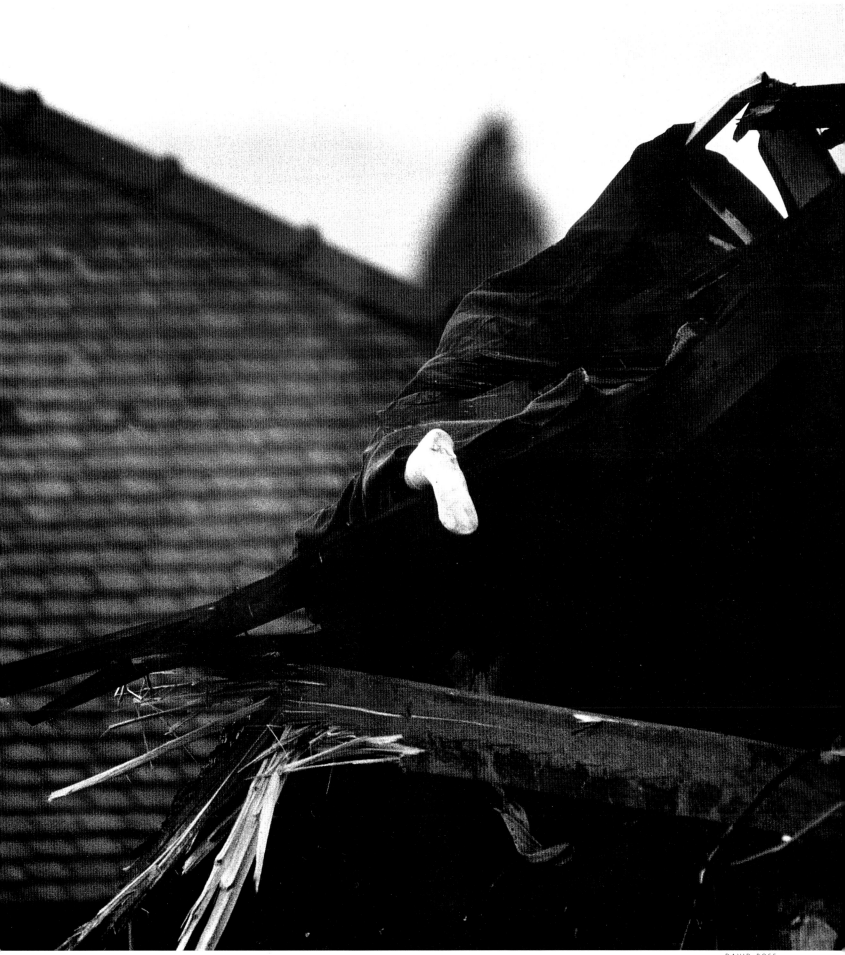

DAVID ROSE

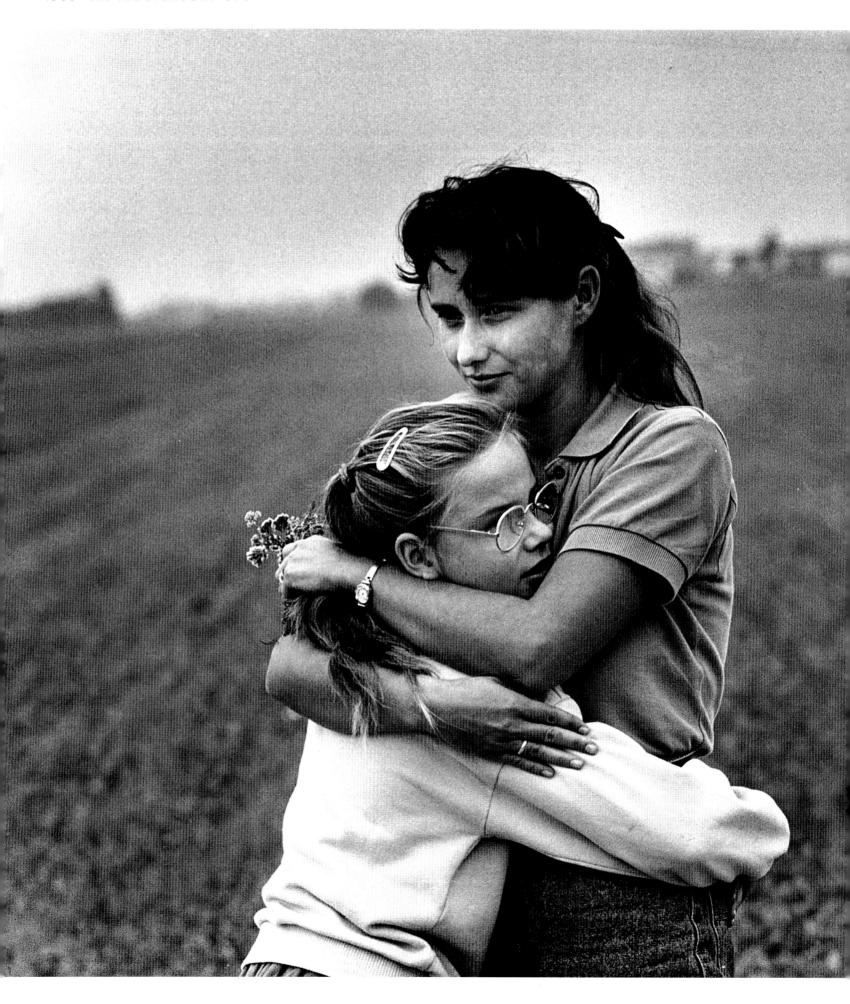

1989

The Hillsborough Stadium disaster in Sheffield results in the death of ninety-five football fans. After nine years' fighting, the last Soviet troops leave Afghanistan. A largely student occupation of Tiananmen Square in Beijing ends in violence when Deng Xiaoping sends in the tanks. Decaying at its heart, the 'Evil Empire' of Soviet-enforced Communist rule in Europe ends peaceably, except in Romania, where President Ceausescu's regime goes down and he and his wife die violently. The new drug Ecstasy powers the 'Chemical Generations' night-long acid-house dancing.

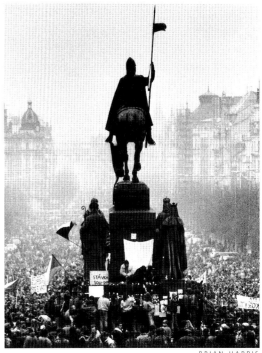

East German refugees,
*safely through the crumbling Iron Curtain,
hug each other on Austrian soil* (left). *Hungary has
opened its borders and so provides a roundabout route
for East Germans to get out to West Germany, via itself
and Austria. The Berlin Wall comes down, making this
detour unnecessary, and then in December the
Czechoslovaks also get rid of their Communists,
and celebrate in Prague's Wenceslaus
Square* (above).

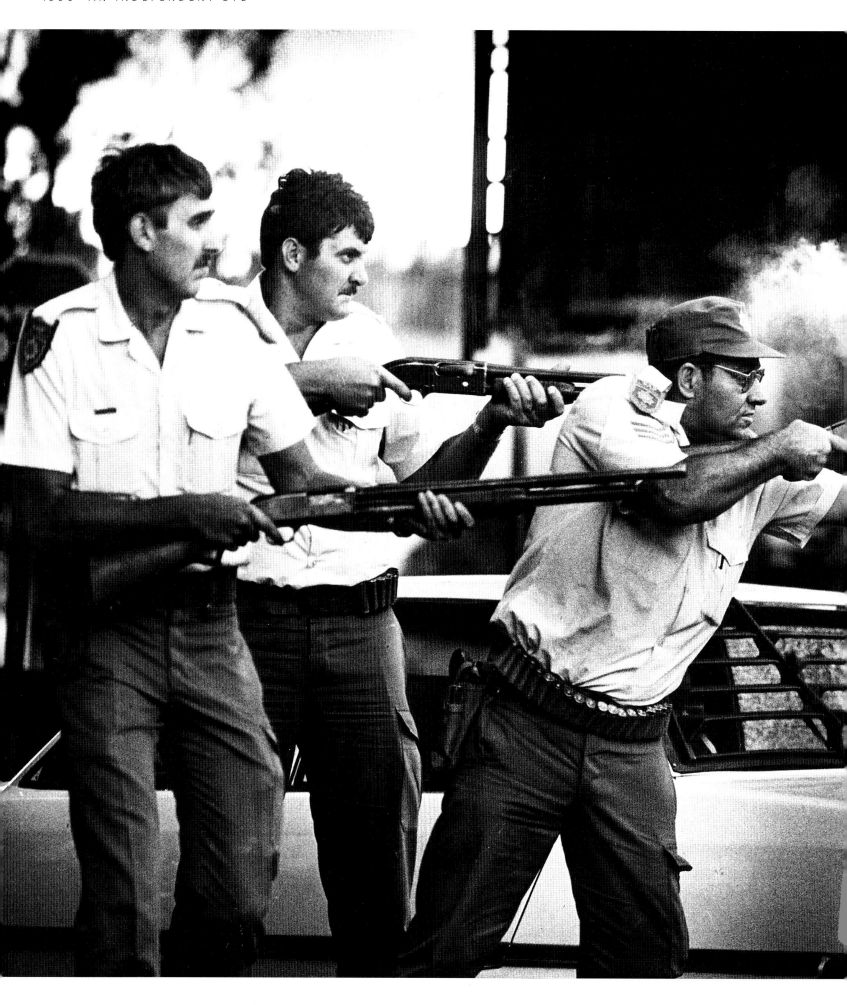

Margaret Thatcher's leadership of the Conservatives is challenged and she is replaced by John Major. The trial of those involved in illegal support of the Guinness Company's share price during its takeover of the Distillers Group in 1986 sends shock waves through the British financial world. West and East Germany are reunited. Lech Walesa is elected President of Poland. Saddam Hussein, dictator of Iraq, invades Kuwait. A massive build-up of US and other forces begins in Saudi Arabia.

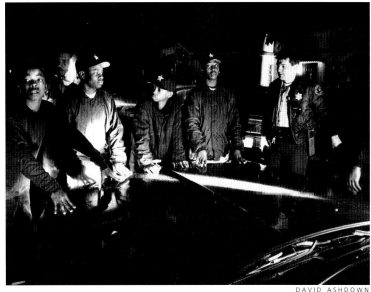

DAVID ASHDOWN

Gang members
in Los Angeles (above) *are made to stand with their hands on a car bonnet (or hood) lit up by another's headlights while police frisk them for weapons. In a city where 70,000 dealers are selling crack cocaine and other drugs, heavily armed hoodlums often have more firepower than the cops, so this is a very necessary precaution.*

South African police
fire pump-action shotguns at demonstrators on the day of Nelson Mandela's release after twenty-seven years in prison (left). *His African National Congress will soon begin negotiations with President F. W. de Klerk.*

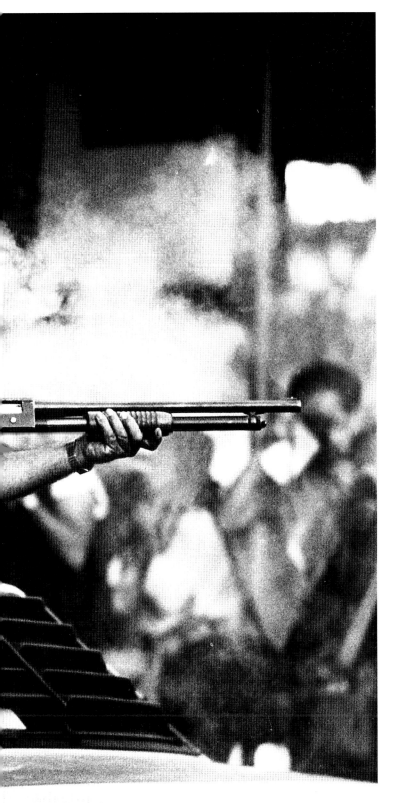

JON JONES

189

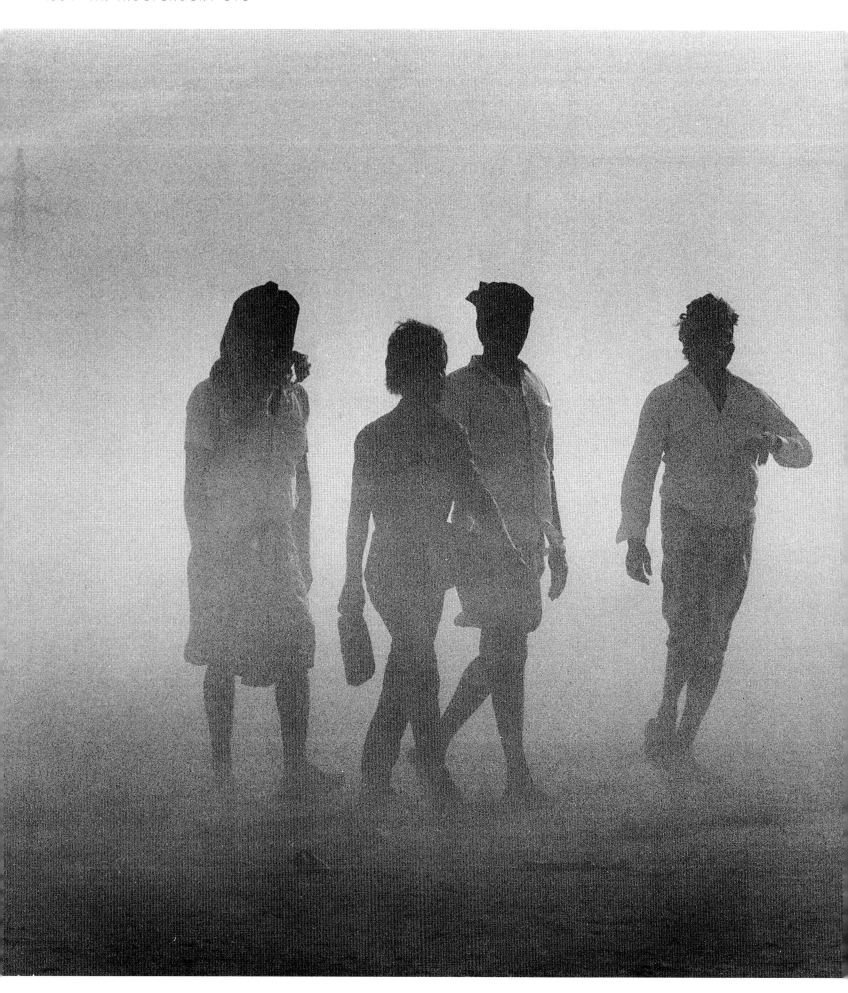

1991

Saddam Hussein ignores the United Nations deadline for withdrawal from Kuwait and Operation 'Desert Storm' begins on 16 January, ending on 28 February with total Iraqi defeat. Saddam then subdues rebelling Kurds in the north and Shias in the south of his country. Slovenia and Croatia break away from Yugoslavia. Serbs are soon fighting Croats. Hardline Russian Communists stage a coup against Gorbachev, but Boris Yeltsin rallies the forces of reform. The former republics within the USSR declare their independence and the Communist Party is disbanded.

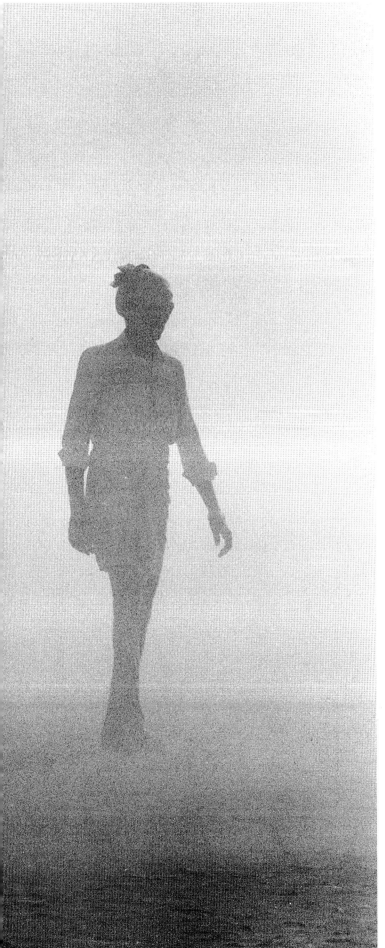

BRIAN HARRIS

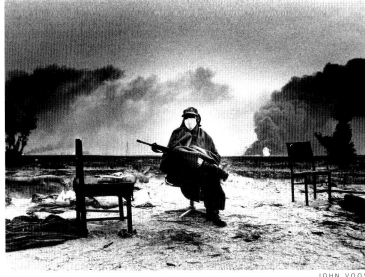

JOHN VOOS

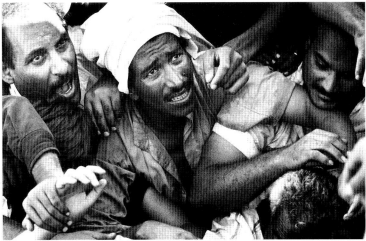

BRIAN HARRIS

Burning oil wells,
deliberately set on fire in Kuwait by the retreating Iraqis,
blot out the desert sun with a pall of smoke (left and top).
Saddam Hussein has also ordered oil to be pumped into the Gulf
to prevent an amphibious landing. The environmental damage
and the human misery brought about by his regime – evident
on these faces at a feeding station for those caught in
no man's land (above) – *is incalculable.*

1992

The Conservatives win their fourth General Election in a row and John Smith replaces Neil Kinnock as Labour leader. Britain is forced to devalue its currency and leave the European Exchange Rate Mechanism. The Queen endures her *annus horribilis* with the Duke of York, the Princess Royal and the Prince of Wales divorcing or separating, and a devastating fire at Windsor Castle. Bill Clinton beats George Bush in the US Presidential election. Bosnia-Herzegovina declares independence and Serbs begin 'ethnic cleansing' there while besieging the capital of Sarajevo.

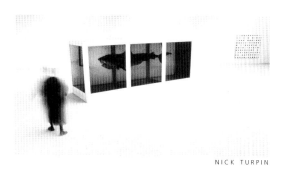

NICK TURPIN

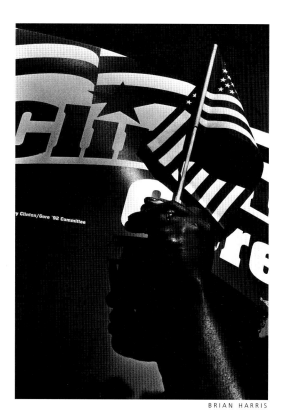

BRIAN HARRIS

Visitors at the Tate Gallery

warily circle Anish Kapoor's Untitled *(right), working out why he won last year's Turner Prize. Showman and restaurateur Damien Hirst's shark in formaldehyde (top) is one of a number of pickled animals and parts he will have signed by the time he wins the prize in 1995. As he says, 'It's amazing what you can do with an E in A-level art, a twisted imagination and a chainsaw.' The flags and flyers for the Clinton/Gore Democratic Presidential campaign (above) hark back to the good old days of Pop Art.*

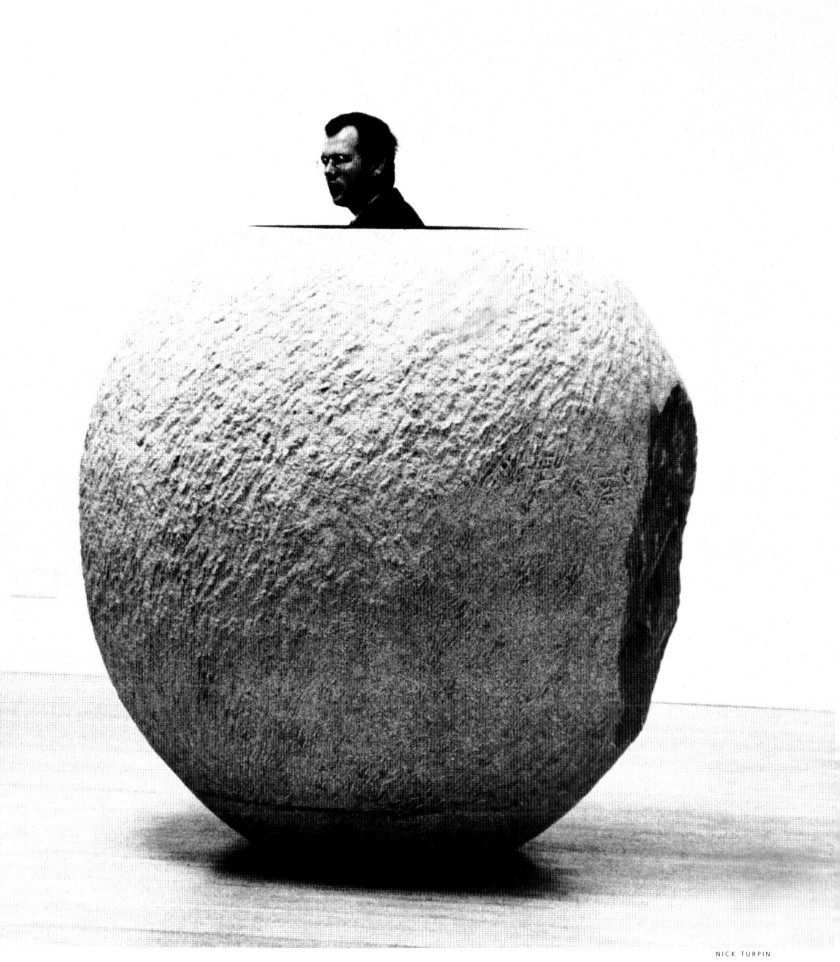

NICK TURPIN

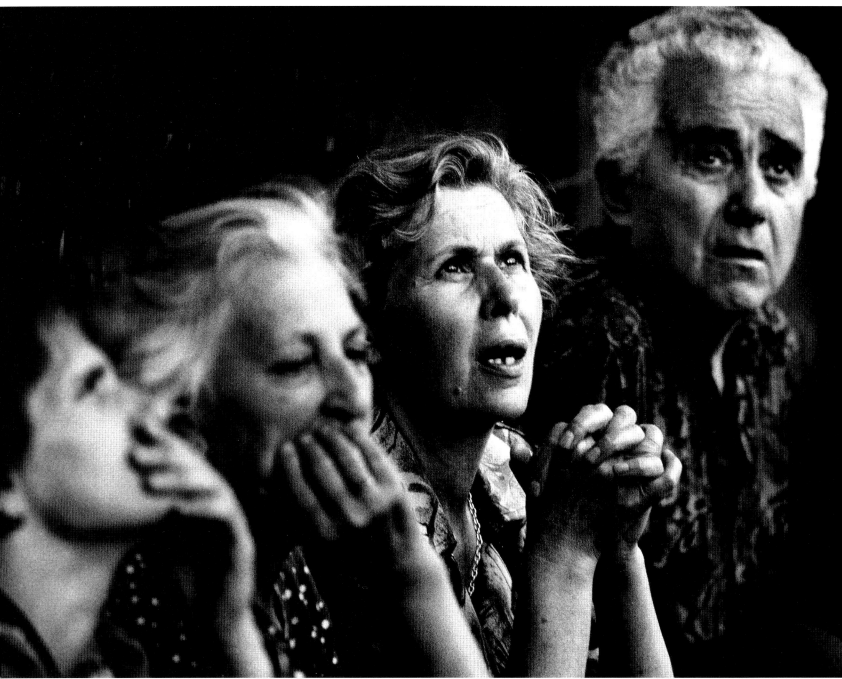

THIS SEQUENCE TOM PILSTON

1993

Britain ratifies the Maastricht Treaty which greatly accelerates the centralising tendency of the EC, now the European Union. Pro- and anti-reform groups struggle for control of Russia, culminating in Yeltsin ordering tanks to bombard the White House parliament building. The siege of the Branch Davidian sect at Waco in Texas is badly mishandled, resulting in seventy-two deaths. Israel and Palestine sign a peace agreement in Washington. Czechoslovakia splits into the Czech and Slovak Republics. Mobile phones become hugely popular and the Internet is up and running.

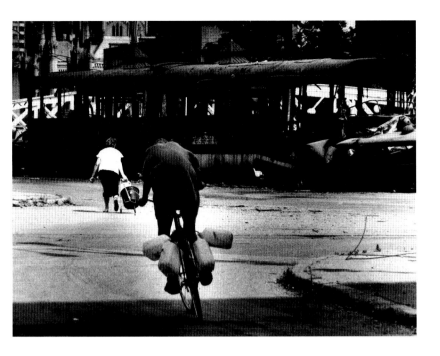

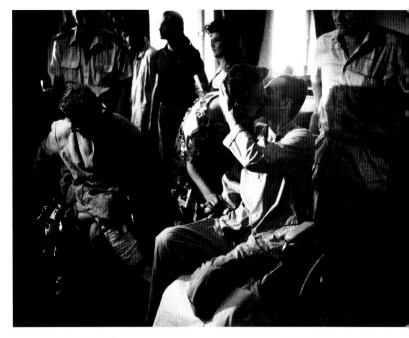

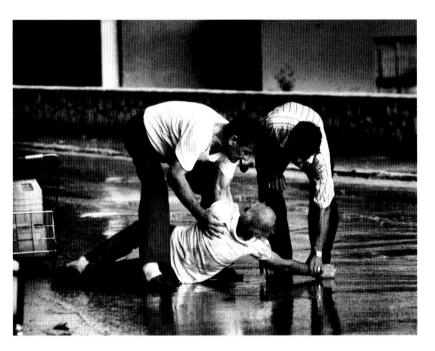

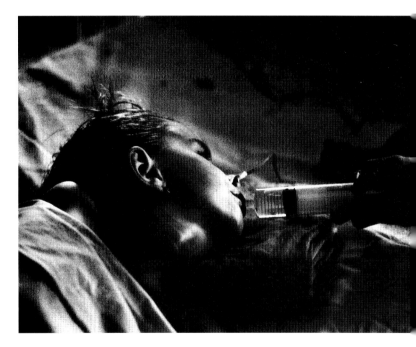

Fear in Sarajevo.
*People queuing for water look up apprehensively at the sound of a
sniper's shot (opposite). With plastic water containers tied to his bicycle a
Sarajevan pedals hard across open ground (top left). A policeman who has lost an arm
and a leg in a grenade attack kisses his bride after his marriage in hospital (top right). Five-
year-old Irma, paralysed from the neck down by a fragment of a mortar bomb, is fed by
syringe shortly before she is transferred to London's Great Ormond Street Hospital
after the intervention of John Major (above right). A man weak from hunger
is helped by passers-by (above left).*

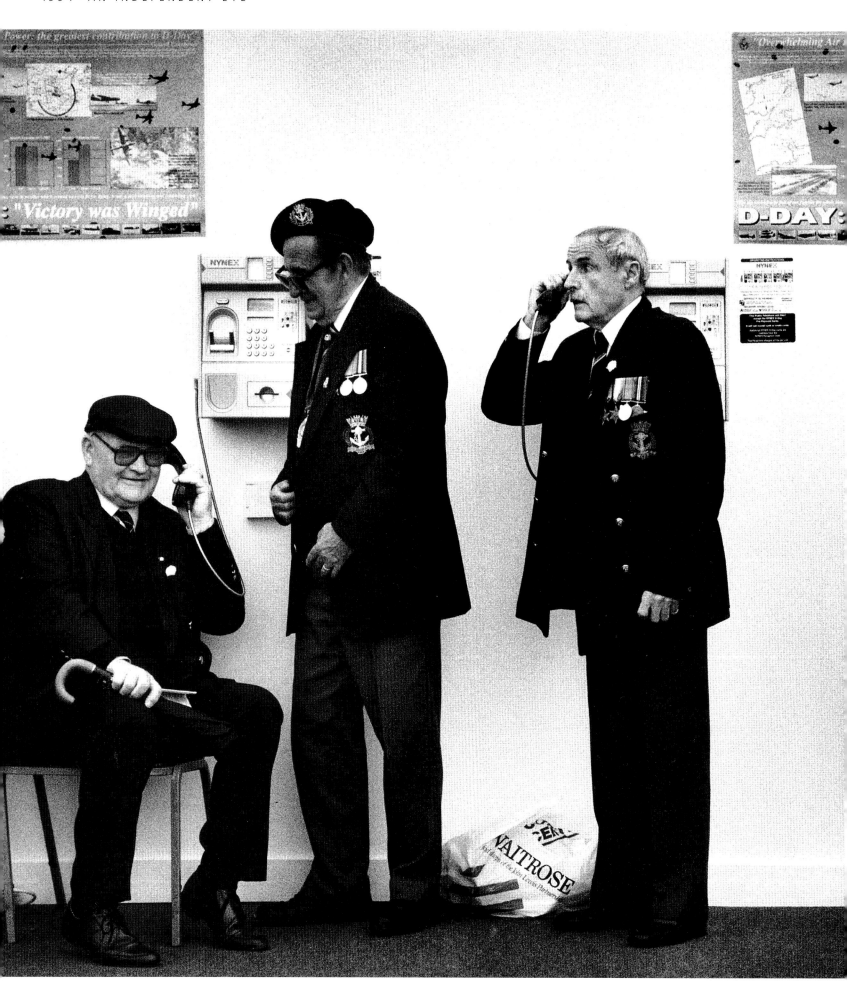

1994

The Channel Tunnel is opened. The death of John Smith gives Tony Blair the leadership of the Labour Party. The IRA announce a ceasefire in Northern Ireland. Up to half a million, mostly Tutsi, Rwandans are massacred and 1½ million become refugees. The first multi-racial elections are held in South Africa and Nelson Mandela becomes President. Britain's first National Lottery draw is held. Steven Spielberg wins an Oscar for *Schindler's List*.

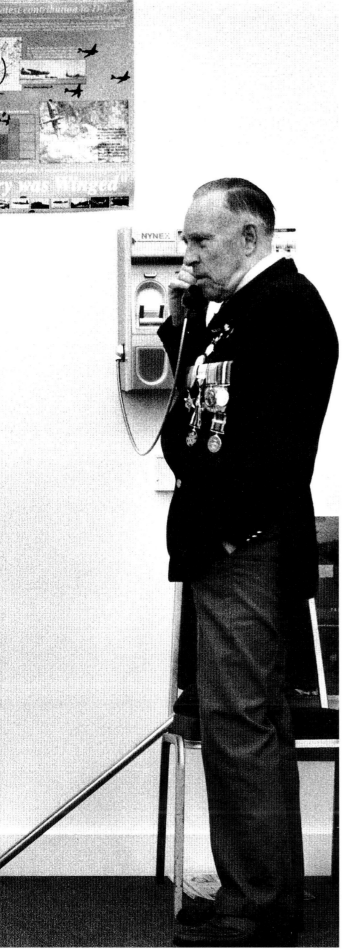

DAVID ROSE

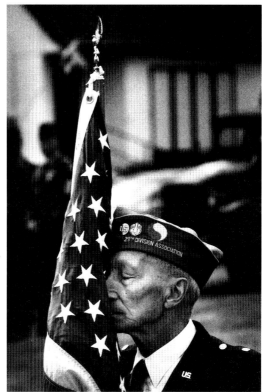

TOM PILSTON

An American D-Day veteran
closes his eyes and perhaps remembers his dead comrades who never made it off Omaha Beach in Normandy on 6 June, fifty years ago.

British veterans
ring their wives from Portsmouth before setting out across the Channel for the commemorations in Normandy.

1995

An employee of Barings bank loses £620 million in the Singapore futures market, which leads to the collapse of the bank. A peace treaty is signed by the warring factions in Bosnia. Russian forces do badly against Chechen nationalists in the Caucasus. America is shocked by the right-wing extremist bombing of a Federal building in Oklahoma. Among the many victims are children aged between one and seven. Israeli Prime Minister Yitzhak Rabin is assassinated by a Jewish extremist. An earthquake in Kobe, Japan, kills 5,000 and destroys over 100,000 buildings. *Pulp Fiction* and *Four Weddings and a Funeral* are the popular films.

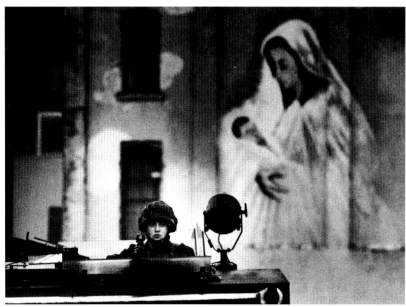

TOM PILSTON

A ceasefire maybe,
*but the Army still has a presence on the
Falls Road in Belfast, with a mural of the Virgin
and Child as a backdrop.*

No flash cars
*with which to pull the girls in Cuba,
in fact very few cars at all in this embattled Socialist
dictatorship, deserted by its erstwhile Soviet
allies and under economic blockade
from the USA.*

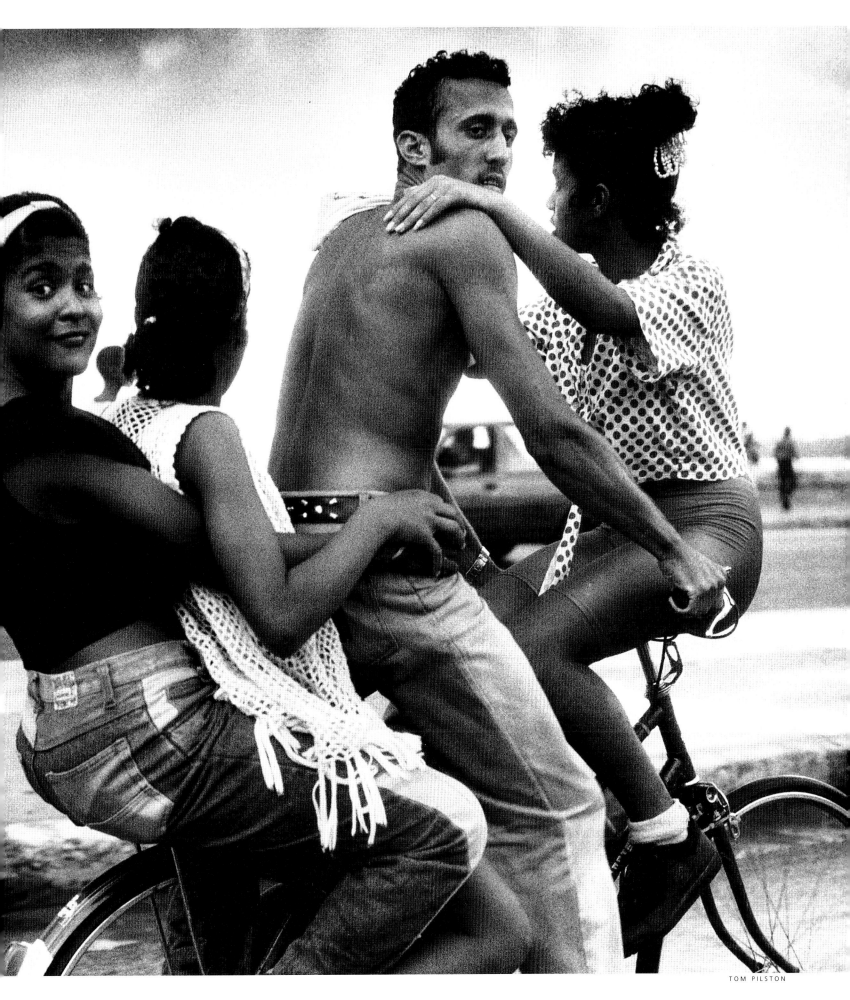

TOM PILSTON

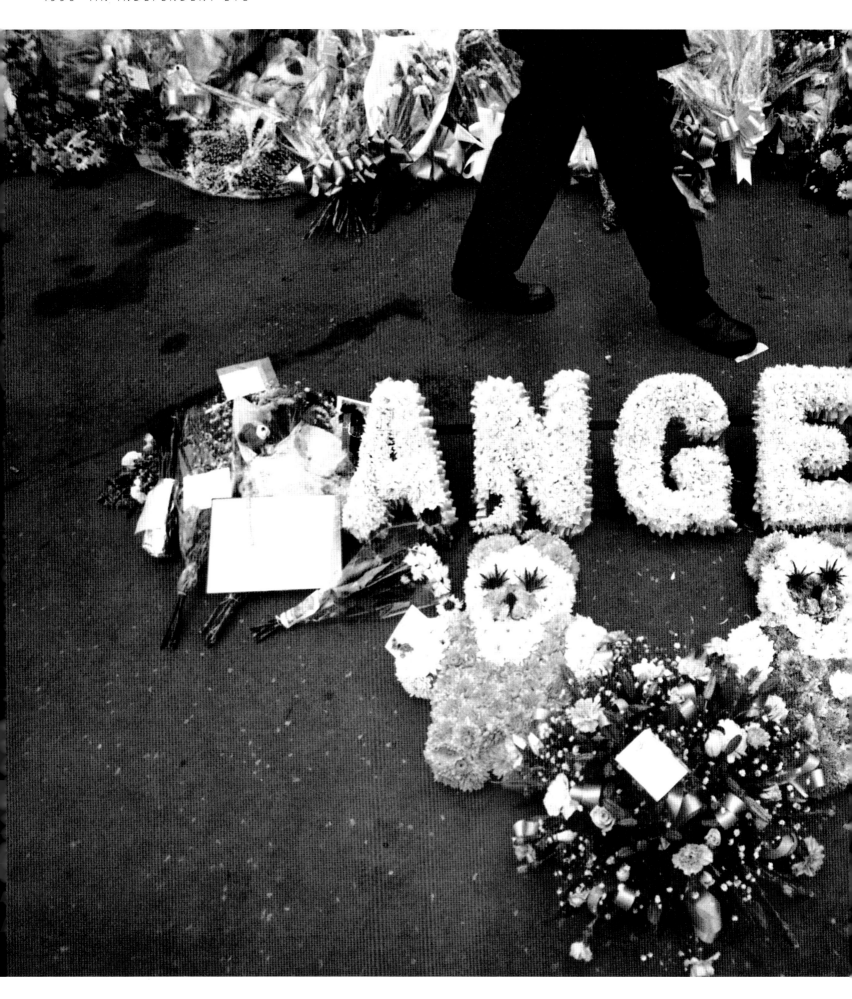

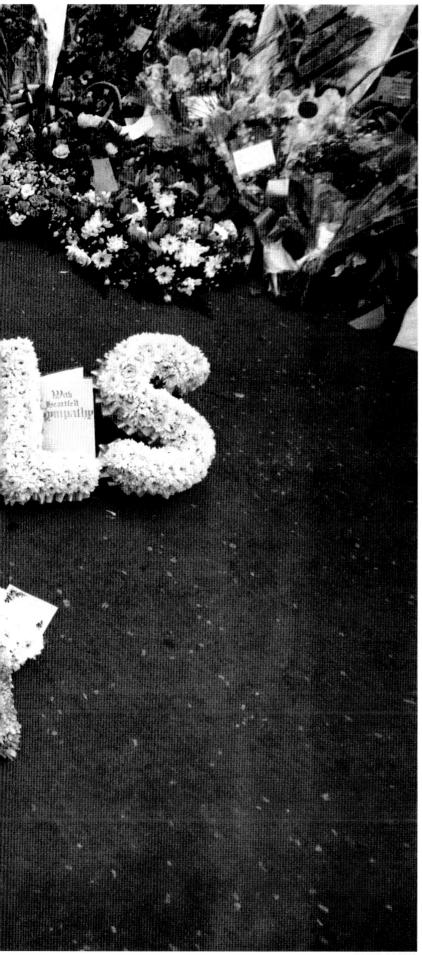

BRIAN HARRIS

1996

A government warning is given about BSE, the 'mad cow disease', spreading to humans, sparking a crisis in the British beef industry. The IRA cease-fire ends with bombs in London's Docklands and Manchester city centre. The Chechnya–Russia war ends in victory for the Chechens. Taliban funda-mentalists control much of Afghanistan including Kabul. Bill Clinton is re-elected as US President and Benjamin Netanyahu takes control in Israel with his hawkish Likud Party.

Sixteen children and a teacher
are killed by a crazed gunman at Dunblane Primary School in Scotland. He then kills himself. Flowers and wreaths are left by mourners trying to express their grief and assuage their shock. In response to public pressure, the Government later bans all handguns.

1997

Tony Blair becomes Prime Minister with a Labour majority of 179 seats in the British General Election. In the Devolution referendums Scotland and Wales vote for separate assemblies. William Hague succeeds John Major as Conservative leader. The IRA ceasefire is renewed and its representatives enter peace talks. Princess Diana is killed in a car crash in Paris. Hong Kong is handed back to the Chinese. Laurent Kabila ousts General Mobutu from Zaire. Deng Xiaoping dies, aged ninety-two, and Jiang Zemin becomes the leading figure in China.

BRIAN HARRIS

The ghostly hoofprint
of a cow or bullock stands for the many
thousands of beasts being slaughtered in a
desperate gesture to try and dispel the fears
aroused by the BSE beef scare.

A hunt saboteur
raises his stick and a huntsman
his whip in a confrontation. In July a
pro-hunting rally in Hyde Park attracts 100,000
mostly country people, many who have never
followed hounds on horseback, but all
passionately opposed to the threat to their
way of life which they see in the new
private member's bill to ban the sport.
In 1998 300,000 will march through
London for the same cause,
and the bill will fail.

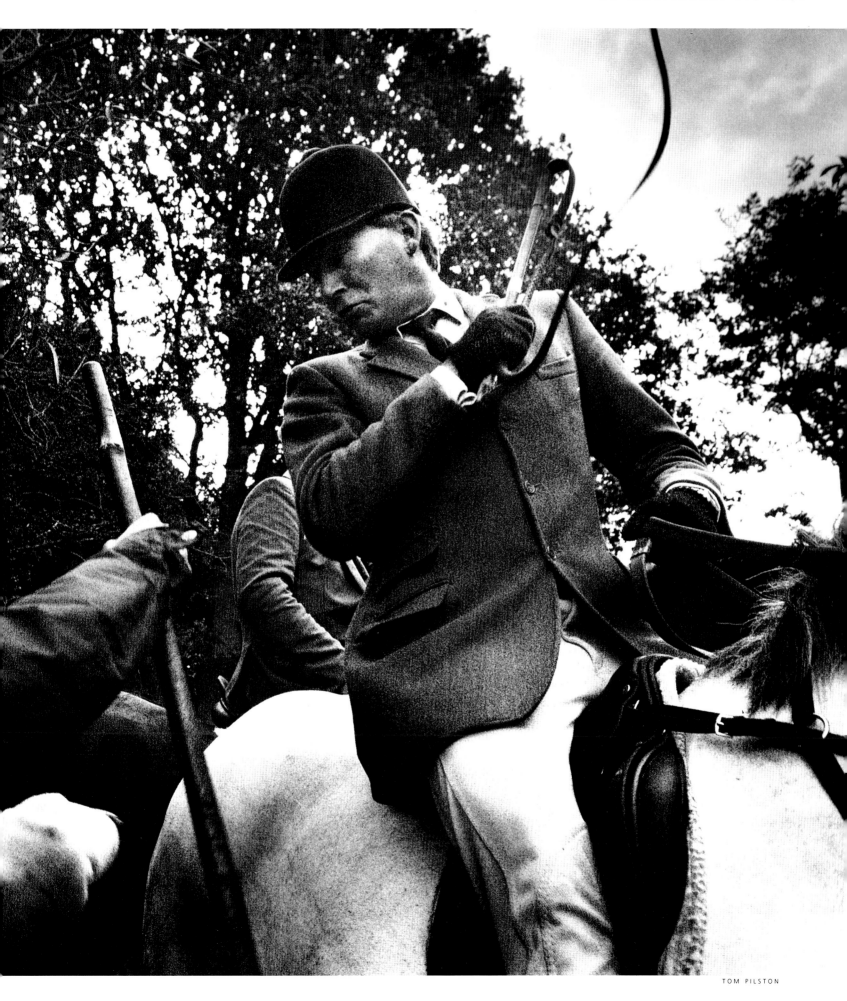

TOM PILSTON

1998

A Northern Ireland peace agreement is brokered and then endorsed by a referendum there and in the Republic. President Clinton continues to be dogged by accusations of sexual scandal, with Monica Lewinsky replacing Paula Jones as the biggest threat to his reputation. The 'Tiger Economies' of South-East Asia fall one after another into recession and this brings an end to the long dictatorship of President Suharto of Indonesia. The Nigerian dictator General Abacha dies. India and then Pakistan carry out nuclear weapons tests. In Kosovo in former Yugoslavia there is fighting between the Albanian majority and the Serbs. Weather patterns around the globe are disturbed by the activities of the Pacific current El Niño, increasing fears of global warming.

A Lapland forest,

and the encroachment of man upon it,
is turned into a warning of what can be lost by the
Finnish photographer Jorma Puranen. 'A closed museum'
is the translation of the elegantly lettered Latin in the
foreground, reminding us of the animal and plant
species that may disappear, or never be discovered,
because of the destruction of their habitat.

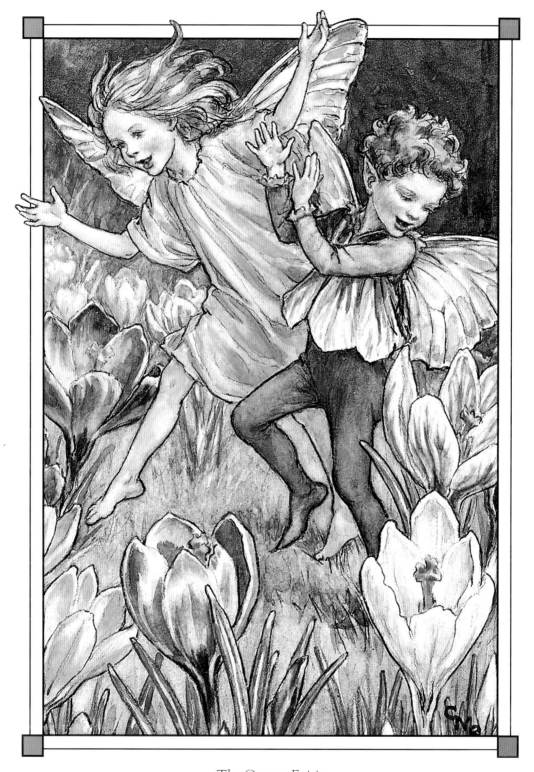

The Crocus Fairies

THE SONG OF
THE COLT'S-FOOT FAIRY

The winds of March are keen and cold;
I fear them not, for I am bold.

I wait not for my leaves to grow;
They follow after: they are slow.

My yellow blooms are brave and bright;
I greet the Spring with all my might.

THE SONG OF
THE CELANDINE FAIRY

Before the hawthorn leaves unfold,
Or buttercups put forth their gold,
By every sunny footpath shine
The stars of Lesser Celandine.

THE SONG OF
THE DANDELION FAIRY

Here's the Dandelion's rhyme:
 See my leaves with tooth-like edges;
Blow my clocks to tell the time;
 See me flaunting by the hedges,
In the meadow, in the lane,
 Gay and naughty in the garden;
Pull me up—I grow again,
 Asking neither leave nor pardon.
Sillies, what are you about
 With your spades and hoes of iron?
You can never drive me out—
 Me, the dauntless Dandelion!

THE SONG OF
THE PRIMROSE FAIRY

The Primrose opens wide in spring;
 Her scent is sweet and good:
It smells of every happy thing
 In sunny lane and wood.
I have not half the skill to sing
 And praise her as I should.

She's dear to folk throughout the land;
 In her is nothing mean:
She freely spreads on every hand
 Her petals pale and clean.
And though she's neither proud nor grand,
 She is the Country Queen.

The Primrose Fairy

THE SONG OF
THE LADY'S-SMOCK FAIRY

Where the grass is damp and green,
Where the shallow streams are flowing,
Where the cowslip buds are showing,
 I am seen.

Dainty as a fairy's frock,
White or mauve, of elfin sewing,
'Tis the meadow-maiden growing—
 Lady's-smock.

THE SONG OF
THE LARCH FAIRY

Sing a song of Larch trees
 Loved by fairy-folk;
Dark stands the pinewood,
 Bare stands the oak,
But the Larch is dressed and trimmed
 Fit for fairy-folk!

Sing a song of Larch trees,
 Sprays that swing aloft,
Pink tufts, and tassels
 Grass-green and soft:
All to please the little elves
 Singing songs aloft!

THE SONG OF
THE WILLOW-CATKIN FAIRY

The people call me Palm, they do;
They call me Pussy-willow too.
And when I'm full in bloom, the bees
Come humming round my yellow trees.

The people trample round about
And spoil the little trees, and shout;
My shiny twigs are thin and brown:
The people pull and break them down.

To keep a Holy Feast, they say,
They take my pretty boughs away.
I should be glad—I should not mind—
If only people weren't unkind.

Oh, you may pick a piece, you may
(So dear and silky, soft and grey);
But if you're rough and greedy, why
You'll make the little fairies cry.

(This catkin is the flower of the Sallow Willow.)

THE SONG OF
THE DOG-VIOLET FAIRY

The wren and robin hop around;
 The Primrose-maids my neighbours be;
The sun has warmed the mossy ground;
Where Spring has come, I too am found:
 The Cuckoo's call has wakened me!

THE SONG OF
THE DAFFODIL FAIRY

I'm everyone's darling: the blackbird and
 starling
Are shouting about me from blossoming
 boughs;
For I, the Lent Lily, the Daffy-down-dilly,
Have heard through the country the call to
 arouse.
The orchards are ringing with voices
 a-singing
The praise of my petticoat, praise of my
 gown;
The children are playing, and hark! they are
 saying
That Daffy-down-dilly is come up to town!

THE SONG OF
THE DAISY FAIRY

Come to me and play with me,
 I'm the babies' flower;
Make a necklace gay with me,
Spend the whole long day with me,
 Till the sunset hour.

I must say Good-night, you know,
 Till tomorrow's playtime;
Close my petals tight, you know,
Shut the red and white, you know,
 Sleeping till the daytime.

THE SONG OF
THE WINDFLOWER FAIRY

While human-folk slumber,
 The fairies espy
Stars without number
 Sprinkling the sky.

The Winter's long sleeping,
 Like night-time, is done;
But day-stars are leaping
 To welcome the sun.

Star-like they sprinkle
 The wildwood with light;
Countless they twinkle—
 The Windflowers white!

("Windflower" is another name for Wood Anemone.)

The Daisy Fairy

THE SONG OF
THE BLUEBELL FAIRY

My hundred thousand bells of blue,
 The splendour of the Spring,
They carpet all the woods anew
With royalty of sapphire hue;
The Primrose is the Queen, 'tis true.
 But surely I am King!
 Ah yes,
 The peerless Woodland King!

Loud, loud the thrushes sing their song;
 The bluebell woods are wide;
My stems are tall and straight and strong;
From ugly streets the children throng,
They gather armfuls, great and long,
 Then home they troop in pride—
 Ah yes,
 With laughter and with pride!

(This is the Wild Hyacinth. The Bluebell of Scotland is the Harebell.)

THE SONG OF
THE STITCHWORT FAIRY

I am brittle-stemmed and slender,
But the grass is my defender.

On the banks where grass is long,
I can stand erect and strong.

All my mass of starry faces
Looking up from wayside places,

From the thick and tangled grass,
Gives you greeting as you pass.

(A prettier name for Stitchwort is Starwort, but it is not so often used.)

THE SONG OF
THE WOOD-SORREL FAIRY

In the wood the trees are tall,
 Up and up they tower;
You and I are very small—
 Fairy-child and flower.

Bracken stalks are shooting high,
 Far and far above us;
We are little, you and I,
 But the fairies love us.

THE SONG OF
THE LORDS-AND-LADIES FAIRY

Here's the song of Lords-and-Ladies
 (in the damp and shade he grows):
I have neither bells nor petals,
 like the foxglove or the rose.
Through the length and breadth of England,
 many flowers you may see—
Petals, bells, and cups in plenty—
 but there's no one else like me.

In the hot-house dwells my kinsman,
 Arum-lily, white and fine;
I am not so tall and stately,
 but the quaintest hood is mine;
And my glossy leaves are handsome;
 I've a spike to make you stare;
And my berries are a glory in September.
 (BUT BEWARE!)

(The Wild Arum has other names beside Lords-and-Ladies,
such as Cuckoo-Pint and Jack-in-the-Pulpit.)

THE SONG OF
THE SPEEDWELL FAIRY

Clear blue are the skies;
　My petals are blue;
　As beautiful, too,
As bluest of eyes.

The heavens are high:
　By the field-path I grow
　Where wayfarers go,
And "Good speed," say I;

"See, here is a prize
　Of wonderful worth:
　A weed of the earth,
As blue as the skies!"

(There are many kinds of Speedwell: this is the Germander.)

THE SONG OF
THE COWSLIP FAIRY

The land is full of happy birds
And flocks of sheep and grazing herds.

I hear the songs of larks that fly
Above me in the breezy sky.

I hear the little lambkins bleat;
My honey-scent is rich and sweet.

Beneath the sun I dance and play
In April and in merry May.

The grass is green as green can be;
The children shout at sight of me.

The Cowslip Fairy

THE SONG OF
THE HEART'S-EASE FAIRY

Like the richest velvet
 (I've heard the fairies tell)
Grow the handsome pansies
 within the garden wall;
When you praise their beauty,
 remember me as well—
Think of little Heart's-ease,
 the brother of them all!

Come away and seek me
 when the year is young,
Through the open ploughlands
 beyond the garden wall;
Many names are pretty
 and many songs are sung:
Mine—because I'm Heart's-ease—
 are prettiest of all!

(An old lady says that when she was a little girl the children's name
for the Heart's-ease or Wild Pansy was Jump-up-and-kiss-me!)

THE SONG OF
THE MAY FAIRY

My buds, they cluster small and green;
 The sunshine gaineth heat:
Soon shall the hawthorn tree be clothed
 As with a snowy sheet.

O magic sight, the hedge is white,
 My scent is very sweet;
And lo, where I am come indeed,
 The Spring and Summer meet.

FLOWER FAIRIES OF THE SUMMER

SUMMER

SPRING GOES, SUMMER COMES

The little darling, Spring,
 Has run away;
The sunshine grew too hot for her to stay.

She kissed her sister, Summer,
 And she said:
"When I am gone, you must be queen
 instead."

Now reigns the Lady Summer,
 Round whose feet
A thousand fairies flock with blossoms sweet.

PLANTAIN AND MOON-DAISY DANCING TOGETHER,
ALL THROUGH THE BEAUTIFUL SUNSHINY WEATHER

THE SONG OF
THE ROSE FAIRY

Best and dearest flower that grows,
Perfect both to see and smell;
Words can never, never tell
Half the beauty of a Rose—
Buds that open to disclose
Fold on fold of purest white,
Lovely pink, or red that glows
Deep, sweet-scented. What delight
 To be Fairy of the Rose!

The Rose Fairy

THE SONG OF
THE TRAVELLER'S JOY FAIRY

Traveller, traveller, tramping by
To the seaport town where the big ships lie,
See, I have built a shady bower
To shelter you from the sun or shower.
Rest for a bit, then on, my boy!
Luck go with you, and Traveller's Joy!

Traveller, traveller, tramping home
From foreign places beyond the foam,
See, I have hung out a white festoon
To greet the lad with the dusty shoon.
Somewhere a lass looks out for a boy:
Luck be with you, and Traveller's Joy!

(Traveller's Joy is Wild Clematis; and when the flowers are over,
it becomes a mass of silky fluff, and then we call it Old-Man's-Beard.)

THE SONG OF
THE WILD ROSE FAIRY

I am the queen whom everybody knows:
 I am the English Rose;
As light and free as any Jenny Wren,
 As dear to Englishmen;
As joyous as a Robin Redbreast's tune,
 I scent the air of June;
My buds are rosy as a baby's cheek;
 I have one word to speak,
One word which is my secret and my song,
'Tis "England, England, England" all day long.

THE SONG OF
THE BUTTERCUP FAIRY

'Tis I whom children love the best;
　My wealth is all for them;
For them is set each glossy cup
　Upon each sturdy stem.

O little playmates whom I love!
　The sky is summer-blue,
And meadows full of buttercups
　Are spread abroad for you.

THE SONG OF
THE RAGWORT FAIRY

Now is the prime of Summer past,
　Farewell she soon must say;
But yet my gold you may behold
　By every grassy way.

And what though Autumn comes apace,
　And brings a shorter day?
Still stand I here, your eyes to cheer,
　In gallant gold array.

THE SONG OF
THE TOADFLAX FAIRY

The children, the children,
 they call me funny names,
They take me for their darling
 and partner in their games;
They pinch my flowers' yellow mouths,
 to open them and close,
Saying, *Snap-Dragon!*
 Toadflax!
 or, *darling Bunny-Nose!*

The Toadflax, the Toadflax,
 with lemon-coloured spikes,
With funny friendly faces
 that everybody likes,
Upon the grassy hillside
 and hedgerow bank it grows,
And it's *Snap-Dragon!*
 Toadflax!
 and *darling Bunny-Nose!*

THE SONG OF
THE FORGET-ME-NOT FAIRY

So small, so blue, in grassy places
 My flowers raise
 Their tiny faces.

By streams my bigger sisters grow,
 And smile in gardens,
 In a row.

I've never seen a garden plot;
 But though I'm small
 Forget me not!

The Forget-me-not Fairy

The Poppy Fairy

THE SONG OF
THE POPPY FAIRY

The green wheat's a-growing,
　　The lark sings on high;
In scarlet silk a-glowing,
　　Here stand I.

The wheat's turning yellow,
　　Ripening for sheaves;
I hear the little fellow
　　Who scares the bird-thieves.

Now the harvest's ended,
　　The wheat-field is bare;
But still, red and splendid,
　　I am there.

THE SONG OF
THE SCABIOUS FAIRY

Like frilly cushions full of pins
For tiny dames and fairykins;

Or else like dancers decked with gems,
My flowers sway on slender stems.

They curtsey in the meadow grass,
And nod to butterflies who pass.

THE SONG OF
THE HAREBELL FAIRY

O bells, on stems so thin and fine!　　When dim and dewy twilight falls,
　　No human ear　　　　　　　　　　　Then comes the time
　　Your sound can hear,　　　　　　　When harebells chime
O lightly chiming bells of mine!　　For fairy feasts and fairy balls.

They tinkle while the fairies play,
　　With dance and song,
　　The whole night long,
Till daybreak wakens, cold and grey,
And elfin music fades away.

(The Harebell is the Bluebell of Scotland.)

THE SONG OF
THE HONEYSUCKLE FAIRY

The lane is deep, the bank is steep,
 The tangled hedge is high;
And clinging, twisting, up I creep,
 And climb towards the sky.
O Honeysuckle, mounting high!
O Woodbine, climbing to the sky!

The people in the lane below
 Look up and see me there,
Where I my honey-trumpets blow,
 Whose sweetness fills the air.
O Honeysuckle, waving there!
O Woodbine, scenting all the air!

THE SONG OF
THE WHITE CLOVER FAIRY

I'm little White Clover, kind and clean;
Look at my threefold leaves so green;
Hark to the buzzing of hungry bees:
"Give us your honey, Clover, please!"

Yes, little bees, and welcome, too!
My honey is good, and meant for you!

THE SONG OF
THE HERB ROBERT FAIRY

Little Herb Robert,
 Bright and small,
Peeps from the bank
 Or the old stone wall.

Little Herb Robert,
 His leaf turns red;
He's wild geranium,
 So it is said.

THE SONG OF
THE FOXGLOVE FAIRY

"Foxglove, Foxglove,
 What do you see?"
The cool green woodland,
 The fat velvet bee;
Hey, Mr Bumble,
 I've honey here for thee!

"Foxglove, Foxglove,
 What see you now?"
The soft summer moonlight
 On bracken, grass, and bough;
And all the fairies dancing
 As only they know how.

The Foxglove Fairy

THE SONG OF
THE NIGHTSHADE FAIRY

My name is Nightshade, also Bittersweet;
 Ah, little folk, be wise!
Hide you your hands behind you when we meet,
 Turn you away your eyes.
My flowers you shall not pick, nor berries eat,
 For in them poison lies.

(Though this is so poisonous, it is not the Deadly Nightshade,
but the Woody Nightshade. The berries turn red a little later on.)

THE SONG OF
THE SCARLET PIMPERNEL FAIRY

By the furrowed fields I lie,
Calling to the passers-by:
"If the weather you would tell,
Look at Scarlet Pimpernel."

When the day is warm and fine,
I unfold these flowers of mine;
Ah, but you must look for rain
When I shut them up again!

Weather-glasses on the walls
Hang in wealthy people's halls:
Though I lie where cart-wheels pass
I'm the Poor Man's Weather-Glass!

THE SONG OF
THE HEATHER FAIRY

"Ho, Heather, ho! From south to north
Spread now your royal purple forth!
Ho, jolly one! From east to west,
The moorland waiteth to be dressed!"

I come, I come! With footsteps sure
I run to clothe the waiting moor;
From heath to heath I leap and stride
To fling my bounty far and wide.

(The heather in the picture is bell heather, or heath; it is
different from the common heather which is also called ling.)

THE SONG OF
THE YARROW FAIRY

Among the harebells and the grass,
 The grass all feathery with seed,
I dream, and see the people pass:
 They pay me little heed.

And yet the children (so I think)
 In spite of other flowers more dear,
Would miss my clusters white and pink,
 If I should disappear.

(The Yarrow has another name, Milfoil, which means
Thousand Leaf; because her leaves are all made up of very
many tiny little leaves.)

THE SONG OF
THE GREATER KNAPWEED FAIRY

Oh, please, little children, take note of my
 name:
To call me a thistle is really a shame:
I'm harmless old Knapweed, who grows
 on the chalk,
I never will prick you when out for your
 walk.

Yet I should be sorry, yes, sorry indeed,
To cut your small fingers and cause them
 to bleed;
So bid me Good Morning when out for
 your walk,
And mind how you pull at my very tough
 stalk.

(Sometimes this Knapweed is called Hardhead; and he has a
brother, the little Knapweed, whose flower is not quite like this.)

THE SONG OF
THE BIRD'S-FOOT TREFOIL FAIRY

Here I dance in a dress like flames,
And laugh to think of my comical names.
Hoppetty hop, with nimble legs!
Some folks call me *Bacon and Eggs*!
While other people, it's really true,
Tell me I'm *Cuckoo's Stockings* too!
Over the hill I skip and prance;
I'm *Lady's Slipper*, and so I dance,
Not like a lady, grand and proud,
But to the grasshoppers' chirping loud.
My pods are shaped like a dicky's toes:
That is what *Bird's-Foot Trefoil* shows;
This is my name which grown-ups use,
But children may call me what they choose.

The Bird's-Foot Trefoil Fairy

FLOWER
FAIRIES
OF THE
AUTUMN

AUTUMN

THE BERRY-QUEEN

An elfin rout,
 With berries laden,
Throngs round about
 A merry maiden.

Red-gold her gown;
 Sun-tanned is she;
She wears a crown
 Of bryony.

The sweet Spring came,
 And lovely Summer:
Guess, then, her name—
 This latest-comer!

SEE ABOVE THE FAIRY'S
HEAD, GUELDER-ROSE'S
BERRIES RED.

THE SONG OF
THE HAWTHORN FAIRY

These thorny branches bore the May
 So many months ago,
That when the scattered petals lay
 Like drifts of fallen snow,
 "This is the story's end," you said;
 But O, not half was told!
For see, my haws are here instead,
And hungry birdies shall be fed
 On these when days are cold.

The Hawthorn Fairy

THE SONG OF
THE CRAB-APPLE FAIRY

Crab-apples, Crab-apples, out in the wood,
Little and bitter, yet little and good!
The apples in orchards, so rosy and fine,
Are children of wild little apples like mine.
The branches are laden, and droop to the ground;

The fairy-fruit falls in a circle around;
Now all you good children, come gather
 them up:
They'll make you sweet jelly to spread
 when you sup.

One little apple I'll catch for myself;
I'll stew it, and strain it, to store on a shelf
In four or five acorn-cups, locked with a key
In a cupboard of mine at the root of the tree.

THE SONG OF
THE ROBIN'S PINCUSHION FAIRY

People come and look at me,
Asking who this rogue may be?
—Up to mischief, they suppose,
Perched upon the briar-rose.

I am nothing else at all
But a fuzzy-wuzzy ball,
Like a little bunch of flame;
I will tell you how I came:

First there came a naughty fly,
Pricked the rose, and made her cry;
Out I popped to see about it;
This is true, so do not doubt it!

THE SONG OF
THE BEECHNUT FAIRY

O the great and happy Beech,
 Glorious and tall!
Changing with the changing months,
 Lovely in them all:

Lovely in the leafless time,
 Lovelier in green;
Loveliest with golden leaves
 And the sky between,

When the nuts are falling fast,
 Thrown by little me—
Tiny things to patter down
 From a forest tree!

(You may eat these.)

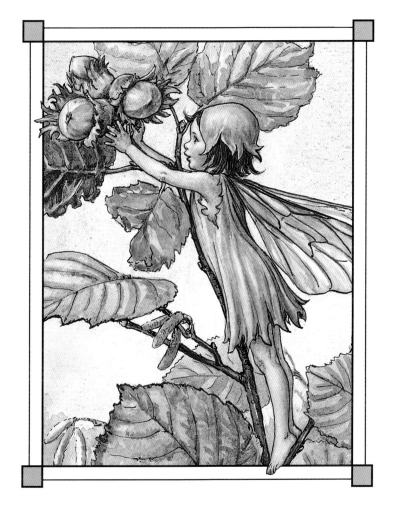

THE SONG OF
THE HAZEL-NUT FAIRY

Slowly, slowly, growing
 While I watched them well,
See, my nuts have ripened;
 Now I've news to tell.
I will tell the Squirrel,
 "Here's a store for you;
But, kind Sir, remember
 The Nuthatch likes them too."

I will tell the Nuthatch,
 "Now, Sir, you may come;
Choose your nuts and crack them,
 But leave the children some."
I will tell the children,
 "You may take your share;
Come and fill your pockets,
 But leave a few to spare."

THE SONG OF
THE MICHAELMAS DAISY FAIRY

"Red Admiral, Red Admiral,
 I'm glad to see you here,
 Alighting on my daisies one by one!
I hope you like their flavour
 and although the Autumn's near,
 Are happy as you sit there in the sun?"

"I thank you very kindly, Sir!
 Your daisies *are* so nice,
 So pretty and so plentiful are they;
The flavour of their honey, Sir,
 it really does entice;
 I'd like to bring my brothers, if I may!"

"Friend butterfly, friend butterfly,
 go fetch them one and all!
 I'm waiting here to welcome every guest;
And tell them it is Michaelmas,
 and soon the leaves will fall,
 But *I* think Autumn sunshine is the best!"

The Michaelmas Daisy Fairy

THE SONG OF
THE ELDERBERRY FAIRY

Tread quietly:
O people, hush!
—For don't you see
A spotted thrush,
One thrush or two,
Or even three,
In every laden elder-tree?

They pull and lug,
They flap and push,
They peck and tug
To strip the bush;
They have forsaken
Snail and slug;
Unseen I watch them, safe and snug!

(These berries do us no harm, though they don't taste very nice. Country
people make wine from them; and boys make whistles from elder stems.)

THE SONG OF
THE WAYFARING TREE FAIRY

My shoots are tipped with buds as dusty-grey
As ancient pilgrims toiling on their way.

Like Thursday's child with far to go, I stand,
All ready for the road to Fairyland;

With hood, and bag, and shoes, my name to suit,
And in my hand my gorgeous-tinted fruit.

THE SONG OF
THE SLOE FAIRY

When Blackthorn blossoms leap to sight,
They deck the hedge with starry light,
 In early Spring
 When rough winds blow,
 Each promising
 A purple sloe.

And now is Autumn here, and lo,
The Blackthorn bears the purple sloe!
 But ah, how much
 Too sharp these plums,
 Until the touch
 Of Winter comes!

(The sloe is a wild plum. One bite will set your teeth on edge until
it has been mellowed by frost; but it is not poisonous.)

THE SONG OF
THE PRIVET FAIRY

Here in the wayside hedge I stand,
And look across the open land;
Rejoicing thus, unclipped and free,
I think how you must envy me,
O garden Privet, prim and neat,
With tidy gravel at your feet!

(In early summer the Privet has spikes of very strongly-scented white flowers.)

THE SONG OF
THE ROSE HIP FAIRY

Cool dewy morning,
 Blue sky at noon,
White mist at evening,
 And large yellow moon;

Blackberries juicy
 For staining of lips;
And scarlet, O scarlet
 The Wild Rose Hips!

Gay as a gipsy
 All Autumn long,
Here on the hedge-top
 This is my song.

THE SONG OF
THE NIGHTSHADE BERRY FAIRY

"You see my berries, how they gleam and glow,
Clear ruby-red, and green, and orange-yellow;
Do they not tempt you, fairies, dangling so?"
 The fairies shake their heads and answer "No!
 You are a crafty fellow!"
"What, won't you try them? There is
 naught to pay!

Why should you think my berries poisoned
 things?
You fairies may look scared and fly away—
The children will believe me when I say
 My fruit is fruit for kings!"
 But all good fairies cry in anxious haste,
"O children, do not taste!"

(You must believe the good fairies, though the berries look nice. This is the
Woody Nightshade, which has purple and yellow flowers in the summer.)

THE SONG OF
THE HORSE CHESTNUT FAIRY

My conkers, they are shiny things,
 And things of mighty joy,
And they are like the wealth of kings
 To every little boy;
I see the upturned face of each
 Who stands around the tree:
He sees his treasure out of reach,
 But does not notice *me*.

For love of conkers bright and brown,
 He pelts the tree all day;
With stones and sticks he knocks them down,
 And thinks it jolly play.
But sometimes I, the elf, am hit
 Until I'm black and blue;
O laddies, only wait a bit,
 I'll shake them down to you!

THE SONG OF
THE ACORN FAIRY

To English folk the mighty oak
 Is England's noblest tree;
Its hard-grained wood is strong and good
 As English hearts can be.
And would you know how oak-trees grow,
 The secret may be told:
You do but need to plant for seed
 One acorn in the mould;
For even so, long years ago,
 Were born the oaks of old.

THE SONG OF
THE DOGWOOD FAIRY

I was a warrior,
 When, long ago,
Arrows of Dogwood
 Flew from the bow.
Passers-by, nowadays,
 Go up and down,
Not one remembering
 My old renown.

Yet when the Autumn sun
 Colours the trees,
Should you come seeking me,
 Know me by these:
Bronze leaves and crimson leaves,
 Soon to be shed;
Dark little berries,
 On stalks turning red.

(Cornel is another name for Dogwood; and Dogwood has nothing
to do with dogs. It used to be Dag-wood, or Dagger-wood, which,
with another name, Prickwood, show that it was used to make
sharp-pointed things.)

The Acorn Fairy

THE SONG OF
THE WHITE BRYONY FAIRY

Have you seen at Autumn-time
 Fairy-folk adorning
All the hedge with necklaces,
 Early in the morning?
Green beads and red beads
 Threaded on a vine:
Is there any handiwork
 Prettier than mine?

(This Bryony has other names—White Vine, Wild Vine, and Red-berried Bryony.
It has tendrils to climb with, which Black Bryony has not, and its leaves and
berries are quite different. They say its root is white, as the other's is black.)

THE SONG OF
THE BLACK BRYONY FAIRY

Bright and wild and beautiful
For the Autumn festival,
I will hang from tree to tree
Wreaths and ropes of Bryony,
To the glory and the praise
Of the sweet September days.

(There is nothing black to be seen about this Bryony, but people do
say it has a black root; and this may be true, but you would need to
dig it up to find out. It used to be thought a cure for freckles.)

THE SONG OF
THE MOUNTAIN ASH FAIRY

They thought me, once, a magic tree
　　Of wondrous lucky charm,
And at the door they planted me
　　To keep the house from harm.

They have no fear of witchcraft now,
　　Yet here am I today;
I've hung my berries from the bough,
　　And merrily I say:

"Come, all you blackbirds, bring your wives,
　　Your sons and daughters too;
The finest banquet of your lives
　　Is here prepared for you."

(The Mountain Ash's other name is Rowan; and it used to be called Witchentree and Witch-wood too.)

THE SONG OF
THE BLACKBERRY FAIRY

My berries cluster black and thick
For rich and poor alike to pick.

I'll tear your dress, and cling, and tease,
And scratch your hands and arms and knees.

I'll stain your fingers and your face,
And then I'll laugh at your disgrace.

But when the bramble-jelly's made,
You'll find your trouble well repaid.

FLOWER
FAIRIES
OF THE
WINTER

THE SONG OF
THE WINTER JASMINE FAIRY

All through the Summer my leaves were green,
But never a flower of mine was seen;
Now Summer is gone, that was so gay,
And my little green leaves are shed away.
 In the grey of the year
 What cheer, what cheer?

The Winter is come, the cold winds blow;
I shall feel the frost and the drifting snow;
But the sun can shine in December too,
And this is the time of my gift to you.
 See here, see here,
 My flowers appear!

The swallows have flown beyond the sea,
But friendly Robin, he stays with me;
And little Tom-Tit, so busy and small,
Hops where the jasmine is thick on the wall;
 And we say: "Good cheer!
 We're here! We're here!"

THE SONG OF
THE BURDOCK FAIRY

Wee little hooks on each brown little bur,
(Mind where you're going, O Madam and Sir!)
How they will cling to your skirt-hem and stocking!
Hear how the Burdock is laughing and mocking:
Try to get rid of me, try as you will,
Shake me and scold me, I'll stick to you still,
 I'll stick to you still!

The Winter Jasmine Fairy

THE SONG OF
THE PLANE TREE FAIRY

You will not find him in the wood,
 Nor in the country lane;
But in the city's parks and streets
 You'll see the Plane.

O turn your eyes from pavements grey,
 And look you up instead,
To where the Plane tree's pretty balls
 Hang overhead!

When he has shed his golden leaves,
 His balls will yet remain,
To deck the tree until the Spring
 Comes back again!

THE SONG OF
THE RUSH-GRASS AND COTTON-GRASS FAIRIES

Safe across the moorland
 Travellers may go,
If they heed our warning—
 We're the ones who know!

Let the footpath guide you—
 You'll be safely led;
There is bog beside you
 Where you cannot tread!

Mind where you are going!
 If you turn aside
Where you see us growing,
 Trouble will betide.

Keep you to the path, then!
 Hark to what we say!
Else, into the quagmire
 You will surely stray.

THE SONG OF
THE HOLLY FAIRY

O, I am green in Winter-time,
　　When other trees are brown;
Of all the trees (So saith the rhyme)
　　The holly bears the crown.
December days are drawing near
　　When I shall come to town,
And carol-boys go singing clear
Of all the trees (O hush and hear!)
　　The holly bears the crown!

For who so well-beloved and merry
As the scarlet Holly Berry?

THE SONG OF
THE BOX TREE FAIRY

Have you seen the Box unclipped,
Never shaped and never snipped?
Often it's a garden hedge,
Just a narrow little edge;
Or in funny shapes it's cut,
And it's very pretty; *but*—

But, unclipped, it is a tree,
Growing as it likes to be;
And it has its blossoms too;
Tiny buds, the Winter through,
Wait to open in the Spring
In a scented yellow ring.

And among its leaves there play
Little blue-tits, brisk and gay.

THE SONG OF
THE LORDS-AND-LADIES FAIRY

Fairies, when you lose your way,
 From the dance returning,
In the darkest undergrowth
 See my candles burning!
These shall make the pathway plain
 Homeward to your beds again.

(These are the berries of the Wild Arum, which has many
other names, and has a flower like a hood in the Spring.
The berries are not to be eaten.)

THE SONG OF
THE BLACKTHORN FAIRY

The wind is cold, the Spring seems long
 a-waking;
 The woods are brown and bare;
Yet this is March: soon April will be making
 All things most sweet and fair.

See, even now, in hedge and thicket tangled,
 One brave and cheering sight:
The leafless branches of the Blackthorn,
 spangled
 With starry blossoms white!

(The cold days of March are sometimes called "Blackthorn Winter".)

THE SONG OF
THE SNOWDROP FAIRY

Deep sleeps the Winter,
 Cold, wet, and grey;
Surely all the world is dead;
 Spring is far away.
Wait! the world shall waken;
 It is not dead, for lo,
The Fair Maids of February
 Stand in the snow!

The Blackthorn Fairy

THE SONG OF
THE PINE TREE FAIRY

A tall, tall tree is the Pine tree,
 With its trunk of bright red-brown—
The red of the merry squirrels
 Who go scampering up and down.

There are cones on the tall, tall Pine tree,
 With its needles sharp and green;
Small seeds in the cones are hidden,
 And they ripen there unseen.

The elves play games with the squirrels
 At the top of the tall, tall tree,
Throwing cones for the squirrels to nibble—
 I wish I were there to see!

THE SONG OF
THE YEW FAIRY

Here, on the dark and solemn Yew,
 A marvel may be seen,
Where waxen berries, pink and new,
 Appear amid the green.

I sit a-dreaming in the tree,
 So old and yet so new;
One hundred years, or two, or three
 Are little to the Yew.

I think of bygone centuries,
 And seem to see anew
The archers face their enemies
 With bended bows of Yew.

THE SONG OF
THE GROUNDSEL FAIRY

If dicky-birds should buy and sell
In tiny markets, I can tell
 The way they'd spend their money.
They'd ask the price of cherries sweet,
They'd choose the pinkest worms for meat,
And common Groundsel for a treat,
 Though *you* might think it funny.

Love me not, or love me well;
That's the way they'd buy and sell.

THE SONG OF
THE DEAD-NETTLE FAIRY

Through sun and rain, the country lane,
The field, the road, are my abode.
Though leaf and bud be splashed with mud,
Who cares? Not I!—I see the sky,
The kindly sun, the wayside fun
Of tramping folk who smoke and joke,
The bairns who heed my dusty weed
(No sting have I to make them cry),
And truth to tell, they love me well.
My brothers, White, and Yellow bright,
Are finer chaps than I, perhaps;
Who cares? Not I! So now good-bye.

THE SONG OF
THE SHEPHERD'S-PURSE FAIRY

Though I'm poor to human eyes
Really I am rich and wise.
Every tiny flower I shed
Leaves a heart-shaped purse instead.

In each purse is wealth indeed--
Every coin a living seed.
Sow the seed upon the earth—
Living plants shall spring to birth.

Silly people's purses hold
Lifeless silver, clinking gold;
But you cannot grow a pound
From a farthing in the ground.

Money may become a curse:
Give me then my Shepherd's Purse.

THE SONG OF
THE HAZEL-CATKIN FAIRY

Like little tails of little lambs,
 On leafless twigs my catkins swing;
They dingle-dangle merrily
 Before the wakening of Spring.

Beside the pollen-laden tails
 My tiny crimson tufts you see
The promise of the autumn nuts
 Upon the slender hazel tree.

While yet the woods lie grey and still
 I give my tidings: "Spring is near!"
One day the land shall leap to life
 With fairies calling: "Spring is HERE!"

THE SONG OF
THE TOTTER-GRASS FAIRY

The leaves on the tree-tops
　　Dance in the breeze;
Totter-grass dances
　　And sways like the trees—

Shaking and quaking!
　　While through it there goes,
Dancing, a fairy,
　　On lightest of toes.

(Totter-grass is also called Quaking-grass.)

THE SONG OF
THE OLD-MAN'S-BEARD FAIRY

This is where the little elves
Cuddle down to hide themselves;
Into fluffy beds they creep,
Say good-night, and go to sleep.

(Old-Man's Beard is Wild Clematis; its flowers are called
Traveller's Joy. This silky fluff belongs to the seeds.)

THE SONG OF
THE WINTER ACONITE FAIRY

Deep in the earth
 I woke, I stirred.
I said: "Was that the Spring I heard?
 For something called!"
 "No, no," they said;
"Go back to sleep. Go back to bed.

"You're far too soon;
 The world's too cold
For you, so small." So I was told.
 But how could I
 Go back to sleep?
I could not wait; I had to peep!

Up, up, I climbed,
 And here am I.
How wide the earth! How great the sky!
 O wintry world,
 See me, awake!
Spring calls, and comes; 'tis no mistake.

THE SONG OF
THE SPINDLE BERRY FAIRY

See the rosy-berried Spindle
All to sunset colours turning,
Till the thicket seems to kindle,
Just as though the trees were burning.
While my berries split and show
Orange-coloured seeds aglow,
One by one my leaves must fall:
Soon the wind will take them all.
Soon must fairies shut their eyes
For the Winter's hushabies;
But, before the Autumn goes,
Spindle turns to flame and rose!

THE SONG OF
THE CHRISTMAS TREE FAIRY

The little Christmas Tree was born
 And dwelt in open air;
It did not guess how bright a dress
 Some day its boughs would wear;
Brown cones were all, it thought, a tall
 And grown-up Fir would bear.

O little Fir! Your forest home
 Is far and far away;
And here indoors these boughs of yours
 With coloured balls are gay,
With candle-light, and tinsel bright,
 For this is Christmas Day!

A dolly-fairy stands on top,
 Till children sleep; then she
(A live one now!) from bough to bough
 Goes gliding silently.
O magic sight, this joyous night!
 O laden, sparkling tree!

The Christmas Tree Fairy

FLOWER FAIRIES OF THE GARDEN

WHERE?

Where are the fairies?
　　Where can we find them?
We've seen the fairy-rings
　　They leave behind them!

When they have danced all night,
　　Where do they go?
Lark, in the sky above,
　　Say, do you know?

Is it a secret
　　No one is telling?
*Why, in your garden
　　Surely they're dwelling!*

*No need for journeying,
　　Seeking afar:
Where there are flowers,
　　There fairies are!*

THE SONG OF
THE CANDYTUFT FAIRY

Why am I "Candytuft"?　　Look at my clusters!
That I don't know!　　See how they grow:
Maybe the fairies　　Some pink or purple,
First called me so;　　Some white as snow;
Maybe the children,　　Petals uneven,
Just for a joke;　　Big ones and small;
(I'm in the gardens　　Not very tufty—
Of most little folk).　　No candy at all!

The Candytuft Fairy

THE SONG OF
THE PERIWINKLE FAIRY

In shady shrubby places,
Right early in the year,
I lift my flowers' faces—
O come and find them here!
My stems are thin and straying,
With leaves of glossy sheen,
The bare brown earth arraying,
For they are ever-green.
No great renown have I. Yet who
Does not love Periwinkle's blue?

(Some Periwinkles are more purple than these;
and every now and then you may find white ones.)

THE SONG OF
THE MARIGOLD FAIRY

Great Sun above me in the sky,
So golden, glorious, and high,
My petals, see, are golden too;
They shine, but cannot shine like you.

I scatter many seeds around;
And where they fall upon the ground,
More Marigolds will spring, more flowers
To open wide in sunny hours.

It is because I love you so,
I turn to watch you as you go;
Without your light, no joy could be.
Look down, great Sun, and shine on me!

THE SONG OF
THE FORGET-ME-NOT FAIRY

Where do fairy babies lie
Till they're old enough to fly?
Here's a likely place, I think,
'Mid these flowers, blue and pink,
(Pink for girls and blue for boys:
Pretty things for babies' toys!)
Let us peep now, gently. Why,
Fairy baby, here you lie!

Kicking there, with no one by,
Baby dear, how good you lie!
All alone, but O, you're not—
You could *never* be—forgot!
O how glad I am I've found you,
With Forget-me-nots around you,
Blue, the colour of the sky!
Fairy baby, Hushaby!

THE SONG OF
THE CORNFLOWER FAIRY

'Mid scarlet of poppies and gold of the corn,
In wide-spreading fields were the Cornflowers born;
But now I look round me, and what do I see?
That lilies and roses are neighbours to me!
There's a beautiful lawn, there are borders and beds,
Where all kinds of flowers raise delicate heads;
For this is a garden, and here, a Boy Blue,
I live and am merry the whole summer through.
My blue is the blue that I always have worn,
And still I remember the poppies and corn.

THE SONG OF
THE CANTERBURY BELL FAIRY

Bells that ring from ancient towers—
 Canterbury Bells—
Give their name to summer flowers—
 Canterbury Bells!
Do the flower-fairies, playing,
Know what those great bells are saying?
 Fairy, in your purple hat,
 Little fairy, tell us that!

"Naught I know of bells in towers—
 Canterbury Bells!
Mine are pink or purple flowers—
 Canterbury Bells!
When I set them all a-swaying,
Something, too, my bells are saying;
Can't you hear them—*ding-dong-ding*—
 Calling fairy-folk to sing?"

THE SONG OF
THE SWEET PEA FAIRIES

Here Sweet Peas are climbing;
　(Here's the Sweet Pea rhyme!)
Here are little tendrils,
　Helping them to climb.

Here are sweetest colours;
　Fragrance very sweet;
Here are silky pods of peas,
　Not for us to eat!

Here's a fairy sister,
　Trying on with care
Such a grand new bonnet
　For the baby there.

Does it suit you, Baby?
　Yes, I really think
Nothing's more becoming
　Than this pretty pink!

THE SONG OF
THE PHLOX FAIRY

August in the garden!
Now the cheerful Phlox
Makes one think of country-girls
　Fresh in summer frocks.

There you see magenta,
　Here is lovely white,
Mauve, and pink, and cherry-red—
　Such a pleasant sight!

Smiling little fairy
　Climbing up the stem,
Tell us which is prettiest?
　She says, "All of them!"

The Sweet Pea Fairies

THE SONG OF
THE POLYANTHUS AND
GRAPE HYACINTH FAIRIES

"How do you do, Grape Hyacinth?
 How do you do?"
"Pleased to see *you*, Polyanthus,
 Pleased to see *you*,
With your stalk so straight
 and your colours so gay."
"Thank you, neighbour!
 I've heard good news today."

"What is the news, Polyanthus?
 What have you heard?"
"News of the joy of Spring,
 In the song of a bird!"
"Yes, Polyanthus, yes,
 I heard it too;
That's why I'm here,
 with my bells in spires of blue."

THE SONG OF
THE GAILLARDIA FAIRY

There once was a child in a garden,
 Who loved all my colours of flame,
The crimson and scarlet and yellow—
 But what was my name?

For *Gaillardia*'s hard to remember!
 She looked at my yellow and red,
And thought of the gold and the glory
 When the sun goes to bed;

And she troubled no more to remember,
 But gave me a splendid new name;
She spoke of my flowers as *Sunsets*—
 Then *you* do the same!

THE SONG OF
THE GERANIUM FAIRY

Red, red, vermilion red,
With buds and blooms in a glorious head!
There isn't a flower, the wide world through,
That glows with a brighter scarlet hue.
Her name—Geranium—ev'ryone knows;
She's just as happy wherever she grows,
In an earthen pot or a garden bed—
 Red, red, vermilion red!

THE SONG OF
THE SHIRLEY POPPY FAIRY

We were all of us scarlet, and counted as
 weeds,
 When we grew in the fields with the corn;
Now, fall from your pepper-pots, wee little
 seeds,
 And lovelier things shall be born!

You shall sleep in the soil, and awaken next
 year;
 Your buds shall burst open; behold!
Soft-tinted and silken, shall petals appear,
 And then into Poppies unfold—

Like daintiest ladies, who dance and are gay,
 All frilly and pretty to see!
So I shake out the ripe little seeds, and I say:
 "Go, sleep, and awaken like me!"

(A clergyman, who was also a clever gardener, made these many-coloured poppies
out of the wild ones, and named them after the village where he was the Vicar.)

110

THE SONG OF
THE PINK FAIRIES

Early in the mornings,
 when children still are sleeping,
Or late, late at night-time,
 beneath the summer moon,
What are they doing,
 the busy fairy people?
Could you creep to spy them,
 in silent magic shoon,

You might learn a secret,
 among the garden borders,
Something never guessed at,
 that no one knows or thinks:
Snip, snip, snip, go busy fairy scissors,
Pinking out the edges
 of the petals of the Pinks!

Pink Pinks, white Pinks,
 double Pinks, and single,—
Look at them and see
 if it's not the truth I tell!
Why call them Pinks
 if they weren't pinked out by *someone*?
And what but fairy scissors
 could pink them out so well?

THE SONG OF
THE HELIOTROPE FAIRY

Heliotrope's my name; and why
People call me "Cherry Pie",
That I really do not know;
But perhaps they call me so,
'Cause I give them such a treat,
Just like something nice to eat.
For my scent—O come and smell it!

How can words describe or tell it?
And my buds and flowers, see,
Soft and rich and velvety—
Deepest purple first, that fades
To the palest lilac shades.
Well-beloved, I know, am I—
Heliotrope, or Cherry Pie!

The Heliotrope Fairy

The Lavender Fairy

THE SONG OF
THE LAVENDER FAIRY

"Lavender's blue, diddle diddle"—
 So goes the song;
All round her bush, diddle diddle,
 Butterflies throng;
(They love her well, diddle diddle,
 So do the bees;)
While she herself, diddle diddle,
 Sways in the breeze!

"Lavender's blue, diddle diddle,
 Lavender's green";
She'll scent the clothes, diddle diddle,
 Put away clean—
Clean from the wash, diddle diddle,
 Hanky and sheet;
Lavender's spikes, diddle diddle,
 Make them all sweet!

(The word "blue" was often used in old days where we should say "purple" or "mauve".)

THE SONG OF
THE TULIP FAIRY

Our stalks are very straight and tall,
 Our colours clear and bright;
Too many-hued to name them all—
 Red, yellow, pink, or white.

And some are splashed, and some, maybe,
 As dark as any plum.
From tulip-fields across the sea
 To England did we come.

We were a peaceful country's pride,
 And Holland is its name.
Now in your gardens we abide—
 And aren't you glad we came?

(But long, long ago, tulips were brought from Persian
gardens, before there were any in Holland.)

THE SONG OF
THE SCILLA FAIRY

"Scilla, Scilla, tell me true,
Why are you so very blue?"

Oh, I really cannot say
Why I'm made this lovely way!

I might know, if I were wise.
Yet—I've heard of seas and skies,

Where the blue is deeper far
Than our skies of Springtime are.

P'r'aps I'm here to let you see
What that Summer blue will be.

When you see it, think of me!

THE SONG OF
THE SNAPDRAGON FAIRY

Into the Dragon's mouth he goes;
 Never afraid is he!
There's honey within for him, he knows,
 Clever old Bumble Bee!
The mouth snaps tight; he is lost to sight—
 How will he ever get out?
He's doing it backwards—nimbly too,
 Though he is somewhat stout!

Off to another mouth he goes;
 Never a rest has he;
He must fill his honey-bag full, he knows—
 Busy old Bumble Bee!
And Snapdragon's name is only a game—
 It isn't as fierce as it sounds;
The Snapdragon elf is pleased as Punch
 When Bumble comes on his rounds!

THE SONG OF
THE NARCISSUS FAIRY

Brown bulbs were buried deep; Flowers on stems that sway;
Now, from the kind old earth, Flowers of snowy white;
Out of the winter's sleep, Flowers as sweet as day,
 Comes a new birth! After the night.

So does Narcissus bring
Tidings most glad and plain:
"Winter's gone; here is Spring—
 Easter again!"

FLOWER
FAIRIES
OF THE
TREES

LOOK UP!

Look up, look up, at any tree!
There is so much for eyes to see:
Twigs, catkins, blossoms; and the blue
Of sky, most lovely, peeping through
Between the leaves, some large, some small,
Some green, some gold before their fall;
Fruits you can pick; fruits out of reach;
And little birds with twittering speech;
And, if you're quick enough, maybe
A laughing fairy in the tree!

THE SONG OF
THE WILLOW FAIRY

By the peaceful stream or the shady pool
I dip my leaves in the water cool.

Over the water I lean all day,
Where the sticklebacks and the minnows play.

I dance, I dance, when the breezes blow,
And dip my toes in the stream below.

The Willow Fairy

THE SONG OF
THE LABURNUM FAIRY

All Laburnum's	Why folks call them
Yellow flowers	"Golden Rain"!
Hanging thick	"Golden Chains"
In happy showers,—	They call them too,
Look at them!	Swinging there
The reason's plain	Against the blue.

(After the flowers, the Laburnum has pods with what look like tiny
green peas in them; but it is best not to play with them, and they
must never, never be eaten, as they are poisonous.)

THE SONG OF
THE LIME TREE FAIRY

Bees! bees! come to the trees
Where the Lime has hung her treasures;
Come, come, hover and hum;
Come and enjoy your pleasures!
The feast is ready, the guests are bidden;
Under the petals the honey is hidden;
Like pearls shine the drops of sweetness there,
And the scent of the Lime-flowers fills the air.
But soon these blossoms pretty and pale
Will all be gone; and the leaf-like sail
Will bear the little round fruits away;
So bees! bees! come while you may!

THE SONG OF
THE SILVER BIRCH FAIRY

There's a gentle tree with a satiny bark,
All silver-white, and upon it, dark,
Is many a crosswise line and mark—
 She's a tree there's no mistaking!
The Birch is this light and lovely tree,
And as light and lovely still is she
When the Summer's time has come to flee,
 As she was at Spring's awaking.
She has new Birch-catkins, small and tight,
Though the old ones scatter
 and take their flight,

And the little leaves, all yellow and bright,
 In the autumn winds are shaking.
And with fluttering wings
 and hands that cling,
The fairies play and the fairies swing
On the fine thin twigs,
 that will toss and spring
 With never a fear of breaking.

THE SONG OF
THE ALDER FAIRY

By the lake or river-side
 Where the Alders dwell,
In the Autumn may be spied
 Baby catkins; cones beside—
Old and new as well.
 Seasons come and seasons go;
That's the tale they tell!

After Autumn, Winter's cold
 Leads us to the Spring;
And, before the leaves unfold,
On the Alder you'll behold,
 Crimson catkins swing!
They are making ready now:
 That's the song I sing!

THE SONG OF
THE SWEET CHESTNUT FAIRY

Chestnuts, sweet Chestnuts,
 To pick up and eat,
Or keep until Winter,
 When, hot, they're a treat!

Like hedgehogs, their shells
 Are prickly outside;
But silky within,
 Where the little nuts hide,

Till the shell is split open,
 And, shiny and fat,
The Chestnut appears;
 Says the Fairy: "How's *that*?"

THE SONG OF
THE ELM TREE FAIRY

Soft and brown in Winter-time,
Dark and green in Summer's prime,
All their leaves a yellow haze
In the pleasant Autumn days—
See the lines of Elm trees stand
Keeping watch through all the land
Over lanes, and crops, and cows,
And the fields where Dobbin ploughs.

All day long, with listening ears,
Sits the Elm-tree Elf, and hears
Distant bell, and bleat, and bark,
Whistling boy, and singing lark.
Often on the topmost boughs
Many a rook has built a house;
Evening comes; and overhead,
Cawing, home they fly to bed.

THE SONG OF
THE LILAC FAIRY

White May is flowering,
　Red May beside;
Laburnum is showering
　Gold far and wide;
But *I* sing of Lilac,
　The dearly-loved Lilac,
Lilac, in Maytime
　A joy and a pride!

I love her so much
　That I never can tell
If she's sweeter to look at,
　Or sweeter to smell.

The Lilac Fairy

THE SONG OF
THE ELDER FAIRY

When the days have grown in length,
When the sun has greater power,
Shining in his noonday strength;
When the Elder Tree's in flower;
When each shady kind of place
By the stream and up the lane,
Shows its mass of creamy lace—
Summer's really come again!

THE SONG OF
THE BEECH TREE FAIRY

The trunks of Beeches are smooth and grey,
 Like tall straight pillars of stone
In great Cathedrals where people pray;
 Yet from tiny things they've grown.
About their roots is the moss; and wide
 Their branches spread, and high;
It seems to us, on the earth who bide,
 That their heads are in the sky.

And when Spring is here,
 and their leaves appear,
 With a silky fringe on each,
Nothing is seen so new and green
 As the new young green of Beech.
O the great grey Beech is young, is young,
 When, dangling soft and small,
Round balls of bloom from its twigs are hung,
 And the sun shines over all.

THE SONG OF
THE SYCAMORE FAIRY

Because my seeds have wings, you know,
 They fly away to earth;
And where they fall, why, there they grow—
 New Sycamores have birth!
Perhaps a score? Oh, hundreds more!
 Too many, people say!

And yet to me it's fun to see
 My winged seeds fly away.
(But first they must turn ripe and brown,
 And lose their flush of red;
And *then* they'll all go twirling down
 To earth, to find a bed.)

THE SONG OF
THE MULBERRY FAIRY

"Here we go round the Mulberry bush!"
 You remember the rhyme—oh yes!
 But which of you know
 How Mulberries grow
On the slender branches, drooping low?
 Not many of you, I guess.

Someone goes round the Mulberry bush
 When nobody's there to see;
 He takes the best
 And he leaves the rest,
From top to toe like a Mulberry drest:
 This fat little fairy's he!

133

THE SONG OF
THE ALMOND BLOSSOM FAIRY

Joy! the Winter's nearly gone!
Soon will Spring come dancing on;
And, before her, here dance I,
Pink like sunrise in the sky.
Other lovely things will follow;
Soon will cuckoo come, and swallow;
Birds will sing and buds will burst,
But the Almond is the first!

THE SONG OF
THE GUELDER ROSE FAIRIES

There are two little trees:
In the garden there grows
The one with the snowballs;
All children love *those*!

The other small tree
Not everyone knows,
With her blossoms spread flat—
Yet they're both Guelder Rose!

But the garden Guelder has nothing
When her beautiful balls are shed;
While in Autumn her wild little sister
Bears berries of ruby red!

THE SONG OF
THE WILD CHERRY BLOSSOM FAIRY

In April when the woodland ways
 Are all made glad and sweet
With primroses and violets
 New-opened at your feet,
 Look up and see
 A fairy tree,
 With blossoms white
 In clusters light,
All set on stalks so slender,
 With pinky leaves so tender.
O Cherry tree, wild Cherry tree!
 You lovely, lovely thing to see!

THE SONG OF
THE ASH TREE FAIRY

Trunk and branches are smooth and grey; The leaves make patterns against the sky,
 (Ash-grey, my honey!) (Blue sky, my honey!)
The buds of the Ash-tree, black are they; And the keys in bunches hang on high;
 (And the days are long and sunny.) (To call them "keys" is funny!)

Each with its seed, the keys hang there,
(Still there, my honey!)
When the leaves are gone
and the woods are bare;
(Short days may yet be sunny.)

THE SONG OF
THE POPLAR FAIRY

White fluff is drifting like snow round our feet;
 Puff! it goes blowing
 Away down the street.

Where does it come from? Look up and see!
 There, from the Poplar!
 Yes, from that tree!

Tassels of silky white fluffiness there
 Hang among leaves
 All a-shake in the air.

Fairies, you well may guess, use it to stuff
 Pillows and cushions,
 And play with it—puff!

(This is called the Black Poplar; but only, I think, because there is also a White Poplar,
which has white leaves. The very tall thin Poplar is the Lombardy.)

THE SONG OF
THE PEAR BLOSSOM FAIRY

Sing, sing, sing, you blackbirds!
 Sing, you beautiful thrush!
It's Spring, Spring, Spring; so sing, sing, sing,
 From dawn till the stars say "hush".

See, see, see the blossom
 On the Pear Tree shining white!
It will fall like snow, but the pears will grow
 For people's and birds' delight.

Build, build, build, you chaffinch;
 Build, you robin and wren,
A safe warm nest where your eggs may rest;
 Then sit, sit, sit, little hen!

THE SONG OF
THE CHERRY TREE FAIRY

Cherries, a treat for the blackbirds;
 Cherries for girls and boys;
And there's never an elf in the treetops
 But cherries are what he enjoys!

Cherries in garden and orchard,
 Ripe and red in the sun;
And the merriest elf in the treetops
 Is the fortunate Cherry-tree one!

FLOWER
FAIRIES
OF THE
WAYSIDE

OPEN YOUR EYES!

To shop, and school, to work and play,
The busy people pass all day;
They hurry, hurry, to and fro,
And hardly notice as they go
The wayside flowers, known so well,
Whose names so few of them can tell.

They never think of fairy-folk
Who may be hiding for a joke!

O, if these people understood
What's to be found by field and wood;
What fairy secrets are made plain
By any footpath, road, or lane—
They'd go with open eyes, and *look*,
(As you will, when you've read this book)
And then at least they'd learn to see
How pretty common things can be!

THE SONG OF
THE WHITE BINDWEED FAIRY

O long long stems that twine!
O buds, so neatly furled!
O great white bells of mine,
(None purer in the world)
Each lasting but one day!
O leafy garlands, hung
In wreaths beside the way—
Well may your praise be sung!

(But this Bindweed, which is a big sister to the little pink Field Convolvulus, is not good
to have in gardens, though it is so beautiful; because it winds around other plants and trees.
One of its names is "Hedge Strangler". Morning Glories are a garden kind of Convolvulus.)

The White Bindweed Fairy

THE SONG OF
THE JACK-GO-TO-BED-AT-NOON FAIRY

I'll be asleep by noon!
Though bedtime comes so soon,
 I'm busy too.
Twelve puffs!—and then from sight
I shut my flowers tight;
Only by morning light
 They're seen by you.

Then, on some day of sun,
They'll open wide, each one,
 As something new!
Shepherd, who minds his flock,
Calls it a Shepherd's Clock,
Though it can't say "tick-tock"
 As others do!

(Another of Jack's names, besides Shepherd's Clock is Goat's Beard.)

THE SONG OF
THE SOW THISTLE FAIRY

I have handsome leaves, and my stalk is tall,
 And my flowers are prettily yellow;
Yet nobody thinks me nice at all:
 They think me a tiresome fellow—
 An ugly weed
 And a rogue indeed.

For wherever I happen to spy,
 As I look around,
 That they've dug their ground,
I say to my seeds "Go, fly!"

 And because I am found
 On the nice soft ground,
 A trespassing weed am I!

(But I have heard that Sow Thistle is good rabbit-food,
so perhaps it is not so useless as most people think.)

145

THE SONG OF
THE JACK-BY-THE-HEDGE FAIRY

"'Morning, Sir, and how-d'ye-do?
　'Morning, pretty lady!"
That is Jack saluting you,
　Where the lane is shady.

Don't you know him? Straight and tall—
　Taller than the nettles;
Large and light his leaves; and small
　Are his buds and petals.

Small and white, with petals four,
　See his flowers growing!
If you never knew before,
　There is Jack for knowing!

(Jack-by-the-hedge is also called Garlic Mustard, and Sauce Alone.)

THE SONG OF
THE GREATER CELANDINE FAIRY

You come with the Spring,
 O swallow on high!
You come with the Spring,
 And so do I.

Your nest, I know,
 Is under the eaves;
While far below
 Are my flowers and leaves.

Yet, to and fro
 As you dart and fly,
You swoop so low
 That you brush me by!

I come with the Spring;
 The wall is my home;
I come with the Spring
 When the swallows come.

(The name "Celandine" comes from the Greek word for "swallow",
and this celandine used sometimes to be called "swallow-wort".
It has orange-coloured juice in its stems, and is no relation to the
Lesser Celandine, from *Flower Fairies of the Spring*; but it is a relation
of the Horned Poppy, which you will find further on in this book.)

THE SONG OF
THE BLACK MEDICK FAIRIES

"Why are we called 'Black', sister,
 When we've yellow flowers?"
"I will show you why, brother:
 See these seeds of ours?
Very soon each tiny seed
 Will be turning black indeed!"

THE SONG OF
THE ROSE-BAY WILLOW-HERB FAIRY

On the breeze my fluff is blown;
So my airy seeds are sown.

Where the earth is burnt and sad,
I will come to make it glad.

All forlorn and ruined places,
All neglected empty spaces,

I can cover—only think!—
With a mass of rosy pink.

Burst then, seed-pods; breezes, blow!
Far and wide my seeds shall go!

(Another name for this Willow-Herb is "Fireweed", because of its
way of growing where there have been heath or forest fires.)

THE SONG OF
THE FUMITORY FAIRY

Given me hundreds of years ago,
My name has a meaning you shall know:
It means, in the speech of the bygone folk,
"Smoke of the Earth" —a soft green smoke!

A wonderful plant to them I seemed;
Strange indeed were the dreams they dreamed,
Partly fancy and partly true,
About "Fumiter" and the way it grew.

Where men have ploughed
 or have dug the ground,
Still, with my rosy flowers, I'm found;
Known and prized by the bygone folk
As "Smoke of the Earth" —
 a soft green smoke!

(The name "Fumitory" was "Fumiter" 300 years ago; and long before
that, "Fume Terre", which is the French name, still, for the plant.
"Fume" means "smoke", "terre" means "earth".)

The Rose-Bay Willow-Herb Fairy

THE SONG OF
THE SELF-HEAL FAIRY

When little elves have cut themselves,
 Or Mouse has hurt her tail,
Or Froggie's arm has come to harm,
 This herb will never fail.
The fairy's skill can cure each ill
 And soothe the sorest pain;
She'll bathe, and bind, and soon they'll find
 That they are well again.

(This plant was a famous herb of healing in old days, as you can tell by the
names it was given—Self-Heal, All-Heal, and others. It is also called Prunella.)

THE SONG OF
THE GROUND IVY FAIRY

In Spring he is found;
He creeps on the ground;
But someone's to blame
For the rest of his name—
For Ivy he's *not*!
Oh dear, what a lot

Of muddles we make!
It's quite a mistake,
And really a pity
Because he's so pretty;
He deserves a nice name—
Yes, *someone's* to blame!

(But he has some other names, which we do not hear very often; here are four of them:
Robin-run-up-the-dyke, Runnadyke, Run-away-Jack, Creeping Charlie.)

THE SONG OF
THE RED CAMPION FAIRY

Here's a cheerful somebody,
 By the woodland's edge;
Campion the many-named,
 Robin-in-the-hedge.

Coming when the bluebells come,
 When they're gone, he stays,
(Round Robin, Red Robin)
 All the summer days.

Soldiers' Buttons, Robin Flower,
 In the lane or wood;
Robin Redbreast, Red Jack,
 Yes, and Robin Hood!

THE SONG OF
THE RED CLOVER FAIRY

The Fairy: O, what a great big bee
 Has come to visit me!
 He's come to find my honey.
 O, what a great big bee!

The Bee: O, what a great big Clover!
 I'll search it well, all over,
 And gather all its honey.
 O, what a great big Clover!

THE SONG OF
THE STORK'S-BILL FAIRY

"Good morning, Mr Grasshopper!
　　Please stay and talk a bit!"
"Why yes, you pretty Fairy;
　　Upon this grass I'll sit.
And let us ask some riddles;
　　They're better fun than chat:
Why am I like the Stork's-bill?
　　Come, can you answer that?"

"Oh no, you clever Grasshopper!
　　I fear I am a dunce;
I cannot guess the answer—
　　I give it up at once!"
"When children think they've caught me,
　　I'm gone, with leap and hop;
And when they gather Stork's-bill,
　　Why, all the petals drop!"

(The Stork's-bill gets her name from the long seed-pod, which looks
like a stork's beak or bill. Others of her family are called Crane's-bills.)

THE SONG OF
THE TANSY FAIRY

In busy kitchens, in olden days,
Tansy was used in a score of ways;
Chopped and pounded,
 when cooks would make
Tansy puddings and tansy cake,
Tansy posset, or tansy tea;
Physic or flavouring tansy'd be.
 People who know
 Have told me so!

That is my tale of the past; today,
Still I'm here by the King's Highway,
Where the air from the fields
 is fresh and sweet,
With my fine-cut leaves and my flowers neat.
Were ever such button-like flowers seen—
Yellow, for elfin coats of green?
 Three in a row—
 I stitch them so!

The Tansy Fairy

THE SONG OF
THE BEE ORCHIS FAIRY

In the grass o' the bank,
 by the side o' the way,
 Where your feet may stray
 On your luckiest day,
There's a sight most rare
 that your eyes may see:

A beautiful orchis that looks like a bee!
A velvety bee, with a proud little elf,
Who looks like the wonderful
 orchis himself—
 In the grass o' the hill,
 Not often, but still
 Just once in a way
 On your luckiest day!

THE SONG OF
THE RIBWORT PLANTAIN FAIRY

Hullo, Snailey-O!
How's the world with *you*?
Put your little horns out;
Tell me how you do?
There's rain, and dust, and sunshine,
Where carts go creaking by;
You like it wet, Snailey;
I like it dry!

Hey ho, Snailey-O,
I'll whistle you a tune!
I'm merry in September
As e'er I am in June.
By any stony roadside
Wherever you may roam,
All the summer through, Snailey,
Plantain's at home!

(There are some other kinds of Plantain besides this. The one with wide leaves,
and tall spikes of seed which canaries enjoy, is Greater Plantain.)

THE SONG OF
THE AGRIMONY FAIRIES

Spikes of yellow flowers,
All along the lane;
When the petals vanish,
Burrs of red remain.

First the spike of flowers,
Then the spike of burrs;
Carry them like soldiers,
Smartly, little sirs!

THE SONG OF
THE HORNED POPPY FAIRY

These are the things I love and know:
The sound of the waves, the sight of the sea;
The great wide shore when the tide is low;
Where there's salt in the air, it's home to me—
With my petals of gold—the home for me!
The waves come up and cover the sand,
Then turn at the pebbly slope of the beach;
I feel the spray of them, where I stand,
Safe and happy, beyond their reach—
With my marvellous horns—
 beyond their reach!

THE SONG OF
THE CHICORY FAIRY

By the white cart-road,
 Dusty and dry,
Look! there is Chicory,
 Blue as the sky!

Or, where the footpath
 Goes through the corn,
See her bright flowers,
 Each one new-born!

Though they fade quickly,
 O, have no sorrow!
There will be others
 New-born tomorrow!

(Chicory is also called Succory.)

The Chicory Fairy

A
FLOWER
FAIRY
ALPHABET

THE SONG OF
THE APPLE BLOSSOM FAIRIES

Up in the tree we see you, blossom-babies,
　　All pink and white;
We think there must be fairies to protect you
　　From frost and blight,
Until, some windy day, in drifts of petals,
　　You take your flight.

You'll fly away! But if we wait with patience,
　　Some day we'll find
Here, in your place, full-grown and ripe, the apples
　　You left behind—
A goodly gift indeed, from blossom-babies
　　To human-kind!

THE SONG OF
THE BUGLE FAIRY

At the edge of the woodland
Where good fairies dwell,
Stands, on the look-out,
A brave sentinel.
At the call of his bugle
Out the elves run,

Ready for anything,
Danger, or fun,
Hunting, or warfare,
By moonshine or sun.

With bluebells and campions
The woodlands are gay,
Where bronzy-leaved Bugle
Keeps watch night and day.

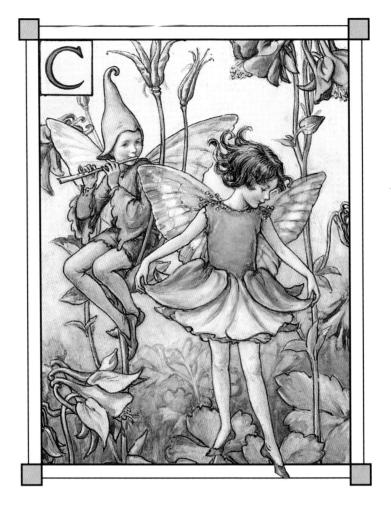

THE SONG OF
THE COLUMBINE FAIRY

Who shall the chosen fairy be
 For letter C?
There's Candytuft, and Cornflower blue,
Campanula and Crocus too,
Chrysanthemum so bold and fine,
And pretty dancing Columbine.

Yes, Columbine! The choice is she;
 And with her, see,
An elfin piper, piping sweet
A little tune for those light feet
That dance among the leaves and flowers
In *someone's* garden.
 (Is it ours?)

THE SONG OF
THE DOUBLE DAISY FAIRY

Dahlias and Delphiniums,
 you're too tall for me;
Isn't there a *little* flower
 I can choose for D?

In the smallest flower-bed
Double Daisy lifts his head,
With a smile to greet the sun,
You, and me, and everyone.

 Crimson Daisy, now I see
 You're the little lad for me!

THE SONG OF
THE EYEBRIGHT FAIRY

Eyebright for letter E:
Where shall we look for him?
Bright eyes we'll need to see
Someone so small as he.
Where is the nook for him?

Look on the hillside bare,
Nibbled by bunnies;
Harebells and thyme are there,
All in the open air
Where the great sun is.

There in the turf is he,
(No sheltered nook for him!)
Eyebright for letter E,
Saying, "Please, this is me!"
That's where to look for him.

THE SONG OF
THE FUCHSIA FAIRY

Fuchsia is a dancer
Dancing on her toes,
Clad in red and purple,
By a cottage wall;
Sometimes in a greenhouse,
In frilly white and rose,
Dressed in her best for the fairies' evening ball!

(This is the little out-door Fuchsia.)

The Fuchsia Fairy

THE SONG OF
THE GORSE FAIRIES

"When gorse is out of blossom,"
 (Its prickles bare of gold)
"Then kissing's out of fashion,"
 Said country-folk of old.
Now Gorse is in its glory
 In May when skies are blue,
But when its time is over,
 Whatever shall we do?

O dreary would the world be,
 With everyone grown cold
Forlorn as prickly bushes
 Without their fairy gold!
But this will never happen:
 At every time of year
You'll find one bit of blossom—
 A kiss from someone dear!

THE SONG OF
THE HERB TWOPENCE FAIRY

Have you pennies? I have many:
 Each round leaf of mine's a penny,
Two and two along the stem—
 Such a business, counting them!
(While I talk, and while you listen,
 Notice how the green leaves glisten,
Also every flower-cup:
 Don't I keep them polished up?)

Have you *one* name? I have many:
 "Wandering Sailor", "Creeping Jenny",
"Money-wort", and of the rest
 "Strings of Sovereigns" is the best,
(That's my yellow flowers, you see.)
 "Meadow Runagates" is me,
And "Herb Twopence". Tell me which
 Show I stray, and show I'm rich?

(Hyacinth, Heliotrope, Honeysuckle, and Hollyhock, are some more flowers beginning with H.)

171

The Iris Fairy

THE SONG OF
THE IRIS FAIRY

I am Iris: I'm the daughter
Of the marshland and the water.
Looking down, I see the gleam
Of the clear and peaceful stream;
Water-lilies large and fair
With their leaves are floating there;
All the water-world I see,
And my own face smiles at me!

(This is the wild Iris.)

THE SONG OF
THE JASMINE FAIRY

In heat of summer days
With sunshine all ablaze,
Here, here are cool green bowers,
Starry with Jasmine flowers;
Sweet-scented, like a dream
Of Fairyland they seem.

And when the long hot day
At length has worn away,
And twilight deepens, till
The darkness comes—then, still,
The glimmering Jasmine white
Gives fragrance to the night.

THE SONG OF
THE KINGCUP FAIRY

Golden King of marsh and swamp,
Reigning in your springtime pomp,
Hear the little elves you've found
Trespassing on royal ground:—

"Please, your Kingship, we were told
Of your shining cups of gold;
So we came here, just to see—
Not to rob your Majesty!"

Golden Kingcup, well I know
You will smile and let them go!
Yet let human folk beware
How they thieve and trespass there:

Kingcup-laden, they may lose
In the swamp their boots and shoes!

THE SONG OF
THE LILY-OF-THE-VALLEY FAIRY

Gentle fairies, hush your singing:
Can you hear my white bells ringing,
Ringing as from far away?
Who can tell me what they say?

Little snowy bells out-springing
From the stem and softly ringing—
Tell they of a country where
Everything is good and fair?

Lovely, lovely things for L!
Lilac, Lavender as well;
And, more sweet than rhyming tells,
Lily-of-the-Valley's bells.

(Lily-of-the-Valley is sometimes called Ladders to Heaven.)

THE SONG OF
THE MALLOW FAIRY

I am Mallow; here sit I
Watching all the passers-by.
Though my leaves are torn and tattered,
Dust-besprinkled, mud-bespattered,
See, my seeds are fairy cheeses,
Freshest, finest, fairy cheeses!
These are what an elf will munch
For his supper or his lunch.

Fairy housewives, going down
To their busy market-town,
Hear me wheedling: "Lady, please,
Pretty lady, buy a cheese!"
And I never find it matters
That I'm nicknamed Rags-and-Tatters,
For they buy my fairy cheeses,
Freshest, finest, fairy cheeses!

THE SONG OF
THE NASTURTIUM FAIRY

Nasturtium the jolly,
　O ho, O ho!
He holds up his brolly
　Just so, just so!
(A shelter from showers,
　A shade from the sun;)
'Mid flame-coloured flowers
　He grins at the fun.

Up fences he scrambles,
　Sing hey, sing hey!
All summer he rambles
　So gay, so gay—
Till the night-frost strikes chilly,
　And Autumn leaves fall,
And he's gone, willy-nilly,
　Umbrella and all.

THE SONG OF
THE ORCHIS FAIRY

The families of orchids,
 they are the strangest clan,
With spots and twists resembling
 a bee, or fly, or man;
And some are in the hot-house,
 and some in foreign lands,
But Early Purple Orchis
 in English pasture stands.

He loves the grassy hill-top,
 he breathes the April air;
He knows the baby rabbits,
 he knows the Easter hare,
The nesting of the skylarks,
 the bleat of lambkins too,
The cowslips, and the rainbow,
 the sunshine, and the dew.

O orchids of the hot-house,
 what miles away you are!
O flaming tropic orchids,
 how far, how very far!

THE SONG OF
THE PANSY FAIRY

Pansy and Petunia,
 Periwinkle, Pink—
How to choose the best of them,
Leaving out the rest of them,
 That is hard, I think.

Poppy with its pepper-pots,
 Polyanthus, Pea—
Though I wouldn't slight the rest,
Isn't Pansy *quite* the best,
 Quite the best for P?

Black and brown and velvety,
 Purple, yellow, red;
Loved by people big and small,
All who plant and dig at all
 In a garden bed.

P

The Pansy Fairy

THE SONG OF
THE QUEEN OF THE MEADOW FAIRY

Queen of the Meadow
 where small streams are flowing,
What is your kingdom
 and whom do you rule?
"Mine are the places
 where wet grass is growing,
Mine are the people of marshland and pool.

"Kingfisher-courtiers,
 swift-flashing, beautiful,
Dragon-flies, minnows,
 are mine one and all;
Little frog-servants who
 wait round me, dutiful,
Hop on my errands and come when I call."

Gentle Queen Meadowsweet,
 served with such loyalty,
Have you no crown then,
 no jewels to wear?
"Nothing I need
 for a sign of my royalty,
Nothing at all but my own fluffy hair!"

THE SONG OF
THE RAGGED ROBIN FAIRY

In wet marshy meadows
A tattered piper strays—
Ragged, ragged Robin;
On thin reeds he plays.

He asks for no payment;
He plays, for delight,
A tune for the fairies
To dance to, at night.

They nod and they whisper,
And say, looking wise,
"A princeling is Robin,
For all his disguise!"

THE SONG OF
THE STRAWBERRY FAIRY

A flower for S!
Is Sunflower he?
He's handsome, yes,
But what of me?—

In my party suit
Of red and white,
And a gift of fruit
For the feast tonight:

Strawberries small
And wild and sweet,
For the Queen and all
Of her Court to eat!

THE SONG OF
THE THRIFT FAIRY

Now will we tell of splendid things:
Seagulls, that sail on fearless wings
Where great cliffs tower, grand and high
Against the blue, blue summer sky.
Where none but birds (and sprites) can go.
Oh there the rosy sea-pinks grow,
(Sea-pinks, whose other name is Thrift);

They fill each crevice, chink, and rift
Where no one climbs; and at the top,
Too near the edge for sheep to crop,
Thick in the grass pink patches show.
The sea lies sparkling far below.
Oh lucky Thrift, to live so free
Between blue sky and bluer sea!

THE SONG OF
THE VETCH FAIRY

Poor little U
Has nothing to do!
He hasn't a flower: not one.
For U is Unlucky, I'm sorry to tell;
U stands for Unfortunate, Ugly as well;
No single sweet flowery name will it spell—
Is there nothing at all to be done?

"Don't fret, little neighbour,"
 says kind fairy V,
"You're welcome to share
 all my flowers with me—
Come, play with them, laugh, and have fun.
I've Vetches in plenty for me and for you,
Verbena, Valerian, Violets too:
Don't cry then, because you have none."

(There are many kinds of Vetch; some are in the hay-fields,
but this is Tufted Vetch, which climbs in the hedges.)

183

THE SONG OF
THE WALLFLOWER FAIRY

Wallflower, Wallflower, up on the wall,
Who sowed your seed there?
 "No one at all:
Long, long ago it was blown by the breeze
To the crannies of walls
 where I live as I please.

"Garden walls, castle walls, mossy and old,
These are my dwellings;
 from these I behold
The changes of years;
 yet, each spring that goes by,
Unchanged in my sweet-smelling
 velvet am I!"

THE SONG OF
THE YELLOW DEADNETTLE FAIRY

You saucy X! You love to vex
Your next-door neighbour Y:
And just because no flower is yours,
You tease him on the sly.
Straight, yellow, tall,—of Nettles all,
The handsomest is his;
He thinks no ill, and wonders still
What all your mischief is.
Yet have a care! Bad imp, beware
His upraised hand and arm:
Though stingless, he comes leaping—see!—
To save his flower from harm.

THE SONG OF
THE ZINNIA FAIRY

Z for Zinnias, pink or red;
See them in the flower-bed,
Copper, orange, all aglow,
Making such a stately show.

I, their fairy, say Good-bye,
For the last of all am I.
Now the Alphabet is said
All the way from A to Z.

The Zinnia Fairy

INDEX